OPEN IT UP!
Integrating the Arts into Jewish Education

Peter and Ellen Allard
Aliya Cheskis-Cotel
Gabrielle Kaplan-Mayer
Gwen Mayer Samuels

A.R.E. Publishing, Inc.
Behrman House, Inc.
Springfield, New Jersey

The following publishers and individuals have graciously granted permission to use material from copyrighted works:

Page 14: Lyrics to "The Latke Song" © 1988 Deborah Lynn Friedman (ASCAP). Published by Sounds Write Productions, Inc. (ASCAP), www.soundswrite.com. Used with permission.

Page 22: Excerpt from "Heroes," a column by Rabbi Berel Wein, in The Jerusalem Post, January 2, 2004. Used with permission. Rabbi Wein, historian, author, and international lecturer, offers a complete selection of CDs, audio tapes, video tapes, DVDs, and books on Jewish history at www.rabbiwein.com.

Page 54: Excerpt from Rabbi Ephraim Buchwald's weekly Torah commentary from December 27, 2004. From the Web site of the National Jewish Outreach Program, http://www.njop.org.

Page 56: "Miriam's Cup Chant" and "Blessing/Song for the Miriam's Cup Celebration" © 2005 80-Z Music. Written by Peter and Ellen Allard, www.peterandellen.com. Used with permission.

Page 66: From *The Book of Miracles: A Young Person's Guide to Jewish Spiritual Awareness* by Lawrence Kushner, © UAHC Press 1987. Used with permission.

Page 66: From the song, "Round and Round," © Steve Brodsky 1999. From the recording, *Turn It* by Mah Tovu, http://www.mahtovu.com. Used with permission.

Page 93: Excerpt from "How Children Develop Empathy" by Lawrence Kutner, Ph.D., http://www.drkutner.com.

Page 95: Lyrics to "Hey, Little Ant" © Phil and Hannah Hoose 1992. Used with permission.

Page 114: From *Mind Tools on Active Listening* by Kellie Fowler. © Mind Tools 2005, http://www.mindtools.com.

Page 116 : Lyrics to "*S'lichah, Todah, B'vakashah*" © 2001 Judy Caplan Ginsburgh, http://www.judymusic.com. Used with permission.

Page 140: Lyrics to "My Hebrew Name" by Larry Milder, ©1993 Laurence Elis Milder, http://www.larrymilder.com. Used with permission.

Page 162: Lyrics to "Joshua, I Wanna Talk with You" © 1999 80-Z Music. Written by Peter and Ellen Allard, www.peterandellen.com. Used with permission.

Page 171: "Memorywork" by Jack Riemer and Sylvan D. Kamens. Used with permission.

Page 175: Lyrics to "We Remember" © 2002 80-Z Music. Written by Peter and Ellen Allard, www.peterandellen.com. Used with permission.

Cover design: Aqua Studio, Denver, Colorado
Editor and Project Manager: Steve Brodsky
Editorial Assistant: Stacey Frishman Delcau

Copyright © 2006 by A.R.E. Publishing

A.R.E. Publishing, Inc.
An imprint of Behrman House, Inc.
Springfield, New Jersey 07081
www.behrmanhouse.com

Library of Congress Catalog Number 2005910874
ISBN 10: 0-86705-089-6
ISBN 13: 978-0-86705-089-9

Printed in the United States of America

All rights reserved. No part of this book may be reproduced in any form or by any means without permission in writing from the publisher.

ACKNOWLEDGMENTS

Peter and Ellen Allard
We would like to thank the many children, parents, and educators with whom we've sung and made music. They are the reason we do this important work. We would also like to thank Randee Friedman of Sounds Write Productions, Inc. She believed in us from the start and her support and enthusiasm have contributed significantly to our work in the field of Jewish music.

Aliya Cheskis-Cotel
I wish to acknowledge my husband, Rabbi Moshe Cotel, and my children, Orli and Sivan, for serving as my personal editors, advisors, and inspiration for creative teaching; my father, Barzillai Cheskis, for teaching all of his girls the importance of reading first-person narration with expression; students from age 4 to 75 whom I have taught over a forty-year period, for showing me the importance of teaching through the use of multiple intelligences; and Kathy Parnes for co-creating the concept of experiential creative writing with me eighteen years ago, making historic figures come alive from Harriet Tubman to Moshe Rabeinu.

Gabrielle Kaplan-Mayer
I would like to thank the many teachers who have participated in my drama workshops for sharing their feedback about my techniques and so helping me to fine-tune the work presented in this book.

Gwen Mayer Samuels
I would like to thank my good friend and colleague Ellen Froncek who shared my love of Judaism and teaching using the creative process, and Aliya Cheskis-Cotel who appreciated my work and recommended me for this much-needed manual for teachers in Jewish schools.

Steve Brodsky
I wish to offer special thanks to Stacey Frishman Delcau, Dr. Ofra Arieli Backenroth, and Peri Smilow for their significant contributions to this work, and to Terry Kaye for guidance and support.

CONTENTS

Introduction *by Ofra Arieli Backenroth and Steve Brodsky* .. vii
About the Artists .. xvii

PART I: HOLIDAYS

Shabbat (Grades K–1) ... 1
Music	Creation: The Soundtrack	2
Drama	Bringing to Life the Story of Creation	4
Creative Writing	*Shabbat Hamalkah*: The Sabbath Queen	7
Visual Arts	Sacred Time, Set Apart: Shabbat Challah Covers	9

Chanukah (Grades 2–3) ... 11
Music	The Sounds of Freedom	12
Drama	The Story of the Maccabees: You Were There!	15
Creative Writing	The Thousandth Day	17
Visual Arts	The Few Against the Many: Working Toward a Common Goal	19

Sukkot (Grades 4–6) .. 21
Music	Theme Songs of the *Ushpizin*	22
Drama	The *Ushpizin*: Honored Guests	24
Creative Writing	Back to Nature: Dwelling in a Sukkah	26
Visual Arts	*Hiddur Mitzvah:* Make Before God a Beautiful Sukkah	28

Pesach (Family Education) .. 31
Music	From Slavery to Freedom: We Shall Overcome	32
Drama	From Generation to Generation: Telling the Tale	35
Creative Writing	Nachshon Takes a Leap of Faith	37
Visual Arts	A Promise of Redemption: Elijah's Cup	39

PART II: TORAH

Noah's Ark (Grades K–1) ... 43
Music	They Came on by Twosies, Twosies	44
Drama	The Sights and Sounds of Noah's Ark	47
Creative Writing	If I Could Talk to the Animals	49
Visual Arts	All the Colors of the Rainbow: Playing "Pass the Paint"	51

Three Righteous Women (Grades 2–3) .. 53
Music	Miriam's Cup, Full of History	54
Drama	Moments of Courage	57
Creative Writing	Miriam Saves a Life	59
Visual Arts	*Tevah:* The Ark of Life	62

Moses and the Burning Bush (Grades 4–6) .. 65
- Music — Signs, Signs, Everywhere Signs ... 66
- Drama — Standing on Holy Ground ... 69
- Creative Writing — Me, God? You're Sure You Want Me? 71
- Visual Arts — A Special Place, A Holy Place 73

Jacob and Esau (Family Education) .. 77
- Music — Dissonance and Accord .. 78
- Drama — Jacob and Esau: The Rivals Speak ... 80
- Creative Writing — All for a Pot of Lentil Soup 83
- Visual Arts — Honoring Differences: Making a Family Tree 85

PART III: MITZVOT AND MIDDOT

Tza'ar Ba'alay Chayim: Kindness to Animals (Grades K–1) 91
- Music — Hey, Little Ant! ... 92
- Drama — Pet Play ... 96
- Creative Writing — The Ants Go Marching One by One 98
- Visual Arts — This Mitzvah Is for the Birds! 100

Hachnasat Orchim: Welcoming Guests (Grades 2–3) 103
- Music — A Musical Mitzvah ... 104
- Drama — Welcome to Abraham and Sarah's Tent 106
- Creative Writing — Let Your House Be Opened Wide 109
- Visual Arts — Welcoming Guests to a Special Place 111

Derech Eretz: Proper Behavior (Grades 4–6) 113
- Music — Are You Listening? .. 114
- Drama — *Derech Eretz:* Rules to Live By .. 117
- Creative Writing — A Jar Full of Compliments 119
- Visual Arts — Such a Face! .. 123

Bal Tashchit: Do Not Destroy (Family Education) 125
- Music — Making Trashy Music ... 126
- Drama — The More You Know: The Three R's .. 129
- Creative Writing — That Nothing Should Be Lost 131
- Visual Arts — Picture This! ... 133

Introduction

PART IV: JEWISH LIFE CYCLE

Baby Naming (Grades K–1) .. 137
- Music — My Hebrew Name 138
- Drama — The Crown of a Good Name 141
- Creative Writing — What's in a Name? 143
- Visual Arts — A New Name, a New Identity 145

Growing Older (Grades 2–3) .. 147
- Music — Musical Memories 148
- Drama — Becoming Older 151
- Creative Writing — Standing on the Shoulders of the Ones Who Came Before 153
- Visual Arts — Bringing Out the Beauty in Our Elders' Faces 156

Bar/Bat Mitzvah (Grades 4–6) .. 159
- Music — And You Shall Put Some of Your Honor upon Him 160
- Drama — Finding the "Mitzvah" in Bar/Bat Mitzvah 163
- Creative Writing — Becoming a Child of the Commandments 165
- Visual Arts — Taking on Responsibility, Taking Action 167

Death (Family Education) .. 171
- Music — Songs that Spark Memory 172
- Drama — Making a *Shiva* Call 176
- Creative Writing — *Zich'ronam Liv'racha:* May Their Memory Be a Blessing 178
- Visual Arts — Ritual and Memory 180

INTRODUCTION
Ofra Arieli Backenroth and Steve Brodsky

THE ARTS IN JEWISH LIFE

Aesthetic appreciation and the creation of works of art have always been central to the Jewish experience. In the book of Exodus, in fact, we begin to see that God is an art lover. Throughout nearly six chapters we read in tremendous detail the shapes, sizes, and colors of the materials that God dictates for use in building the Tabernacle and the Ark of the Covenant. Then, in Exodus 31:1–3, we read:

> *"Adonai spoke to Moses, saying: See, I have singled out by name Bezalel, son of Uri, son of Hur, of the tribe of Judah. I have endowed him with a divine spirit of skill, ability, and knowledge in any kind of craft . . . and in all manner of workmanship"* (Exodus 31:1–3).

Here we see that the beauty and workmanship involved in the completion of this artistic endeavor was so important that God "singled out by name" the artist who would oversee the work, and endowed him with "a divine spirit." Clearly, the beauty of each object in the Tabernacle—from the Ark itself to the lampstand, the curtains, the bowls, the firepans—was of great importance to God. And from this insight, we can draw certain conclusions about the importance of art and beauty in our lives, in the lives of our students, and in our schools.

Yet, despite the great tradition of artistic endeavor in Jewish life, the reality in our schools is quite different. With a small (though growing) number of notable exceptions, the arts typically play a minor role in Jewish education and, in general, are not integrated into the Jewish school curriculum in any meaningful way. The arts tend to be considered as an extracurricular activity and are implemented rarely and sporadically, or worse are neglected altogether. This lack of the arts and experiential teaching is an impediment to what Professor Isadore Twersky (z"l) identified in *A Time to Act* as the primary goal of Jewish education:

> *"Our goal should be to make it possible for every Jewish person, child or adult, to be exposed to the mystery and romance of Jewish history, to the enthralling insights and special sensitivities of Jewish thought, to the sanctity and symbolism of Jewish existence, and to the power and profundity of Jewish faith."*[1]

Yet there are a growing number of Jewish educators who understand that the arts can play a major role in achieving this goal. Ofra Arieli Backenroth is one of the leading advocates of the integration of the arts into the Jewish school curriculum. Dr. Backenroth is the education director of MeltonArts.org, a Web site of The Melton Coalition for Creative Interaction, a partnership between the Melton Centers at the Ohio State University, the Hebrew University, and the Jewish Theological Seminary of America. Through engagement with visual media, dance, music, and other expressive arts, the Coalition seeks to further the teaching and study of Jewish culture and to strengthen Jewish identity. Dr. Backenroth has conducted extensive research on the arts and Jewish education, and writes and presents workshops on the merits and impact of using the arts in teaching Judaic subjects in schools. Much of the material that follows in this Introduction was drawn from her research.

Dr. Backenroth grew up in Israel and received a B.A. in Comparative Literature and a teaching diploma from Tel Aviv University, an M.F.A. in Dance Education from Teachers College, Columbia University, and an Ed.D. from the William Davidson Graduate School of Jewish

1. From *A Time to Act: The Report of the Commission on Jewish Education in North America* (Lanham, MD: University Press of America, 1991).

Introduction

Education at the Jewish Theological Seminary in New York. For the past thirty years she has taught dance, literature, and Hebrew to children of all ages in a variety of settings in Israel, New York, and New Jersey. She is an assistant professor of education at Gratz College and has taught education classes at the Hebrew Union College, the William Davidson Graduate School of Jewish Education at the Jewish Theological Seminary in New York, and recently taught one semester at the Revivim program at Hebrew University in Jerusalem. Dr. Backenroth begins by explaining her personal background in the arts, and the motivation for her research:

> For me, growing up in Israel, being passionate about learning meant taking dance classes in the afternoon dance school. Going to school in the morning was what I had to do, but my really interesting learning took place in the afternoon. It all began when I was six years old, when my grandmother sent me to take dance classes at the neighborhood school. After that I took daily dance classes for many years. My dance teacher took me under her wing and provided me with many opportunities for success. Eventually she encouraged me to start teaching, and at seventeen, I taught my own dance class; by twenty, I had my own dance school. This teacher, in addition to being an expert in her field, was more than just an authority on dance; she was a role model, a mentor, and a friend. Thanks to her encouragement I taught dance when I was still a teenager, continued to teach during my college years, and, soon after I completed my army service, I took my Masters in Dance Education at Teachers College, Columbia University. When teaching dance technique, I was weaving in the teaching of language, literature, values, and social skills. However, it was all done in between the walls and the mirrors of a dance studio and only in the afternoons.
>
> As I established my family, I eventually became a Suzuki mother.[2] I was involved in my children's music education for many years and was astonished to see the commitment of students, parents, and teachers in these music schools to excellent education. Trying to understand this excitement and love of learning, willingness to practice, to learn cooperatively, and to compete with oneself constantly, I wondered why this excitement was missing in the Jewish schools my children attended and where I had taught Hebrew language and literature for many years. Moreover, I was struck by the lack of arts education, the lack of creative expression in education, and particularly by the absence of the visual arts, music, and dance education in these schools. The contrasts between morning and afternoon, Jewish vs. secular studies, required courses vs. electives, and boredom vs. exhilaration and inspiration were an enigma and a great disappointment for me. Eventually, following my career as a dance teacher, I spent several years working in a Jewish day school, teaching and coordinating an "art integration into the curriculum" project. Watching teachers and artists work together toward one goal—to engage the students with the content of the lessons—motivated me to investigate what researchers had to say about teaching through the arts. In addition, my experience as a parent active in school organizations and a teacher in a Jewish day school inspired me to embark on this research to try to understand the value of the arts to education in . . . Jewish schools.[3]

2. The Suzuki system demands that parents be actively involved in their children's music education. Among other obligations, parents need to be present during the music lessons of their children, and practice with their children every day.
3. O. A. Backenroth, "The Blossom School: Teaching Judaism in an Arts-based School." (Ph.D. dissertation, The Jewish Theological Seminary, 2004).

THE VALUE OF ARTS IN JEWISH EDUCATION

Like Dr. Backenroth, many Jewish educators have been struck by the absence of arts education in Jewish schools. Others have implemented some level of arts programming in their schools, but seek ways to better integrate the arts into the classroom and to weave them more naturally into the school curriculum. Intuitively, most Jewish educators recognize that this integration has inherent value. Yet how can we quantify this value, how can we build a case for the integration of art and Jewish education in our schools?

First, we recognize that art is a gift—not only is artistic ability a gift endowed by God, but the use of that ability can be a gift that the artist gives back to God, and to his or her community. By integrating artistic expression into our schools and classrooms, we encourage that exchange of gifts and nurture that "divine spirit" with which every student is endowed.

Second, we understand that art brings pleasure. Art delights the eye, the ear, and all the other senses. Art is fun to do, bringing pleasure to the artist, and the sharing of the art brings pleasure to others. Education that is fun is more engaging and more effective.

Third, art challenges us to stretch beyond our usual boundaries, to explore and create. God creates, and we, *b'tzelem Elohim* (in the image of God), create as well. Art offers opportunities to explore and to nurture the divine spark inside each of us.

Fourth, we know that art builds community. Every Israelite contributed to the building of the Tabernacle by giving gold, silver, copper, precious stones, animal skins, or fine linen. Many also gave of their skills and talents. The process of working together toward a common goal forges new connections among people, enhances existing relationships, and builds community. All of these are important objectives in Jewish education.

Fifth is the concept of *hiddur mitzvah*, beautifying or embellishing the commandments. *Mitzvot* are at the very core of Judaism, guiding our actions and providing a structure to our lives. *Hiddur mitzvah* involves everything from selecting the most beautiful *etrog* on Sukkot to composing the most beautiful melodies for prayers. It is going above and beyond what is required, making the usual special and the special spectacular. An example: Kiddush can be made over wine in a simple paper cup—the mitzvah relates to the wine, not the container. But we can elevate the performance of the mitzvah by using a special Kiddush cup that is an object of great beauty. And how much more meaning is infused into the performance of the mitzvah when the beautiful Kiddush cup is something that one created oneself! Artistic expression raises the *kavanah* (intention) of the act to a whole new level, and enhances our ability to find greater meaning in our actions. Greater meaning leads to greater understanding, one of the ultimate goals of Jewish education.

Sixth, arts experiences give students a hands-on opportunity to express their individual ways of learning. Howard Gardner, a developmental psychologist and Professor of Cognition and Education at the Harvard Graduate School of Education, developed in 1983 the theory of multiple intelligences, quantifying what many educators know intuitively: students think and learn in many different ways. Gardner viewed intelligence as "the capacity to solve problems or to fashion products that are valued in one or more cultural settings." He questioned the idea that intelligence is a single entity, that it results from a single factor, and that it can be measured simply via IQ tests. Gardner initially identified seven distinct intelligences: verbal/linguistic, logical/mathematical, musical/rhythmic, visual/spatial, bodily/kinesthetic, interpersonal, and intrapersonal.[4] While it is not practical to elaborate in great detail here on Gardner's

4. An eighth intelligence, naturalist intelligence, has since been identified by Gardner.

theories, it is important to note that they have been embraced by a great number of educators who seek to develop new approaches to education that will better meet the needs of the range of learners in their classrooms. Educators have come to understand that their teaching must reach beyond the narrow confines of the verbal/linguistic and logical/mathematical intelligences on which education has traditionally been focused. Because three of the identified intelligences—musical/rhythmic, visual/spatial, and bodily/kinesthetic—are closely associated with the arts, a basic understanding of these three intelligences can be of great benefit to those wishing to integrate arts activities into the Jewish classroom.

Renee Frank Holtz, Ph.D. and Barbara Lapetina, Ph.D. are Jewish educators who have written about Gardner's theories and how they can be applied to Jewish education. In their article "Multiple Intelligences," published in *The Ultimate Jewish Teacher's Handbook*,[5] they describe the musical/rhythmic, visual/spatial, and bodily/kinesthetic intelligences:

> Musical/rhythmic intelligence involves skill in the performance, composition, and appreciation of musical patterns. It allows people to create, communicate, and understand meanings made out of sound. Students who are attracted to the singing of birds outside the classroom window or who can tap out intricate rhythms with a pencil exhibit musical intelligence.[6]
>
> Visual/spatial intelligence makes it possible for people to use visual or spatial information, to transform this information, and to recreate visual images from memory. The students who turn first to graphs, charts, and pictures in their textbooks, who like to web ideas prior to writing a paper, and who intricately doodle in their notebooks show evidence of spatial intelligence.[7]
>
> Bodily/kinesthetic intelligence entails the potential of using one's whole body or parts of the body to create products or to solve problems. The student who can accurately toss a crumpled piece of paper into a wastepaper basket located across the room displays this intelligence. Students who love physical education class and school dances, who prefer to do class projects by making models instead of writing reports, display bodily/kinesthetic intelligence.[8]

Multiple intelligences education appeals to educators who opt for depth over breadth, who strive for understanding as opposed to the accumulation of knowledge. Understanding entails the application of knowledge, specifically the taking of knowledge gained in one setting and using it in another. To enhance understanding, students should have extended opportunities to work on a topic and be given opportunities to approach it from a variety of different intelligences.[9] The seven intelligences that Gardner identified rarely operate independently of one another—most students have the ability to "tap into" several of their intelligences at one time. This is precisely why integrative arts activities that utilize several different skills can be very successful in helping students to achieve understanding. At the same time, experienced educators know that some students will not display strength in the "artistic" intelligences, and will struggle with arts-based activities. Proponents of multiple intelligences teaching advise that the important thing is to vary the modalities and appeal to different intelligences as often as possible. It is also important to recog-

5. Nachama Skolnik Moskowitz, ed., *The Ultimate Jewish Teacher's Handbook* (Denver, CO: A.R.E. Publishing, Inc., 2003).
6. Tina Blythe, Noel White, and Howard Gardner, *Teaching Practical Intelligence: What Research Tells Us* (West Lafayette, IN: Kappa Delta Pi, 1995), p. 6.
7. Ibid., p. 8.
8. Ibid., p. 7.
9. Mindy L. Kornhaber, "Howard Gardner," in Joy A. Palmer, ed., *Fifty Modern Thinkers on Education: From Piaget to the Present Day* (London: Routledge, 2001), p. 276.

nize that as teachers, we often prepare lessons that are directed toward our own intelligence preference. It can be helpful to analyze our own strengths in order to make certain that other intelligences are included in our lessons.

Lastly, history is firmly on the side of the arts. Using the arts in Jewish education is by no means a new idea. Congregational schools and informal Jewish education have from the earliest days practiced experiential education and used the arts to enhance and deepen Jewish consciousness. Early in the twentieth century Dr. Samson Benderly, director of the first Bureau of Jewish Education in the United States in New York and commonly regarded as the architect of the Jewish synagogue school system, strongly believed that to attain the goals of Jewish education—namely, deep understanding of the historical events—drama, music, and dance should be used as tools for bringing to life the characters and events that would otherwise remain vague and unreal in the minds of students.

The eminent Gratz College educator Elsie Chomsky used the arts in teaching Hebrew and Judaic studies, noting, "intuitively [I felt] that [using the arts] was a vital expression of the creative urges of the children and not studied and mechanical repetitions of lines."[10] Mordecai Kaplan, who would later become the founder of Reconstructionist Judaism and who presided as principal of the Teachers Institute of the Jewish Theological Seminary of America from 1909 to 1931, believed that the arts would perpetuate Jewish life and keep the Jewish tradition alive; therefore he considered the arts as an integral part of the Jewish religion.[11] Kaplan argued that "Art education in the public school, public libraries, public museums, public concerts has added something of inestimable value to our social life."[12] Following his conviction about the arts, Kaplan wanted to establish the arts as part of Jewish education. The first arts class to be introduced to the teachers college was in music, believed to be historically the most Jewish of the arts.[13] The well-known composer and choir director Samuel Goldfarb was invited in 1927 to teach a class titled "Jewish Music and Methods of Teaching Jewish Songs." In later years such luminaries as Judith Kaplan, Tzipora Jochsberger, Ari Kutai, and Temima Gezari would join the faculty of the Teachers Institute, teaching courses in such disciplines as music, elocution, dramatics, and art education.

In 1949 Dvora Lapson, a pioneer in Hebraic dance, originated the concept of integrating dance into the curriculum of Jewish schools while serving as Dance Consultant and Director of the Dance Education Department of the Board of Jewish Education in New York. Miss Lapson believed that by learning traditional Jewish and Israeli folk dances, students could forge connections with five thousand years of Jewish history and with modern Israel. To advance these ideas, she organized and conducted dance seminars and workshops for hundreds of teachers in Jewish schools and trained and inspired a corps of professional dance instructors to teach Jewish dance.

These are just a handful of examples of the many extensive arts education programs that have been implemented in Jewish schools in the past. Indeed, there are numerous examples of successful programs currently in operation. A detailed description of these is beyond the scope of this Introduction.

With such successful precedent, and with all of the clear benefits that arts education offers, one might assume that today Jewish schools have enthusiastically embraced the concept of integrating arts activities into the curriculum

10. Harriet Feinberg, *Elsie Chomsky: A Life in Jewish Education* (Waltham, MA: Hadassah International Research Institue on Women, 1999).
11. Dr. Jack Wertheimer, *Jewish Education in the United States: Recent Trends and Issues* (Bloomsburg, PA: Haddon Craftsmen, 1999).
12. Ibid, 138.
13. David Kaufman in Dr. Jack Wertheimer, ed., *Tradition Renewed: A History of the Jewish Theological Seminary* (New York: The Jewish Theological Seminary, 1997), 698.

and are happily reaping such benefits as deeper understanding by students, a greater sense of community, and students and staff who are more engaged in and more fulfilled by their learning and teaching. This assumption might be further reinforced by what seems to an explosion of interest in the Jewish arts in popular American culture in recent years. Klezmer music has undergone a major renaissance and is being performed on the world's greatest concert stages and in the hippest urban jazz and rock clubs. Other forms of Jewish music have also gained in popularity, from folk to rock to jazz-fusion. Yiddish theatre has also seen a resurgence in popularity, and Jewish culture and characters seem to be ubiquitous in film, on television, in literature, and in comedy. Yet, this contemporary interest in the arts has not had a major impact on the Jewish educational system. In most Jewish schools the arts still play a minor role in the curriculum in general and have typically not been integrated as tools for teaching Jewish texts. One of the reasons why the arts have received short shrift in the contemporary Jewish educational world is that Jewish schools, and especially Jewish day schools, are already overburdened by the requirements of their curriculum in general and the enormousness of the Judaic curriculum in particular.

IMPEDIMENTS TO INTEGRATED ARTS EDUCATION IN JEWISH SCHOOLS

The typical Jewish synagogue school covers a wide range of Jewish subjects, including Bible and history, Jewish holidays, Israel, prayer, Jewish values, life cycle events, and Hebrew. Jewish day schools cover all of these, as well as the required secular subjects of English, math, history, and science. Because of these extensive curricular requirements, the arts are often neglected and are considered to be "extracurricular" or "add-on" activities.

The shortage of time for covering the required curricular material is just one obstacle that Jewish schools face. Given the current well-documented shortage of qualified Jewish teachers, finding able bodies can be hard enough; finding teachers skilled in Judaic studies who also are able to effectively integrate arts activities into the curriculum can be nearly impossible. Educators with skills as visual artists, musicians, storytellers, or dancers are most often categorized as "specialists" and, in an effort to maximize their exposure to the greatest number of students, usually spend short, intermittent blocks of time with a particular class or grade. Thus, students will go down the hall to visit the art room once or twice a semester, or have the music specialist drop in for a brief music session once every few weeks. Under these circumstances it can be difficult to build continuity in an arts program, and the specialists can be disconnected from the ongoing education occurring in the classroom.

Furthermore, enrichment programs in the arts create an added burden in costs and space requirements for art studios, dance space, and music rooms that can be prohibitive for some schools. The cost of art supplies, musical instruments, and other tools and equipment can be significant. Skilled "specialists" often command a higher rate of pay than classroom teachers, and can be difficult to find. As a result, taking into account the expenses "[w]hen it comes to budgets, art is always the first piece that goes" says Jo Kay, director of the Hebrew Union College School of Education in New York. "It's gaining more acceptance, but it's still a struggle."[14]

14. Julie Wiener, "Moving Arts to the Head of the Class," *The Jewish Week* (12/6/2002).

GOOD NEWS FOR ARTS EDUCATION

Despite these significant obstacles, there is good news for arts education. There is increasing recognition by some schools of the merits of teaching through the arts. Indeed, driven by progressive and modern theories of education such as Gardner's theory of multiple intelligences, "Jewish education is becoming increasingly inclusive of the arts. [T]he trend is not limited to the visual arts, but also includes newfound interest in using music, filmmaking, dance, and even creative writing as a way to teach Judaism."[15] The arts have also become a serious topic for policy makers. The 2002 Partnership for Excellence in Jewish Education (PEJE) conference included a special session about arts experiences. Presenters from Jewish day schools led the participants through experiential activities in visual arts, storytelling, music making, prayer and listening, and multimedia events.[16] More recently, a vivid conversation began about the place of the arts in the education of Yeshivah students. Orthodox luminaries such as Rabbi Haim Brovender, disillusioned with the authenticity of *kavanah* in high school students' prayers and disappointed with the lack of engagement in Torah studies, suggested that visual art has a place in Orthodox Jewish religious schools. He implied that the wonder and creativity that the study of art engenders is applicable to Torah study and to the enhancement of spiritualism. In their description of "educational excellence," Rabbi Joshua Elkin and Naava Frank of PEJE stated that one of the characteristics of excellent Jewish education is the ability to "exhibit a strong presence of Judaic culture in multiple forms: literature, language, visual arts, music, and dance."[17]

"OPENING UP" THE ARTS, OUR STUDENTS, OURSELVES

It is into this exciting, challenging, and rapidly changing environment that *Open It Up!: Integrating the Arts into Jewish Education* makes its debut. In 2001 playwright, author, and Jewish educator Gabrielle Kaplan-Mayer planted the seed of an idea with A.R.E. Publishing, Inc. for a teacher resource manual that would help classroom teachers to integrate arts activities into the Jewish school curriculum. Kaplan-Mayer had authored two books of Jewish plays for children, but recognized that many classroom teachers who had no background or skill in dramatics did not know how to use her plays effectively in the classroom. She understood that the vast majority of Jewish teachers do not consider themselves to be "artists" and are intimidated by the idea of singing, dancing, acting, painting, drawing, or otherwise implementing arts activities in their classrooms. Further, there existed in the literature of the field little quantified evidence of the benefits of integrative arts education, and virtually no guidelines for how to go about creating such a program. Over several years, the concept evolved beyond drama to include music, creative writing, and the visual arts, the four arts disciplines most frequently implemented in Jewish schools. Finally in April, 2004 a team of four artists, one researcher, and one publisher convened several days of meetings in New York to move the as-yet unnamed project from concept to reality. Dramatist Kaplan-Mayer was joined by musician Peri Smilow, creative writer Aliya Cheskis-Cotel, and visual artist Gwen Mayer Samuels. Also joining the team were Ofra Arieli Backenroth, whose personal experience detailed above had led her to become a writer and researcher in the area of the arts and Jewish education, and Steve Brodsky, owner

15. Ibid.
16. Stephen Horenstein, "Interactia: Five Models for Excellence in the Arts in Jewish Education" (paper presented at the Partnership for Excellence in Jewish Education Conference for Grantees, November 3, 2002).
17. Joshua Elkin and Naava Frank, "Portrait of Educational Excellence" (paper presented at the inaugural Leadership Assembly of the Partnership for Excellence in Jewish Education, Los Angeles, 2003), p. 2.

Introduction

and president of A.R.E. Publishing, Inc. All of these contributors had many years of experience in Jewish education, and brought to the project a tremendous amount of practical experience in integrating the arts into the Jewish school curriculum. It must be noted that after several months, due to numerous other commitments Peri Smilow made the difficult decision to step out of the project. The other team members gratefully acknowledge Peri's significant contribution to this book during the time she was involved in the project. Fortunately, Peter and Ellen Allard, highly respected early childhood music specialists, recording artists, and performers, agreed to step in for Peri and the team was complete once again. Over the next eighteen months, each artist created, developed, and fine-tuned sixteen activities in his or her particular discipline.

Why the title *Open It Up?* Open what up? The title is a metaphor that operates on many levels, from the simple (open up the book and use it) to the sophisticated (open up your mind, your heart, your creativity, your passion) to the complex (open up your students to the beauty and wonder of Jewish life through the arts, open up your school to a new way of teaching). The title, like art itself, will speak to each user of this book in a unique and personal way.

HOW TO USE THIS BOOK

Open It Up! is designed to set free the hidden artist inside every classroom teacher. It is designed not for arts specialists (though it will be valuable to them), but for average classroom teachers who think they aren't musicians, actors, writers, or artists. *Open It Up!* provides the ideas, the inspiration, and the tools to weave music, drama, creative writing, and the visual arts organically into the classroom curriculum. It shows every teacher how to breathe life into any subject matter through creative, engaging integrative arts activities. Rather than sending your students down the hall to the art room, use these activities to bring art into your classroom. Don't wait for the music specialist to come around once every few weeks, provide a fun and engaging music activity for your students whenever you like—and you don't need any particular musical talent to do so! *Open It Up!* aims to break the perception of the arts as "extra" or "add-on" activities, and "open up" the subject matter by weaving arts activities into the curriculum in a natural, organic way.

How *Open It Up!* Is Organized

At the heart of *Open It Up!* are sixty-four creative, dynamic arts activities in four topic areas: Jewish Holidays, Torah, Mitzvot and Middot, and Jewish Life Cycle. Within each topic area are subjects for four grade levels—K–1, 2–3, 4–6, and family education—and within each subject for a particular grade level is one activity in each of the four arts disciplines: music, drama, creative writing, and visual arts. Each activity is clearly marked at the top of the page with a graphic indicating the art (the same icons appearing on the cover of this book) as well as the suggested grade level. See the Table of Contents (page iv) for a clear listing of all topics, subjects, grade levels, and activities.

One special feature of *Open It Up!* is its flexibility. A look at the Table of Contents shows that in the Jewish Holidays section, for example, there are four individual activities for grades 2–3 under the subject of Chanukah. But, you say, I need a Chanukah activity for my grade 4 classroom! Here we discover one of the beauties of *Open It Up!*: The activities are infinitely adaptable. With a little thought and preparation, you can take one of the Chanukah activities designed for grades 2–3 and adapt it for your fourth graders by adding more sophisticated background material, or by extending the activity in some way to make it more age-appropriate and challenging. By the same token, you can adapt an activity to a lower grade level by shortening the activity, simplifying the

discussion, or focusing on a less sophisticated concept related to the topic. An activity designed for family education can easily be adapted for use in a standard classroom. Through this type of adaptation, you can use the sixty-four core activities to create literally hundreds of potential arts activities for a wide range of settings.

Each of the sixty-four lessons follows a standard format, similar to many typical classroom lesson plans. Following is an explanation of the various sections found in each lesson.

The Big Idea

In recent years, many Jewish educators have found value in a theory of curriculum design developed by a group of researchers at the Harvard University Graduate School of Education and published in 1998 by Grant Wiggins and Jay McTighe as *Understanding by Design*. UbD, as it is affectionately known, is a "backward design process," building curriculum upon enduring understandings, the "big ideas" that remain with students when all the little details disappear from their memories. According to Wiggins and McTighe,

> A big idea is a concept, theme, or issue that gives meaning and connection to discrete facts and skills.... Big ideas are at the "core" of the subject; they need to be uncovered; we have to dig deep until we get to the core.... The big ideas "connect the dots" for the learner by establishing learning priorities.... they serve as "conceptual Velcro" [helping] the facts and skills stick together and stick in our minds.
>
> A big idea may be thought of as a linchpin. The linchpin is the device that keeps the wheel in place on an axle. Thus, a linchpin is one that is essential for understanding. Without grasping the idea and using it to "hold together" related content knowledge, we are left with bits and pieces of inert facts that cannot take us anywhere.

A big idea can be thought of as

- Providing a focusing conceptual "lens" for any study

- Providing a breadth of meaning by connecting and organizing many facts, skills, and experiences; serving as the linchpin of understanding

- Pointing to ideas at the heart of expert understanding of the subject

- Requiring "uncoverage" because its meaning or value is rarely obvious to the learner, is counterintuitive or prone to misunderstanding

- Having great transfer value; applying to many other inquiries and issues over time—"horizontally" (across subjects) and "vertically" (through the years in later courses) in the curriculum and out of school.[18]

As an example, in teaching about the Jewish holiday of Pesach a teacher might ask students to memorize the ten plagues in order, have them recite the Four Questions, have them draw a map of the Israelites' route from Egypt through the Sea of Reeds to the Promised Land, and teach them to bake matzah. These are all wonderful activities, but without the "Velcro" of a big idea to hold them together they are simply disparate facts, concepts, and skills and do not provide any enduring understanding about Pesach. If, on the other hand, we start with a clear, concise conceptual anchor—the big idea that once we were slaves, and now we are free—we get down to the core of the Exodus story and provide a framework for establishing learning

18. Wiggins, Grant, and Jay McTighe, *Understanding by Design,* Expanded 2nd Edition (Alexandria, VA: Association for Supervision and Curriculum Development, 2005).

priorities. Soon we begin to see that the plagues, the Four Questions, our route through the desert, and matzah—as well as the other foods on our seder plate, the organization of the Haggadah, and even the way we recline at the seder table—all lead back to the powerful, meaningful big idea of our people's journey from slavery to freedom. This big idea provides a focusing lens for our study and connects and organizes many facts, skills, and experiences. It points to ideas that are at the heart of understanding not only of Pesach, but of all of Jewish life. This big idea requires "uncoverage" because it causes us to ask questions about why we were slaves in the first place and how we became free. And it has tremendous transfer value, in that the understanding of this core concept filters through our inquiries into many other aspects of Jewish life: Why do we recite the *Mi Chamocha* prayer several times a day? Why does Judaism place such an emphasis on proper treatment of strangers? A grasp of the underlying concept opens up new possibilities for understanding, and begins to connect the dots for learners in ways that are powerful and enduring.

The first page of each topic area in this book provides the big idea around which the arts activities for that topic are organized. The big idea is often drawn from Jewish textual sources, providing a connection to Jewish history and culture on yet another level. And, in good backward-design fashion, the big idea clearly frames what the learners should come to understand. Encourage students to constantly consider the big idea anew as they engage in the activities and move toward understanding. (Users are encouraged to read *Understanding by Design* by Wiggins and McTighe for an in-depth explanation of big ideas and the backward design philosophy.)

Inspiration

The "Inspiration" section in each activity provides a bridge between the big idea for the topic and the activity itself. Often drawn from Jewish textual sources, this material helps participants to focus on one particular aspect of the big idea, which by nature is broad and abstract. Though not in the form of a question, the inspiration material functions similarly to what Wiggins and McTighe call an "essential question"—it points to and highlights certain aspects of the big idea, elicits understanding and alternative views, and sparks meaningful connections with what learners bring to the classroom from prior classes and their own life experiences.[19] The material in this section moves the learning process from the abstraction of the big idea to the concreteness of a music, drama, creative writing, or visual arts activity.

Often the inspiration material found in the activity for one arts discipline can be used as additional background for the activity in a different discipline under the same topic. Be sure to review all four activities under any particular topic to see what additional material might be useful.

Objective

The objective is the goal of the activity, in very simple, clear terms. The objective almost always starts with the words, "The student will . . ." The objective can be used as an evaluation tool at the completion of the activity: if the students did what the objective said they would do, the activity was successful at meeting its objective.

Materials

Here you will find a complete list of all the materials you will need to complete the project or accomplish the activity.

19. Ibid

Process

In this section you will find clear, step-by-step instructions for implementing the activity. It's always a good idea to read through the instructions completely before beginning the activity, to be sure that you understand each step. Some activities require advance preparation and a few activities require more than one class session. In these cases, the instructions clearly specify the steps to be taken.

Helpful Hints

This section includes tips and suggestions for successfully implementing the activity, or offers ideas for extending the activity. Read this section carefully, as sometimes it provides information on where to find certain materials or suggests alternatives to materials that may be difficult to find.

Resources

The final section of each lesson includes a few suggested resources that can be helpful in implementing or extending the activity. Included are adult resource books, Jewish and secular children's books, music resources, films, Web sites, and other types of materials. Teachers can use these resources to further research the topic, or bring the materials into class to enhance the experience of the students.

ABOUT THE ARTISTS

Five very talented artists created the sixty-four activities found in this book. In true collaborative form, they worked together to identify the big ideas, provide the inspiration, and create the activities, bringing to life the concept of true integration of the arts and Jewish education. Following are a brief biography of each artist and a short introduction, in the words of each artist, to each particular arts discipline.

MUSIC
Peter and Ellen Allard

"Then God formed man of the dust of the ground, and breathed into his nostrils the breath of life; and man became a living soul" (Genesis 2:7).

From the very beginning, music has been part of the Jewish soul. It is in our breath, in our spirit, and in our blood. It is as ancient as the *Mi Chamocha,* the song our people sang at the shore of the Sea of Reeds while Miriam led the women in dance. It is as poetic as the Psalms of King David, as stirring as the call of the shofar, as mournful as the strains of Tevya's fiddler on the roof. Whether found in the hypnotic, wordless melodies of a *niggun* or the rousing spirit of a Shlomo Carlebach tune, the mixture of voice, melody, and breath is rooted deep in the Jewish psyche and tradition.

Music touches and embellishes every facet of Jewish life. It is our spiritual language, facilitating our people's most intimate conversations with God. Modern liturgy includes the chanting of the *V'ahavta* virtually unchanged from the way it was chanted over two thousand years ago, providing a common touch point for every ensuing generation of worshipers.

Music provides the soundtrack to our Jewish lives, from birth to death, from youth to old age, from strength to healing. Whether dancing with the scrolls at Simchat Torah or singing *"Dayenu"* around the seder table, music carries us through the cycles of the Jewish year.

Music is a source of pride and a connection to a rich history. From Irving Berlin to Bob Dylan, Al Jolson to Neil Diamond, Benny Goodman to Paul Simon, Jews have been well-represented among the greatest composers, musicians, singers, and conductors in the history of the world. And a new generation of Jewish rappers and hip-hop artists continue to redefine Jewish music for a new generation.

Introduction

Music is a highly effective means of teaching and learning with children and adults. Because we all have a voice, singing together allows for shared breathing and harmonious expression that everyone can appreciate and share in. Musical/rhythmic intelligence is one of the seven modalities identified by Howard Gardner in his theory of multiple intelligences. It enables people to create, communicate, and understand meanings made out of sound. Music allows for audio, visual, and kinesthetic transmission of information in ways few other modalities can match.

Music is all about doing and experiencing. It requires participation and cooperation. Music moves the body as well as the spirit. In combination with movement or dance, it provides a multidisciplinary, multisensory experience that promotes healthy, active learning.

And finally, music builds community. It is a medium that bonds people together, whether as voices rising together around a campfire or as a congregation rising together to chant the *Amidah*. Jewish music in particular has the power to build *kehilah k'dosha*, sacred community. Synagogue 2000, a transdenominational synagogue transformation project that helps synagogues examine their current structure and reimagine ways to be better at what they do, defines sacred community as one in which members are welcoming, caring, and responsive. In a sacred community people study together, pray together, sing together, and share one another's life journeys. Through it all, music is at the forefront. Most of the music activities in this book encourage group activity, leading to shared experiences—because, after all, Judaism is all about shared experiences. As Rabbi Pinchas of Koretz taught, "Alone I cannot lift my voice in song—then you come near and sing with me. Our prayers fuse, and a new voice soars. Our bond is beyond voice and voice. Our bond is one of spirit and spirit."

Incorporating music into the Jewish classroom can provide all of these benefits, and more. We have attempted to provide a wide range of activities to appeal to many different tastes, abilities, and teaching styles as well as different learning modalities. Some of the activities found here will require research and preparation on your part, while others are ready to go "out of the box." Some may challenge you to open your ears to new kinds of music to which your students are listening. Some activities may be enhanced by adding the talents of a trained musician, but all can be done effectively by any teacher with spirit and enthusiasm. Don't get hung up on labels like "musician" or "singer"—in the spirit of this book, open up your mind to the many possibilities of what music might be. Help all students find their own voices so that their Jewish souls can be strengthened and internalized through music.

Music infuses Jewish worship, Jewish celebration, indeed all of Jewish life. Our hope is that these activities will help you and your students explore the rich world of Jewish music. Join in, the world is waiting for your voice!

Peter and Ellen Allard are children's recording artists, early childhood music specialists, and performers who have won multiple awards for their work. Drawing on a rich tradition of musical experiences, they present captivating family performances, Tot Shabbat and Family Shabbat worship services, keynote presentations, and teacher workshops for audiences throughout the United States. Peter and Ellen are enthusiastically committed to helping children and families strengthen their Jewish identities. Through creative programming they are able to make Judaism accessible to everyone, helping young and old alike explore and enrich their spiritual lives. They have released eight recordings and numerous songbooks, and their music is used in synagogues and religious schools across North America. Recently, sixteen of Peter and Ellen's

original songs were included in The Complete Jewish Songbook for Children Volume II: Manginot *and three of their tunes were included on the recording* Torah Alive! Music Connection: Torah Songs for Kids *(both from Transcontinental Music Publications). Peter and Ellen have five adult children between them, and travel the country from their home in Worcester, Massachusetts. Visit their Web site at www.peterandellen.com.*

DRAMA
Gabrielle Kaplan-Mayer

When I reflect on my own Jewish education, one particular experience stands out among all others: staging our seventh grade play about the founding of the modern state of Israel, when I had the opportunity to play Golda Meir. I don't imagine that my teachers then knew the impact that working on this play would have on me—that years of learning Jewish history through books would suddenly come alive in a way that has never since loosened its grip on my imagination. What they clearly did understand in putting the play into our curriculum was that the active learning that comes with staging a play—through learning lines, embodying characters, rehearsing scenes in pairs and in ensembles, painting sets, putting together props and costumes—is an excellent way to engage high-energy students and create classroom community.

As both a professional theater artist and religious school teacher and director, I strive to bring that kind of active engagement into the classroom by using a variety of drama techniques—from staging full plays to playing improvisational games to helping students write their own dramatic scenes and monologues inspired by Jewish texts. In this book, I present a variety of these techniques and take you, the educator, through a step-by-step methodology to bring theater alive in your classrooms. This way, you don't need to have personal background or experience in drama yourself; rather, the activities will give you the tools needed to experiment with a variety of dramatic techniques that can help engage your students in Jewish learning.

Many of us try our hand at drama when Purim time comes around—and with good reason. The Purim *shpiel* (play) was historically the time during the Jewish year when even the most observant of rabbis acknowledged the importance of theater in acting out the story of the brave Queen Esther, her guardian Mordechai, and the perils of the Jews of Persia. The *shpiel* expanded to include all kinds of satires and masquerades and eventually the Yiddish theater grew out of this tradition. In post-Enlightenment Europe, a small group of actors decided to expand the plays beyond the occasion of Purim and create comedies and dramas written and performed in Yiddish—thus Yiddish theater was born. The plays, including adaptations of Shakespeare and original works by such playwrights as Shalom Asch, came to define and reflect the culture of the time, and Yiddish theater traveled with its creators and supporters across the ocean to both America and Israel.

Today, Jewish theater continues to thrive around the world, with new and classic plays by Jewish playwrights containing Jewish content being staged in community, regional, and Broadway theaters. In the last couple of centuries, the Jewish people has embraced the power of the theater for telling and transmitting its stories. This recognition should come as no surprise: our sacred texts are full of human drama and our rituals, such as the performance of the Passover seder, encourage us not simply to listen but to actively imagine that we were, in fact, once slaves in the land of Egypt. Playacting allows us to connect to our stories and the characters in them on an emotional, spiritual, and kinesthetic level that cannot be understood by simply reading or analyzing them.

Introduction

For these reasons, I encourage you to bring this "newish Jewish" tradition into your classrooms. Be silly and try on different costumes. Be serious and write and perform scenes about contemporary issues. Drama can help you and your students connect to tradition and connect to each other—the reason, I believe, that we create Jewish schools to begin with.

Gabrielle Kaplan-Mayer is a playwright, author, and educator based in Philadelphia, PA. She is the author of two books of plays for children, The Magic Tanach and Other Short Plays *and* Extraordinary Jews: Staging Their Lives *(both from A.R.E.), as well as two nonfiction books for adults,* Insulin Pump Therapy Demystified: An Essential Guide for Everyone Pumping Insulin *(Marlowe & Company) and* The Creative Jewish Wedding Book *(Jewish Lights). A 1993 graduate of Emerson College with a B.F.A. cum laude in performing arts, Gabrielle also earned a Master's degree in Jewish studies at the Reconstructionist Rabbinical College. Kaplan-Mayer currently serves as Assistant Education Director at Congregation Mishkan Shalom in Philadelphia, PA. She is married to Fred Kaplan-Mayer and happy mom to two young children, George and June.*

CREATIVE WRITING
Aliya Cheskis-Cotel

In the early 1950s, the great newsman Walter Cronkite hosted a television series called *You Are There*. The show featured reenactments of historical events such as the landing of the Hindenburg, the Salem witchcraft trials, Abraham Lincoln's delivery of the Gettysburg Address, and the fall of Troy. Real network correspondents reported events from the scene, in the style of live television news. *You Are There* brought history to life by placing viewers right in the middle of unfolding events.

Judaism has its own version of *You Are There*. Each year at Pesach we retell the story of the Exodus from Egypt, experiencing it as if we ourselves were delivered from bondage. Each year at Shavuot we remember that we all stood at Sinai and received the Torah. And several times a day in our worship we remember that we all crossed the Sea of Reeds to freedom, and we all danced in joy and awe with Miriam. We all wandered with Moses in the desert, not knowing if we would ever see the Promised Land. We all tore our clothes and fasted with Esther, wondering what would become of us. We all hid in the caves of the Judean hills with the Maccabees and we all stood with Bar Kochba as he led the rebellion against Rome.

Much of the criticism of today's Jewish education stems from the often-heard accusation, "but that's boring . . . it's ancient history . . . I can't relate." Creative experiential writing, by contrast, offers an approach to Jewish history and practice that places students right in the middle of the action, allowing them to view events and ideas through a personal lens. Rather than telling our students about what happened in ancient times, we inspire them to write the story in first-person narrative, from the point of view of one of the characters on the scene. The story becomes real, and the experience is felt viscerally.

Jews are known as "the people of the book," and, as such, we are the people of the story. For thousands of years we have created *midrashim*, the stories and explanations that help us "read between the lines" of the original biblical text. By engaging in creative experiential writing, we encourage our students to continue the time-honored tradition of exploring and challenging the text, and their writing becomes modern-day midrash.

Some students may find it difficult to relate to a complex, multilayered story such as Jacob stealing Esau's birthright, or an ethical concept such as the prohibition against hurting animals.

But when the student writes from the point of view of a character in the story, he or she comes to feel the emotional and dramatic impact in a powerful, personal way.

The creative experiential writing activities in this book are designed to make writing fluid and natural. All begin with a narrative that will "set the scene" for students, stimulating their imaginations. Encourage students to take on the suggested persona, and let the words flow freely and naturally. Very young students who cannot yet write, or older students who may be unaccustomed to writing, are perfectly willing to spin wonderful imaginative stories orally. So we begin at a young age with creative experiential writing that is dictated aloud to the teacher or to an aide who can write down the students' spoken thoughts. Alternately, students can dictate into a tape recorder and an adult can later transcribe the student's words.

Tell students who are beginning writers: "Write whatever comes into your head—do not worry about how the words are spelled, as long as you can read them." If you wish, you can help students change the inventive spelling into traditional spelling.

Displaying the students' creative writing is a wonderful way to share their work with parents and the rest of the school, and students take great pride in seeing their work on public display. Creative experiential writing pieces make wonderful bulletin board displays, and can be enhanced by adding artwork created by the children. In many cases, the creative writing and visual arts activities for a specific topic in this book are designed to integrate with one another, and the resulting writing and art projects can be combined to create a rich display. One effective technique for a bulletin board display is to mount a question or scenario in the middle of the board, and surround it with responses excerpted from the students' work. You can have the students rewrite the excerpts in their best handwriting or type them on a computer and print them for display.

There are many other creative ways to display the work of the students. Narratives can be collected and bound into journals that can be used in the classroom or added to the school's library. Writings from the Pesach activity (page 37) can decorate the social hall during the congregational seder. Pieces resulting from the Shabbat activity (page 7) can be displayed in the main foyer of the synagogue, adding to the experience of all who attend worship services. The interviews that result from the activity on growing older (page 153) can be delivered to the seniors who participated in the activity, at their retirement or nursing home. The opportunities are limitless.

Finally, creative experiential writing can extend beyond the classroom. When students bring their written pieces home, they may become a focus for discussion with parents, siblings, and friends. Teachers can facilitate this process by sending home background information and suggested discussion questions for various topics. The students' writing can also be used to enhance their home celebrations of holiday or life-cycle events. Be creative in finding ways to extend the experience so that, as students go through a cycle of Jewish holidays, Bible stories, and life-cycle moments, they will be more fully engaged, not just as observers but as participants in each story, each concept, each holiday, and each event—as if they were there.

But let's not delay. We are in the middle of throngs of people, standing at the foot of Mount Sinai. The crowd becomes instantly silent—no one breathes. No bird chirps, no dog barks. Even the wind is still, and the ocean has ceased its roar. The first words of Torah begin to reach our ears . . .

Aliya Cheskis-Cotel specializes in arts programs and creative writing for learners of all ages and abilities. As the Director of Congregational Learning for East End Temple in New York City, she directs the religious school, teaches children and adults of all ages, and develops creative

curricula and educational programs for the diverse East End community. In 1988 Aliya received the Gruss Award for Teaching Excellence nominated by the Abraham Joshua Heschel School. A former actor and singer, she is still a folk dancer and guitarist. Aliya recently authored the study guide that accompanies the DVD The Journey to Golda's Balcony *starring Tovah Feldshuh, and produced, written, and directed by Yves Gérard Issembert, which incorporates multiple intelligence learning in all its activities. She is married to Rabbi Moshe Cotel and is the producer of his performance program* Chronicles: A Jewish Life at the Classical Piano. *Aliya and Moshe are the parents of two grown children, Orli and Sivan.*

VISUAL ARTS
Gwen Mayer Samuels

"For me a painting is like a story which stimulates the imagination and draws the mind into a place filled with expectation, excitement, wonder, and pleasure" (J.P. Hughston, painter).

Perhaps unwittingly, in speaking about art the late artist J.P. Hughston also captured the essence of Jewish life and Jewish education. His observation provides us with important insight into the many reasons for incorporating the visual arts into the Jewish school curriculum.

Both art and Jewish life stimulate the imagination and stir the soul. A beautiful work of art, like a prayer that comes from the heart, speaks to our highest selves and opens up for us an appreciation of the Divine. For many artists, art is a religious expression—is it any wonder that so much of the world's great art, from Michelangelo's statue of David to the stained glass windows of Marc Chagall, embodies religious themes? Art helps us to stop and recognize the wonder and beauty of the world around us. At the very core of Judaism is our system of *mitzvot*, small moments of recognition and sanctification that cause us to acknowledge and be thankful for the presence of God in the world around us. Several of the arts activities found in this book involve creating Jewish ritual objects. These provide an opportunity for fulfilling the injunction of *hiddur mitzvah*, beautifying or embellishing the commandments. The activity goes beyond a simple art project, becoming a way of creating something handmade and beautiful that can elevate a ritual observance to a more powerful, more meaningful level.

Both art and Jewish living are built upon a deep appreciation of history. The work of the master artists of the High Renaissance period in the early sixteenth century—Michelangelo, Leonardo da Vinci, and Raphael, to name a few—was the culmination of the artistic revolution begun by the Early Renaissance artists who had come before them. Each of the "-isms" of the 19th and 20th centuries—Neoclassicism, Romanticism, Impressionism, Modernism, Cubism, Abstract Expressionism, Post-Modernism, and others—reflected an evolution of one period to another. Artists in each movement broke new ground, while building on the work of those who had come before. Jewish life is much the same: each generation traces its ancestry back through previous generations to Moses, Joseph, Jacob, Isaac, Abraham, and ultimately to Adam and Eve. Each generation learns, grows, and innovates, but recognizes a deep-rooted historical connection. We all stand on the shoulders of the ones who came before us. The visual arts are a wonderful way to examine Jewish history because works of art are frequently the most valued records of past civilizations, predating and extending beyond written records. By examining artifacts, students can transcend time and space, and easily make important comparisons between the past and present while finding common threads that remain consistent.

Both art and Jewish living require a sharing of one's self. Artistic ability is a gift from God. The use of that ability can be a gift that the artist gives back to God, or to his or her community—because art can be appreciated only when it is shared with others. By integrating artistic expression into our schools and classrooms, we encourage that exchange of gifts and nurture the divine spirit with which every student is endowed. Each individual art activity in this book provides an opportunity for students to share a part of themselves, express their *kavanah* (intention), and reveal their creative nature. In doing so, students will find greater meaning in and a stronger connection to Jewish life.

Both art and Jewish living are all about sensory perception. Art uses texture, shape, and color to create meaning and understanding. Jewish life uses all of one's senses as well to infuse meaning into our celebrations and observances. The art activities in this book employ a wide variety of media and techniques, challenging students to visualize new ways of doing things, to make decisions and solve problems. By becoming creative thinkers, students are better able to be active participants in the learning process. Many of the activities chosen for this book operate on two levels to deepen the experience and help students enjoy the creative process while making important connections to their lives. For example, in the unit on death the art activity involves using wire to create a holder for a *yahrzeit* candle. This is the first level of meaning, the creative process that allows each student, using the same materials, to discover a different outcome. The second level is much deeper. The "big idea" of the unit on death—the enduring understanding that should remain with students long after the lesson is over—is the concept that memory is our hope, our tie, our connection to our loved ones after they have gone from this earth. Wire has a "memory": it retains the bends and twists of the weaving process that the student will do with intention and repetition. The wire becomes a metaphor for the underlying concept, emphasizing and reinforcing it. This deeper metaphorical level provides crucial connections that will make the concepts relevant and meaningful in students' lives.

Finally, both art and Jewish living begin with creation. The American photographer Peter Witkin said that artists are the people among us who realize that Creation didn't stop on the sixth day. Indeed, the artist's magic is in creating something from nothing, just as God created the world from nothingness. Yet Judaism teaches that Creation is not yet finished, that we are partners with God in the ongoing work of Creation. Our acts of creation can be acts of holiness when done with the proper intention.

It is important to remember in facilitating these activities with students that the process is just as important as the product, the artist just as important as the art. As educators we are facilitators, and above all it is our job to create a safe environment where our students feel comfortable to create, explore, discover, and experiment. To this end, I suggest that teachers become familiar with the instructions and materials for a particular activity before working with their students, and that they take time to experiment with extensions and adaptations of the projects. It is also usually best if the facilitator does not make an example of the finished product for students to copy, but allows each student to discover for him or herself what their particular project wants to be. There are no right or wrong answers in art, just individual expression and creativity. It is my hope that the visual arts activities provided here will inspire you and your students to create, create, create, and that the process of creation will, to return to Hughston's quote, fill you with "expectation, excitement, wonder, and pleasure." If you foster creativity, encourage individual expression, and trust the process, you will be amazed with the results.

Gwen Mayer Samuels is an accomplished artist and educator. She graduated from Syracuse University with a Bachelor of Fine Arts, and after her children were in school Gwen taught Art at Rodeph Sholom School in New York. While there she won the Gruss Award for Teaching Excellence and worked with the Lincoln Center Institute bringing the arts and a variety of arts performances to Rodeph. Gwen then went on to work at the Board of Jewish Education of Greater New York working with both art teachers and classroom teachers, teaching them to incorporate a hands-on creative process into their teaching. She has presented workshops at CAJE, JNF, the Teva Learning Center, and many other Jewish organizations empowering teachers to use this process.

CONCLUSION

"The awareness of grandeur and the sublime is all but gone from the modern mind. Our systems of education stress the importance of enabling the student to exploit the power aspect of reality. To some degree they try to develop his [sic] ability to appreciate beauty. But there is no education for the sublime. We teach the children how to measure, how to weigh. We fail to teach them how to revere, how to sense wonder and awe. The sense for the sublime, the sign of the inward greatness of human soul and something which is potentially given to all men [sic], is now a rare gift. Yet without it, the world becomes flat and the soul a vacuum"[20]

This book provides Jewish educators with the ideas, the inspiration, and the tools to weave music, drama, creative writing, and the visual arts successfully into the classroom curriculum. It aims to break the perception of the arts as "extra" or "add-on" activities, and "open up" the subject matter by integrating arts activities into the curriculum in a natural, organic way. Designed not for arts specialists (though it will be valuable to them), but for average classroom teachers who thinks they aren't musicians, actors, writers, or artists. *Open It Up!* shows every teacher how to breathe life into any subject matter through creative, engaging integrative arts activities. The material found within will stir the creative spirit of every student, opening him or her up to the wonder and awe of Jewish life. It will set free the hidden artist within all Jewish teachers, opening them up to new ways of teaching. All you need to do is . . . *Open It Up!*

20. Abraham Joshua Heschel, *God in Search of Man: A Philosophy of Judaism* (New York: Farrar, Straus, and Giroux, 1955; reprint 1999), p. 36

PART I
HOLIDAYS

Holidays > Shabbat

the **SILENCE** between the **NOTES**

the **SIGHTS** and **SOUNDS** of **CREATION**

The BIG IDEA

SHABBAT
Grades K–1

"The people of Israel shall keep the Sabbath, observing the Sabbath in every generation as a covenant for all time. It is a sign forever between Me and the people of Israel, for in six days the Eternal God made heaven and earth, and on the seventh day God rested from all God's labors" (Exodus 31:16–17).

Like God, human beings work hard all week. As we strive to be like God, we are commanded to set aside Shabbat as a unique, sacred time to rest and refresh, observe, remember, and study. This special time prepares us to continue our partnership with God in the ongoing work of creating the world.

like a **KING** awaiting his **QUEEN**

special **SYMBOLS** and **RITUALS**

INTEGRATING THE ARTS INTO JEWISH EDUCATION 1

Holidays > Shabbat > Music

CREATION: THE SOUND TRACK
Grades K–1

Inspiration
The great rabbi Abraham Joshua Heschel tells this story, likening the experience of Shabbat to listening to wonderful music:

"A great pianist was once asked by an ardent admirer: 'How do you handle the notes as well as you do?' The artist answered: 'The notes I handle no better than many pianists, but the pauses between the notes—ah! That is where the art resides.'

In great living, as in great music, the art may be in the pauses. Surely one of the enduring contributions which Judaism made to the art of living was the Shabbat, 'the pauses between the notes.' And it is to the Shabbat that we must look if we are to restore to our lives the sense of serenity and sanctity which Shabbat offers in such joyous abundance" (Abraham Joshua Heschel, *The Sabbath*).

The "music" of Shabbat is unique—Shabbat is like the silence between the notes. Indeed, without the silence, the music would not be as beautiful.

Objective
Students will use a variety of instruments to create the "music" of Creation and of Shabbat.

Materials
- Tin pots, pans, cookie sheets, wooden and metal spoons
- Plastic bottles of all shapes and sizes
- Percussion instruments: shakers, "eggs," drums, sticks, wood blocks, chimes, etc.
- Harmonicas, kazoos, recorders
- CD/tape player and CD or tape of Shabbat music
- Creation storybook

Process
1. Spark the students' imagination about the sounds of Creation. Integrate the idea of the "pauses between the notes" from the "Inspiration" section above into your introduction. "Set the scene" by reading aloud the following:

 Every week on Shabbat we have a chance to stop and rest from our busy schedules. The Torah tells a wonderful story of how God created the whole world in just six days. Can you imagine how busy God must have been that week—creating the heavens and the earth, daytime and nighttime, the sun, moon, and stars as well as all of the plants, animals, and human beings? So when the seventh day came and God had a chance to think back on all that was created during the week, God was very happy—and very tired—so God rested.

2. With all of God's work creating the world, there must have been a lot of noise! What do you think it sounded like during that amazing week of Creation? How did it sound when the heavens were created? What did it sound like when all of the animals appeared on earth? How do you think it sounded to God on that very first Shabbat? What does quiet sound like? We're going to create the "sound track" (the background music) for Creation and the very first Shabbat.

3. Split the children into six groups. Each group will create the sounds of the day of Creation that is assigned to them. For example, Group 1 will create the sounds of the creation of the heavens and the earth on the first day.

4. Ask the children to lie down on the floor and close their eyes. Place a pile of instruments and music makers in the center of the room (see the "Helpful Hints" section below). Invite the children to imagine that they are watching as God begins to create the entire world. Tell them that they will be creating the "sound track"—like the background music in a movie or video—of the Creation story.

5. Read aloud from an easy-to-understand translation of the Creation story (Genesis 1). Tell the children that they should listen to you read first. Then, each time you stop, they should reach over and take one of the "instruments" and make the sound that they think might have been heard at that moment in the story. Group 1 will make their sounds after you finish reading about the first day, Group 2 will make their sounds after the second day, and so on. As each group finishes the music of their "day," they should be invited to lie down and close their eyes again and listen to the music of the following days. When you reach Shabbat, all of the children should open their eyes, and, using only their own bodies as instruments, create the sounds of Shabbat. For example, they can use their breath, their arms tapping on their skin, or their hands running through their hair.

6. Conclude the activity by asking the children to lie down again and listen to your favorite Shabbat melody played on a CD or sing your favorite Shabbat melody together with the children.

Helpful Hints

- Be sure to provide lots of instruments and music makers from which the children can choose. The more variety you have available, the more the children are likely to want to engage in making sounds for all six days of Creation.

- The instruments need not be true musical instruments—be creative! Cardboard tubes from the inside of toilet paper and paper towel rolls, spoons, pots and pans, aluminum foil, and paper cups partially filled with uncooked rice and covered with plastic wrap held on top with a rubber band all make terrific "instruments."

Resources

Heschel, Abraham Joshua. *The Sabbath*. New York: Farrar, Straus and Giroux, 1951.
This classic of Jewish spirituality is a brief yet profound meditation on the meaning of the Seventh Day.

Kolatch, Alfred J. *Classic Bible Stories for Jewish Children*. New York: Jonathan David, 1994.
Twenty-four brief stories that introduce young readers to biblical heroes and events.

Shabbat Shalom! Jewish Children's Songs for Sabbath at Home. New York: Transcontinental Music Publications, 2003.
This collection of blessings and original songs sets the perfect mood for Shabbat.

Holidays > Shabbat > Drama

BRINGING TO LIFE THE STORY OF CREATION
Grades K–1

Inspiration
"When God began creating the heaven and earth, the earth was empty and void and darkness was on the face of the abyss. . . . And God saw every thing that God had made, and, behold, it was very good" (Genesis 1:1, 1:31).

"On the seventh day God ceased from work and was refreshed" (Exodus 31:17).

The very first story in the Torah tells about the six days of Creation and the seventh day, on which God and all of Creation rested. From nothingness, God spoke and the world came into being. Imagine the incredible sights and sounds of those seven days! Imagine the amazing frenzy of activity, followed by the peace, quiet, and restfulness of the first Shabbat.

Objective
The students will interpret the story of Creation through movement and sound.

Materials
The students' bodies and voices are all that are needed, though optional props such as scarves in different colors, pots, pans, cookie sheets, wooden spoons, drums, shakers, wood blocks, etc., can add fun to the reenactment.

Process
1. Read a simple version of the Creation story, either directly from the text or from a children's book such as *In Our Image: God's First Creatures* (see the "Resources" section, page 6). When you are finished, ask the students to recount what was created on each of the different days.

2. Explain that you are now going to act out the story of Creation. You will tell the story day by day, and students can use their bodies and voices to act out the different days. While you are telling the story the students should listen. When you pause between the days of Creation, it is time for them to move. You may also want to create a sign—such as putting your hand up in the air—that means it is time for them to get quiet again.

3. If you are using props, demonstrate how they might use a scarf, etc., to help them act out the story.

4. Invite the students to lie down on the floor, as if sleeping. Begin to read the following narration, making sure to leave time for students to act out their parts.

 In the beginning, everything was dark. Darker than dark. Then, it was as if God took a big breath—the darkness opened up and there was light! Let's see you wake up! *(Students "wake up.")* God called the light "day" and the dark "night." It was evening and morning, the first day.

 On the second day, God separated the water, so there were oceans and lakes and rivers and streams below, and clouds above. May I see the ocean waters? *(Students create the water.)* What sounds might a river or an ocean make? *(Students make water noises.)*

Now, imagine you are high up in the sky, walking in the clouds. *(Students play in clouds.)* It was evening and morning, the second day.

On the third day, God separated the dry land from the water. All kinds of plants and trees grew. Let's see some big, tall apple trees, oak trees, willow trees! How about some little plants, vines, bushes? *(Students act out trees and plants.)* It was evening and morning, the third day.

On the fourth day, God created two special lights. The sun shone during the day. Can I see some sunshine, please? And for the night, God created the moon and the stars. Let's see some nice round moons and some twinkling stars! *(Students act out sun, moon, and stars. They can "move" in the sky.)* It was evening and morning, the fourth day.

On the fifth day, God created all kinds of creatures that swim in the waters. What would some of those creatures be? Let's see them swim through the water! *(Students "swim" as the sea creatures.)* And on the land above, God created all kinds of things that fly in the sky—birds and insects and everything with wings! Let's see you fly! *(Students "fly" about the sky.)* It was evening and morning, the fifth day.

On the sixth day, God created every kind of animal! What kind of animal can you be? I want to see some monkeys! And some puppies! And some cheetahs! And some giraffes (etc.)! *(Students act out various animals.)* On the sixth day, God also created man and woman, human beings. Walk around like a man or woman (boy or girl)! *(Students walk around like humans.)* It was evening and morning, the sixth day.

Now it is time for the seventh day. Today, God is tired from all of the busy work of creating the world! The fish are tired, the birds are tired, the animals are tired, and the people are tired. Everyone needs a good rest. How do you show that you are tired? *(Students might yawn or stretch, acting tired.)* So now it is time to lie down. Find a comfortable spot! You're going to need a good rest! *(Children lie down—wait a moment until children are settled.)*

We have reached the seventh day of the week, the day in which God rested, the animals rested, and humans rest. This special day of rest has a name. The seventh day is called Shabbat, and every week we have Shabbat. Shabbat is a special time to rest and relax. On Shabbat we are thankful for the beautiful world that God created. Out of all the creations that you saw during the six days, what are you most thankful for?

Helpful Hints

- Some children may be shy with movement/acting. Using props may help them feel more comfortable.

- As the children are acting, encourage them with positive remarks like "I can really see you in the clouds!" or "What a big lion!" The more you take seriously what they are doing, the more they will feel free to engage in creative play.

- An alternative way of acting out the story would be to assign parts. Individual or small groups of students could act out each day.

- The story of Creation is rich with drama and movement possibilities. By acting it out, not only do students get a chance to connect with the story, but they also get to bring the idea of Shabbat rest—contrasted with the busy work of Creation—to life through their bodies.

Resources

Swartz, Nancy Sohn. *In Our Image: God's First Creatures.* Woodstock, VT: Jewish Lights, 1998.
In this playful new twist to the Genesis story, God asks all of nature to offer gifts to humankind—with a promise that the humans would care for Creation in return.

Tucker, Joanne, and Susan Freeman. *Torah in Motion: Creating Dance Midrash.* Denver, CO: A.R.E., 1990.
This book explores ways to use movement and dance to interpret Torah, and offers a new and contemporary form of prayer and expression. It includes many creative movement suggestions for bringing the stories of the Torah to life in a new way. Out of print; available in electronic format from http://www.ebookmall.com/ebook/140307-ebook.htm.

Holidays > Shabbat > Creative Writing

SHABBAT HAMALKAH: THE SABBATH QUEEN
Grades K–1

Inspiration
A midrash (*Genesis Rabbah* 11) teaches that all of the days of the week were paired together: Sunday with Monday, Tuesday with Wednesday, Thursday with Friday. But the newly created Shabbat was different, set apart from the other days. God told Shabbat, "The people Israel shall be your mate." And so each week Israel greets the approaching Shabbat like a groom awaiting a bride, like a king awaiting his queen. With great joy and anticipation, Israel awaits the arrival of *Shabbat Hamalkah,* the Sabbath Queen.

Objective
The students will write or narrate a paragraph describing the calm and restfulness of Shabbat, contrasting Shabbat with the bustling days of the week.

Materials
- Writing paper
- Pens or pencils

Process
1. Distribute paper and writing instruments.
2. "Set the scene" by reading aloud the following:

 God made the world in six days and then rested on the seventh day. We rest on the seventh day like God did, and we make it a very different day from the other six days of the week. We call this seventh day "Shabbat," from the Hebrew root word "*shavat,*" meaning "to rest."

 Think about everything you did this week: You went to school early every morning and some of you stayed until late afternoon. During schooltime you worked hard at many different activities. When you went home from school you may have had homework, and you may have had chores to do like cleaning your room or helping before or after dinner.

 It is now Friday afternoon. Shabbat is coming, and you are excited because it is the most special part of the week. Imagine *Shabbat Hamalkah,* the Shabbat Queen, coming down from Heaven with angels all around her, wearing a long white gown and a robe that makes her look like a queen. Just as the *Shabbat Hamalkah* sits on her throne, we imagine that our Shabbat table is our own throne. We breathe out—a deep breath. We are now ready to enter Shabbat. We look around at our family and at the Shabbat table—Shabbat candles, Shabbat wine, and challah. Look at the window! Shabbat is finally here as you see the *Shabbat Hamalkah* floating at the window, and she fills the room with a white glowing light.

 Imagine that the very moment you see *Shabbat Hamalkah* everything becomes calm and relaxed. Let the excitement and high energy of the week go as you breathe out a deep breath. What colors do you see? What does the air feel like? What sounds do you hear?

INTEGRATING THE ARTS INTO JEWISH EDUCATION

Give students ten minutes to write freely. Encourage them to write what they are feeling—their anticipation, their excitement, their feelings of rest and relaxation. Those too young to write can dictate to an adult, or into a tape recorder. When everyone is finished, ask for volunteers to share their writings with the group.

Helpful Hints

Create a bulletin board or other display of the students' writings to share with parents and the rest of the school. See the Introduction, page xxi, for several display ideas.

Resources

Jaffe, Nina. *Tales for the Seventh Day: A Collection of Shabbat Stories.* New York: Scholastic Press, 2000.
> *This book of seven tales, all from the Talmud, draws readers into the world of peace, magic, adventure, and harmony that is part of the spirit and ritual of the Sabbath day.*

Shabbat Hamalka
http://www.pantheon.org/articles/s/shabbat_hamalka.html
> *This Web site features an excellent article with background information on the legends surrounding the Sabbath Queen.*

SACRED TIME, SET APART: SHABBAT CHALLAH COVERS
Grades K–1

Inspiration
One way that we make Shabbat unique and sacred is with special foods, symbols, and rituals. The beautiful Shabbat table, the lighting of Shabbat candles, the blessing of the wine, and the wonderful taste of the challah help us to slow down and prepare ourselves for Shabbat.

The challah on our Shabbat table is often covered with a decorative cloth. There are several explanations for this custom. Choose one that inspires you to create a beautiful challah cover of your own!

- Can bread have feelings? The *Shulchan Aruch*, a code of Jewish law written by Joseph Caro in the sixteenth century, tells us that this is one of the reasons we cover the challah during Kiddush on Shabbat. On most days of the week, the bread receives the honor of being the first thing to be blessed. On Shabbat, however, the candles are lit and blessed and the Kiddush is recited over the wine before the challah blessing is recited. Therefore, the challah is kept covered so it is not embarrassed to have lost its place of honor.

- In the Bible we learn that when the Jews were wandering in the desert they received manna as food. The manna was covered on the top and bottom with dew. The tablecloth and challah cover mimic the dew on our Shabbat table.

- In Jewish tradition, the Shabbat is compared to a bride. Just as the veil of the bride is removed after the blessings under the *chupah* (marriage canopy) have been recited, so are the *challot* "unveiled" after the blessing is recited and the bread is about to be eaten.

Objective
Each student will each create a Shabbat challah cover using a fabric crayon transfer technique.

Materials
- Paper and pencils
- Fabric crayons
- Masking tape
- Tracing paper
- White synthetic cloth, cut in at least one-foot-by-one-foot squares. Synthetic materials accept color transfer best—rayon, nylons, acrylics, and polyesters such as Dacron or Trivera.
- Iron with ironing board or other padded surface for ironing

Process
1. Engage the students in a discussion about challah. Elicit from them what they know about challah: What are the ingredients in challah? What special shape does it have? Why is the challah covered before we bless it? Emphasize the significance of the challah cover, using the "Inspiration" section above for background.

2. Tell the students that they are each going to create their own special challah cover. Ask them to brainstorm to come up with a list of symbols connected with Shabbat that would be appropriate for decorating their challah cover.

3. Have the students practice drawing Shabbat symbols on a regular piece of paper with pencils. They can then choose their favorite symbols to put on their challah cover.

4. Assist the students in drawing their designs with fabric crayons on a piece of tracing paper. Make sure areas are filled in well and colors are strong.

5. Once the drawing is complete, lay the tracing paper facedown on the cloth. Make sure the cloth is on a padded surface ready for ironing. You can use a towel or blanket in addition to an ironing board. Secure the tracing paper to the cloth with tape to avoid shifting.

6. Lay another piece of tracing paper on top of the first for protection, and secure with tape.

7. Set the iron to the cotton setting. Gently, evenly, slowly iron over the surface, allowing the heat to transfer the image to the cloth. Check for image transfer by carefully lifting one corner. Continue ironing until the entire drawing has transferred.

Helpful Hints

- Words must be written in reverse to transfer correctly. To write words in reverse, simply write them on tracing paper, then turn it over and copy. You will need to do this for the students who want to write letters. If you have too many children in the class to help, tell them to draw only Shabbat symbols.

- Remember that at the Shabbat table there are usually two *challot*, to represent the double portion of manna that the Israelites received before Shabbat in the wilderness. Be sure to cut the cloth large enough to cover two *challot*!

- Encourage students to be creative and make their challah cover a unique expression of their feelings about Shabbat. Have them draw upon previous lessons from the classroom about Shabbat (if applicable).

Resources

My Jewish Learning.com—Culture: Challah
http://www.myjewishlearning.com/culture/food/
> *This Web site features an interesting article with much information about the history and significance of challah, a photo of a braided challah, and a link to a challah recipe.*

Reider, Freda. *The Hallah Book: Recipes, History, and Traditions.* Hoboken, NJ: Ktav, 1987. *This book explores the whys and wherefores of challah. It traces the source of customs around making, serving, and eating challah.*

Holidays > Chanukah

helping OTHERS / FREEDOM

the FEW against the MANY

The BIG IDEA

CHANUKAH
Grades 2–3

"We give thanks for the redeeming wonders and the mighty deeds by which, at this season, our people was saved in days of old. In the days of the Hasmoneans, a tyrant arose against our ancestors, determined to make them forget Your Torah, and to turn them away from obedience to Your will. But You were at their side in time of trouble. You gave them strength to struggle and to triumph, that they might serve you in freedom. Through the power of Your spirit, the weak defeated the strong, the few prevailed over the many, and the righteous were triumphant" (From the Al Hanisim prayer, included in the Amidah and the Grace After Meals during Chanukah).

Traditionally the observance of Chanukah centers around the miracle of the oil lasting for eight days. The underlying celebration, however, is the historical fight for religious freedom and the victory of Jews over a larger, more powerful force. Chanukah is a festival of faith, affirming the declaration of the prophet Zechariah: "Not by might, nor by power, but by my spirit, says God" (Zechariah 4:6).

true FAITH

RIGHT over MIGHT

COOPERATION

WORKING toward a common GOAL

INTEGRATING THE ARTS INTO JEWISH EDUCATION

Holidays > Chanukah > Music

THE SOUNDS OF FREEDOM
Grades 2–3

Inspiration
"The Festival of Lights is a powerful reminder each year that the age-old struggle for religious freedom is not yet over. From the days of the ancient Maccabees down to our present time, tyrants have sought to deny people the free expression of their faith and the right to live according to their own conscience and convictions. Chanukah symbolizes the heroic struggle of all who seek to defeat such oppression and the miracles that come to those full of faith and courage. This holiday holds special meaning for us in America, where freedom of religion is one of the cornerstones of democracy" (U.S. President Bill Clinton, Chanukah 1997).

Objective
Students will visualize through sound and noises a latke's "journey" from the potato fields to the kitchen table. Students will understand how the Chanukah theme of freedom is connected to the importance of helping others.

Materials
- CD player
- Recording of Debbie Friedman's "The Latke Song"
- Copies of lyrics to "The Latke Song"

Process
1. Begin by asking the students which foods are associated with the holiday of Chanukah. Elicit from them that oil is a key ingredient in many of the foods. Ask them: Why is oil important in the Chanukah story? What was the meaning of the *ner tamid* burning in the Temple? How did this relate to what the Maccabees were fighting for?

2. Tell the students that we are going to learn more about Chanukah through the eyes of a latke, one of our favorite Chanukah foods.

3. Have the students close their eyes and visualize an imaginary journey:

 Imagine that you are a potato—a single, bored potato sitting in the potato fields in Idaho. Then one day, it is time for the harvest, and the trucks and people come to take you and all the other potatoes from the fields. What does this sound like? Make noises to represent the sounds you might hear during harvesttime. What do the machines sound like that are coming to dig you out of the ground?

 You have now traveled from the potato farm all the way on a truck to the grocery store. Wow, it was a bumpy ride! Once you arrive at the grocery store, you are dumped onto a large shelf with many other potatoes. Someone even put a sticker on you! What sounds do you hear in the grocery store? Do you hear people coming?

 The Schwartz family is running up to your section in the vegetable aisle. They grab a bag and stuff you in with about ten other potatoes. How exciting! You're going home! What sounds do you make to show your excitement? What sounds do the Schwartz children make to show their excitement?

Once you reach the Schwartz home, they put you on a cutting board and chop you into small pieces. When Mrs. Schwartz takes out the blender, you really get excited! You are going to become a Chanukah treat, a latke! When you are in the blender, what sound do you hear? Make that sound!

You are taken from the blender and mixed in with a few other ingredients like onions. Whew, they smell! Suddenly, you hear the lovely sound of oil frying in a pan. You are then scooped up and splattered into the frying pan. You are on your way to becoming a latke! Wow, that's a loud noise—what do I hear? Latkes frying in a pan?

You have made the journey. It was tiring, but you're now sitting on a plate with a little bit of sour cream and applesauce on top of you. And you are happy. The dream of every little Idaho potato has come true—you have become a latke! What sounds do you hear as you're being gobbled down?

4. Play "The Latke Song" by Debbie Friedman. Hand out the lyrics to the song (see page 14), or write them on the blackboard. Have the students sing along.

5. Engage the students in a discussion: We've had fun imagining ourselves as latkes, and heard a fellow latke friend sing a song about becoming a latke. Chanukah is a fun and happy holiday, but it's about much more than just latkes and presents. There are also many important lessons that we can learn. Let's look at the final verse of the song. What is this latke talking about in the last verse (review the last few lines)? Why do you think this latke felt that it was important to help others in need?

As we discussed at the beginning of class, the Maccabees were fighting for their right to worship God and practice Judaism. In other words, they were fighting for their freedom to be Jewish. (You may wish to read the section on "Freedom" in Cherie Karo Schwartz's book *My Lucky Dreidel*—see the "Resources" section on page 14.) The sounds that we created today—potatoes in the blender, latkes frying in the pan—may be silly and fun, but they are the sounds of freedom. We are fortunate to live in a society where we are free to celebrate Chanukah, sing our songs, and eat our traditional foods. If it weren't for the bravery of the Maccabees—and many who came after them—we wouldn't have the freedom to do these things. What does being free mean to you? Does "freedom" mean we get to do anything we want? What does being responsible mean to you? How can we both have freedom and be responsible people?

At Chanukah, along with the fun, we must remember to show thanks to all those who fought for our freedom. One way we can do this is by fulfilling mitzvot (commandments) and performing *g'milut chasadim* (acts of kindness). Look back at the "Big Idea" for this topic (page 11). Read the students the quote from Al Hanisim about serving God in freedom: *"You gave them strength to struggle and to triumph, that they might serve you in freedom."* What does it mean to serve God? How is our freedom connected to the responsibility of helping others? "Not by might, not by power, but by My spirit"—what does this mean? How does God's spirit help us to do good?

Wrap up the discussion by having students share their thoughts on how to help others and why it is important to do so year-round. Remind them that at this time of year it is easy to get caught up in the celebration, but that Chanukah reminds us of our responsibility to behave as God wants us to behave.

Holidays > Chanukah > Music

Helpful Hints
- Read the lyrics of "The Latke Song" out loud together as a group.
- Invite your cantor or music specialist to teach "The Latke Song" to the class.

Resources
Friedman, Debbie. *Light These Lights* (compact disc). San Diego, CA: Sounds Write Productions, 2004.
Includes "The Latke Song."

Schwartz, Cherie Karo. *My Lucky Dreidel*. New York: Smithmark, 1994.
Eight sections, one for each night of Chanukah, filled with stories, songs, poems, crafts, recipes, and fun for kids.

THE LATKE SONG
From DEBBIE FRIEDMAN LIVE AT THE DEL. Music and lyrics by Debbie Friedman. © 1988 Deborah Lynn Friedman (ASCAP). Published by Sounds Write Productions, Inc. (ASCAP).

I am so mixed up that I cannot tell you,
I'm sitting in this blender turning brown.
I've made friends with the onions and the flour,
And the cook is scouting oil in the town.
I sit here wondering what will come of me,
I can't be eaten looking as I do.
I need someone to take me out and cook me,
Or I'll really end up in a royal stew.

Chorus:
 I am a latke, I'm a latke
 And I am waiting for Chanukah to come,
 I am a latke, I'm a latke
 And I am waiting for Chanukah to come.

Every holiday has foods so special,
I'd like to have that same attention too.
I do not want to spend life in this blender,
Wondering what it is that I'm supposed to do.
Matzah and charoset are for Pesach,
Chopped liver and challah for Shabbat.
Blintzes on Shavuot are delicious,
And gefilte fish no holiday's without.

Chorus

It's important that I have an understanding
Of what it is that I'm supposed to do.
You see, there are so many who are homeless,
With no jobs, no clothes and very little food.
It's so important that we all remember
That while we have most of the things we need
We must think of those who have so little,
We must help them, we must be the ones to feed.

Chorus

Holidays > Chanukah > Drama

THE STORY OF THE MACCABEES: YOU WERE THERE!
Grades 2–3

Inspiration
Judah Maccabee and his brothers saw that this was going to be a difficult war, the few against the many. The Judeans were scared. Judah, their leader, heard their concerns and responded strongly, knowing that God was on their side:

"The Judeans cried out, 'How can we, few as we are, fight against such a strong army? Besides, we are faint, for we have had nothing to eat today.' Judah responded, 'It is easy for the many to fall into the hands of the few. There is no difference in the sight of God . . . for victory in war does not depend upon the size of the force, but strength comes from God. . . . Prepare yourselves and be brave men, and be ready in the morning to fight' " (1 Maccabees 3:17–22).

Objective
Students will act out the Maccabees' story by imagining that they are part of the action, a soldier in the Maccabean army.

Materials
- Costumes and props such as shields, swords, robes, hats, etc.
- Prop microphones for reporters

Process
1. Tell the children the story of Chanukah, emphasizing that with God's help, a small group of people were able to stand up for their rights against a mighty ruler. You may want to read them the story of Chanukah—an excellent version can be found in the book *My Lucky Dreidel* by Cherie Karo Schwartz (see the "Resources" section, page 16). Read the "Inspiration" section above to begin stirring the children's imaginative process.

2. Ask the children to imagine that they were part of the Chanukah story. They were soldiers who decided to join Judah and the Maccabees in their fight for religious freedom. You may want to list on the board some of the possible characters:
 - Judah
 - Mattathias
 - One of the other Maccabee brothers
 - A female soldier who has joined the brigade
 - Any other soldier—old, young, male, female—who wants to fight for freedom.

3. Explain to the students that you (the teacher) will be playing the part of a television reporter who will be interviewing them about what they are doing. Be sure to acknowledge that in the time of the Chanukah story, there was no television, but that this is a fun way to bring the story to life. Give the students a chance to "get into character" while you call up one student at a time to be interviewed. If possible, invite a parent in to videotape the interviews.

4. Assume the role of a television broadcaster on the front lines. Use such lines as:
 "You there, soldier . . . can you take a moment away from the fighting for an interview?"
 "I'm standing here live in Modi'in with a young soldier."

INTEGRATING THE ARTS INTO JEWISH EDUCATION

Holidays > Chanukah > Drama

"Listen to the sounds of the fighting around me. Ladies and gentlemen, we are now about to meet a Jewish soldier fighting for the freedom of all of us Jews."

5. Give the students these questions to think about while they are waiting for their turn, or provide the questions in advance and have students sit and write out their responses. Use these questions for the interviews.
 - What is your name?
 - What is going on here in Judea?
 - Why did you decide to join the Maccabees?
 - How does it feel to be out here fighting?
 - What is the hardest part about being a soldier?
 - What would you like the people at home to know about this struggle?
 - Judah encouraged you to be brave and prepare yourself. How do you do that?

After all of the students have had a chance to play soldiers, take some time to debrief their experience. Ask the students how it felt to play their character. Allow them to share the feelings or issues that may have come up for them.

Helpful Hints

An alternative to the teacher playing the role of the reporter is to have some students become a "news team," with "anchors" in the studio and field reporters on the scene.

Resources

Goodman, Robert. *Teaching Jewish Holidays: History, Values, and Activities.* Denver, CO: A.R.E., 1997.
 Detailed information on the history and observance of all Jewish holidays, including Chanukah.

Schwartz, Cherie Karo. *My Lucky Dreidel.* New York: Smithmark, 1994.
 Eight sections, one for each night of Chanukah, filled with stories, songs, poems, crafts, recipes, and fun for kids.

Holidays > Chanukah > Creative Writing

THE THOUSANDTH DAY
Grades 2–3

Inspiration
In the First Book of Maccabees (4:6–11), we read:

"As soon as it was daybreak, Judah was seen in the plain with three thousand men, although they had neither such armor nor swords as they would have wished. They saw the strongly [fortified] camp of the [enemy], with horsemen who were experienced in war surrounding it. Judah said to the men who were with him: 'Do not fear their number, and do not be afraid of their attack. Remember how our fathers were saved at the Red Sea, when Pharaoh pursued them. Now then, let us cry to heaven to see if God will have mercy upon us, and will be mindful of the testament of the father, and will destroy this camp before us today, that all the [enemy] may know that there is One who will redeem and save Israel.'"

With this speech Judah reminds the soldiers that throughout Jewish history God has given our people strength during their battles. The Maccabees, greatly outnumbered, had true faith in God's power and believed that right would triumph over might. They fought not only for their own survival, but for the survival of the Jewish people.

Objective
Students will write at least ten sentences from the viewpoint of a child who has grown up during the Maccabean war, expressing that child's thoughts and feelings.

Materials
- Paper
- Pens or pencils

Process
1. Engage the students in a discussion about the underlying themes of Chanukah. Use the "Big Idea" for this topic (page 11) and the "Inspiration" section above to provide background. Focus specifically on the idea of the few against the many, and the Maccabees' faith that right would triumph over might.

2. Distribute paper and writing instruments.

3. "Set the scene" by reading aloud the following paragraphs. If you like, have the students close their eyes to help in the imagination process. Ask them to try to picture these words in a story in their minds.

 Tomorrow will be the one thousandth day of the war between the Maccabees and the Syrian-Greeks. You have been living for nearly three years in the Judean hills outside Jerusalem with your mother and siblings while your father fights in the Maccabean army. The army is amazing—fighting with crude weapons and farm tools against the Syrian-Greeks, who fight with swords and elephants! But your father and the other farmers have won battle after battle because they know the hill country better.

INTEGRATING THE ARTS INTO JEWISH EDUCATION

Holidays > Chanukah > Creative Writing

> The Syrian-Greeks have forty thousand foot soldiers and seven thousand horsemen. There are only about three thousand Maccabees, but they have tremendous spirit. You know that the Maccabees have to win or be destroyed forever. You know that God is with you and right will win over might.
>
> It is the eve of Shabbat, the day of rest. Mattathias gave the Maccabees permission to fight on Shabbat in order to defend the right to worship the God of Israel and not be forced to bow down to idols. The Maccabees fight at night, so you will not have your father at home for Shabbat tonight. You huddle with your mother, brother, and sister in the cave that has been your home since you were little. You wonder: When will this war finally end so the Maccabee families can return home?

4. Give students ten minutes to write freely. Encourage them to write what they are feeling—their fears, their homesickness, how much they miss their families. Each student should write at least ten sentences, using the following guiding questions. You may wish to write these questions on the blackboard.
 - How do you feel about living in a cave in the hills for so long?
 - Are you afraid?
 - Do you worry about your father and the brave Maccabees?
 - Have you had any encounters with wild animals?
 - What do you miss from your home in Jerusalem?

5. Ask for volunteers to share what they have written by reading aloud to the group. Wrap up the activity by identifying the recurring themes in the students' writing and by making a connection once again to the "Big Idea" (page 11) and the themes expressed in the "Inspiration" section for this activity (page 17).

Helpful Hints
- Create a bulletin board or other display of the students' writings to share with parents and the rest of the school. See the Introduction, page xxi, for several display ideas.

- This activity can be combined with the art activity on creating a mural, or it can be a segue into the drama activity.

Resources
Frishman, Elyse D. *Haneirot Halalu: These Lights Are Holy: A Home Celebration of Chanukah.* New York: Central Conference of American Rabbis, 1989.
 A compendium of liturgy and readings for home use at Chanukah.

Goodman, Phillip. *The Hanukkah Anthology.* Philadelphia, PA: Jewish Publication Society, 1994.
 Part of the JPS Holiday Anthologies Series, this book covers the religious, culinary, artistic, dramatic, and musical ingredients of Chanukah, both the traditional and the offbeat.

THE FEW AGAINST THE MANY: WORKING TOWARD A COMMON GOAL
Grades 2–3

Inspiration
What does it take to work toward a common goal? We can look to the mighty Maccabees as an example of how we can accomplish a goal, no matter how insurmountable that goal might seem.

"Then Judah, his son, who was called Maccabee, arose in his stead,
And all his brothers helped him,
As well as all those who were adherents of his father,
And gladly they fought Israel's war"
(1 Maccabees 3:1–2).

The Maccabees did not have a large army. Therefore it was important that each and every person help with all of his energy and might. It was a battle of the few against the many, but the Maccabees were dedicated to their goal. Experiencing what it feels like to work toward a common goal can help us to better understand this important struggle.

Objective
Students will work collaboratively and use various mixed media to create a large group project. Students will experience cooperation by sharing supplies and ideas, and by helping each other in the creation process.

Materials
- Large roll of brown or white craft paper, spread out on the floor or on a large table with accessibility on all sides
- Tempera paint with cups for water and color mixing
- Large brushes for painting background
- Small brushes for details
- Colored paper, colored cellophane, yarn, and other art materials
- Magazines for cutting out photos and words
- Scissors
- Glue
- Markers

Process
1. Engage the students in a discussion of cooperation. Ask them for specific examples of ways in which they see people cooperating—or not cooperating—in their own lives.
2. Introduce the idea of cooperation as a way of accomplishing a seemingly insurmountable goal. Use the "Inspiration" section above as background. Draw connections between this concept and the previous discussion of cooperation in their own lives. Evoke from the students a list of the themes and symbols of Chanukah. Write the list on the blackboard, on a flip chart, or on a large sheet of butcher paper so all can see.

Holidays > Chanukah > Visual Arts

3. Introduce the activity, a large mural that the students will create as a group. Explain that a mural is a large picture with many parts and numerous small tasks to be accomplished. A cooperative effort will be required for the mural to be successful.

4. Show students examples of the various materials that are provided for them to use in creating the mural. Share various artistic techniques: painting, drawing, writing, glueing on photos or words cut from magazines, affixing other textured materials, etc.

5. Help students brainstorm ideas for how one of the themes identified in step 2 above can be artistically represented. Ask for student volunteers to illustrate on the mural their interpretation of one of the key Chanukah concepts. Be supportive and encouraging!

6. An important part of the cooperative process is in the planning. Guide students in drawing a diagram of the mural and mapping out sections for teams of students to work on. Divide the students into teams of two or three, and help them assign tasks within each team. Some students can paint the background, others can fill in words around the border, and others can draw or cut out objects or magazine photos to be glued to the background once it is dry.

Helpful Hints

- Remind students that creating a mural is a group effort. Each student contributes by sharing in the responsibility and by carrying out an individual task. Be sure that everyone has a role in the creation of the mural, and that no student is left out.

- Periodically, out loud, announce progress of the mural to the entire group. This will give students a sense of accomplishment and keep them working cooperatively.

- Once the class has become engaged in the project, a "creative silence" is a sign of a successful project!

Resources

Schick, Eleanor. *Drawing Your Way Through the Jewish Holidays.* New York: UAHC Press, 1997.
Simple instructions for drawing such objects as a pair of Shabbat candlesticks, the challah, a shofar, the Chanukah menorah, and other Jewish holiday symbols.

Zion, Noam, and Barbara Spectre. *A Different Light: The Hanukkah Book of Celebration.* New York: Devora, 2000.
A how-to guide for a creative celebration of all aspects of Chanukah. Features "The Maccabees' Megillah," which retells the dramatic conflict of the Chanukah story.

Holidays > Sukkot

HONORING our HEROES

WELCOMING special GUESTS

The BIG IDEA

SUKKOT
Grades 4–6

"Mark, on the fifteenth day of the seventh month, when you have gathered in the yield of your land, you shall observe the festival of Adonai to last seven days. . . . You shall live in booths seven days; all citizens in Israel shall live in booths . . . in order that future generations may know that I made the Israelite people live in booths when I brought them out of the land of Egypt, I am Adonai your God" (Leviticus 23:39–43).

"You shall rejoice in your festival . . . and you shall have nothing but joy" (Deuteronomy 16:14–15).

During Sukkot we are commanded to dwell in booths (*sukkot*) for seven days and rejoice with family and friends. We are reminded of the time in our history when the Israelites wandered in the desert for forty years, and later when our agricultural ancestors would live in the fields while harvesting their crops. Sukkot is a time to give thanks for the abundance of the harvest, but also to separate ourselves from our materialistic nature and connect to our family and friends, and the environment.

PERMANENCE and IMPERMANENCE

BEAUTIFYING a MITZVAH

INTEGRATING THE ARTS INTO JEWISH EDUCATION

Holidays > Sukkot > Music

THEME SONGS OF THE *USHPIZIN*
Grades 4–6

Note: This music activity for Sukkot shares much of the same background information and can be easily integrated with the drama activity on page 24.

Inspiration
"Every nation and culture must have heroes to symbolize and inspire it. The Jewish people over the ages perfected a system that allowed for heroes to be appreciated, even if they were viewed as being imperfect or . . . badly flawed. The fact that all of our heroes were seen as human, and that humans cannot escape error and sin, allowed Jewish heroes to be portrayed accurately and yet retain their heroic stature . . . The Torah, and especially the Talmud, looks at people with a balanced view, factoring into its assessment of them the good and the better of their lives, personalities, and their actions.

"The Jews always honored their heroes, biblical or otherwise, without forgetting that they were human beings and subject to mistakes and failures. A human hero accurately portrayed is much more valuable than an imaginary one who is perfect, infallible, and a pure saint" (excerpted from "Heroes," a column by Rabbi Berel Wein, in *The Jerusalem Post*, January 2, 2004).

Objective
Students will choose or create a theme song that they feel best exemplifies the characteristics of a particular biblical guest they will invite into their sukkah.

Materials
- Background material on *ushpizin*
- Recordings of superhero and movie theme songs (see the "Resources" section, page 23)
- A selection of CDs that represent various types of music—slow, fast, classical, rap, etc.
- Copies of the blessing for sitting in the sukkah

Process
1. Begin this activity with a discussion of superheroes—characters such as Superman, Spiderman, Wonder Woman, and Batman. Have students brainstorm to create a list of the heroic characteristics of these and other superheroes. Write the list on the blackboard, a flip chart, or a large piece of butcher paper so all can see.

2. Every good hero has a theme song. Play a few examples of superhero theme songs (see the "Resources" section, page 23, for a Web site with downloadable files). Ask students to think of what makes a good theme song and how a hero's positive qualities can be expressed through music and words.

3. Explain that in Jewish life we have superheroes as well. Engage the students in a discussion of the Sukkot custom of *ushpizin*. Use the material from the "Big Idea" for this topic (page 21), the "Inspiration" section for this activity (above), and material in the Sukkot drama activity (page 24) to supplement the discussion. Ask: Why it is important to remember our biblical ancestors? Why do you think we invite them to visit specifically at this time of the year?

4. Ask the students to list the names of the *ushpizin*, both the traditional list of seven and the modern extended list (see the Sukkot drama activity, page 24). Write the names on the blackboard, on a flip chart, or on a large sheet of butcher paper so all can see.

5. Brainstorm with the students to come up with a list of characteristics of each of the *ushpizin*. Are they old or young, strong or weak, leaders or followers? What qualities make them so revered in Jewish tradition? Write these characteristics on the board. If participants need help with ideas, pass out background information and have them read. Then come back together as a group and brainstorm about more characteristics.

6. Divide the students into groups of six to eight members. Ask each group to select one of the *ushpizin*, or assign one *ushpiz* to each group. Ask each group to think about a style of music that appropriately describes the person they have chosen. Would their biblical guest's music be happy or sad, fast or slow? What style of music and which instruments would best describe their character—classical music? folk music? jazz? rap? Explain that if an audience was watching the arrival of their *ushpiz* and didn't know who he/she was, listening to the theme song would help identify him/her. Play a few examples of possible theme songs, choosing songs that evoke a certain mood or feeling. Examples might include "The William Tell Overture" (better known as the "Lone Ranger" theme), Aaron Copland's "Fanfare for the Common Man," and such movie themes as "Chariots of Fire," "Star Wars," and "The Magnificent Seven."

7. Give each group time to choose the theme song for their *ushpiz*. Remind them that the theme song should match and support what they know about their Sukkot guest and the characteristics they wish to highlight. Walk around the classroom, offering ideas and help if needed.

8. When all the styles of music and theme songs have been selected, take the group to the synagogue's sukkah. Bring a portable CD player, the CDs, and the list of *ushpizin*. Recite the blessing for sitting in the sukkah, then invite each group to either play or sing the theme song for their particular *ushpiz* and explain why they chose this song. After each presentation, ask for comments and questions from the full group.

Helpful Hints

This activity is an exercise in interpretive music. There are no right or wrong answers. Each student will have a different idea about the style or sound of music that best describes a particular Sukkot guest. Encourage the students to be creative, and ask them to explain their choices throughout the project. It will be in the explaining that they learn the most.

Resources

MIDI Movie Theme Song and Movie Video Clips Homepage
http://moviethemes.net/
This Web site has a large collection of downloadable files of movie theme songs.

WavThis—TV and Cartoon Themes
http://wavthis.com/TV.html
This Web site features a collection of downloadable sound files of television and cartoon theme songs, including such superheroes as Batman, Spiderman, Superman, Mighty Mouse, Underdog, and Super Chicken.

Holidays > Sukkot > Drama

THE USHPIZIN: HONORED GUESTS
Grades 4–6

Note: This drama activity for Sukkot shares much of the same background information and can be easily integrated with the music activity on page 22.

Inspiration

"When Rav Huna the Elder would enter the sukkah he used to stand inside the door and say, 'Let us invite the guests and prepare a table.' And he used to stand up and greet them, saying, 'In booths you shall dwell seven days. Sit, most exalted guests, sit. Sit, guest of faith, sit.' He would then raise his hands in joy and say, 'Happy is our portion; happy is the portion of Israel' " (Zohar, *Emor* 103a).

"While eating and drinking himself, one is obligated to feed the stranger, orphan, and widow, along with the other unfortunate poor. . . . [One who does not] is not enjoying a mitzvah, but rather his stomach" (Maimonides, *Laws of Yom Tov* 6:18).

One of the most beautiful customs of Sukkot is *ushpizin*, welcoming into our sukkah symbolic guests. *Ushpizin* is the Aramaic word for guests. This Jewish mystical tradition tells us that one of our biblical ancestors (Abraham, Isaac, Jacob, Joseph, Moses, Aaron, and David) is to be invited into our sukkah each day. A modern-day interpretation of this custom extends the daily invitation to the Jewish matriarchs (Sarah, Rebecca, Rachel, and Leah), as well as other important biblical women (including Miriam, Esther, and Deborah). Some families today include contemporary heroes in their list of those invited symbolically to participate in their celebration of Sukkot. Inviting guests into our sukkah and sharing in the bounty of the harvest fulfills the mitzvah of *hachnasat orchim*, the welcoming of guests.

Objective

Students will research the important characteristics of one of the *ushpizin* and, through a first-person interview, invite that person to join the class in their Sukkot celebration.

Materials

- Simple costume items: hats, scarves, robes, *kippot*
- Stories or excerpts of Torah text about each of the *ushpizin*

Process

1. Engage the students in a discussion of the Sukkot custom of *ushpizin*. Use the material in the "Inspiration" section above to supplement the discussion.

2. Ask the students to list the names of the *ushpizin*, both the traditional list of seven and the modern extended list. Write the names on the blackboard, on a flip chart, or on a large sheet of butcher paper.

3. Brainstorm with the students to see what they remember about each personality. List any stories, symbols, or special characteristics that they identify with that person.

OPEN IT UP!

4. Match each student with a partner. As a pair, have them choose one of the *ushpizin* that interests them. Alternately, each pair could draw a name from a hat.

5. Provide each pair of students with information and background on their biblical guest. They will be preparing to "introduce" their *ushpiz* to the class through a first-person interview, with one student playing the role of the interviewer and the other student playing the role of the invited guest. Be sure to allow plenty of time for the students to prepare and rehearse. The interviewer can ask their guest:

 - Tell me about yourself—your name, where you come from, and why you are famous.
 - What are some of your important characteristics that make you an honored guest in our sukkah?
 - Describe one time in your life when you did something heroic.
 - What is the most important thing that we should remember about you?

 For added fun, have the *ushpizin* dress in character.

6. Take the class to your school's sukkah. One at a time, the interviewers can invite their guest into the sukkah, offer them food and drink, and begin the interview. Allow a few minutes at the end of each interview for other students to ask questions as well.

Helpful Hints

- Upon entering the sukkah, recite the appropriate blessings before welcoming the guests. If a snack or meal will be eaten in the sukkah, be sure to recite the appropriate blessing over food as well.

- To expand this activity, have students draw a life-sized picture of their biblical guest (what they think he or she looked like). Have them write words and draw symbols on the figure to represent the special and memorable characteristics of their guest. Hang these drawings in the sukkah as decorations.

Resources

Isaacs, Ronald H. *Every Person's Guide to Sukkot, Shemini Atzeret and Simchat Torah.* Northvale, NJ: Jason Aronson, 2000.
 Includes a section with suggested texts for an ushpizin *ceremony.*

MyJewishLearning.com—Holidays: *Ushpizin*
http://www.myjewishlearning.com/holidays/Sukkot/
 This Web site provides a comprehensive description of the ushpizin *ritual.*

Holidays > Sukkot > Creative Writing

BACK TO NATURE: DWELLING IN A SUKKAH
Grades 4–6

Inspiration
The holiday of Sukkot is a study in contrasts: exposure versus protection, stability versus instability, permanence versus impermanence. Mishnah *Sukkah* 1–2 tells us that the sukkah must be a temporary structure, is required to have at least three walls, and must be strong enough to withstand ordinary gusts of wind. The shade offered by the roof covering must be sufficient enough to block most of the sun's rays, but must be open enough so that the stars are visible through the roof at night. And although the sukkah is temporary, we are told that for seven days we should make the sukkah our permanent dwelling. These contrasts cause us to recognize the impermanence of the material objects in our lives and to focus on our physical connection to the natural world and our spiritual connection to God.

Objective
Students will write at least ten sentences describing what it feels like to experience both the abundance of the fall harvest and the impermanent nature of the sukkah.

Materials
- Paper
- Pencils
- Storybooks to spark imagination (see the "Resources" section, page 27, for one suggestion)

Process
1. Engage the students in a brief review of Sukkot, and elicit from them the main themes of the holiday. Ask:
 - What is this holiday about?
 - What can you remember about Sukkot last year?
 - What did it feel like to sit in the sukkah?
 - Did it feel like a stable structure?
 - What was involved in decorating the sukkah?

 Trigger the students' thinking by reading them the "Inspiration" section above. Emphasize the theme of stability versus instability, permanence versus impermanence.

2. "Set the scene" by reading the following aloud:

 Close your eyes as we take an imaginary journey, back in time and back to nature. Imagine that you are being transported to ancient Israel, to a time when most Jews were farmers. You and your family are closely tied to the land and to nature. All family members, adults and children alike, work the soil and harvest the crops. Your livelihood depends on God's blessings of fertile soil and abundant rainfall.

 It is now harvesttime. A long hot summer has just ended, but for the first time in many years there was enough rain to produce great crops. We are thankful for huge quantities of beautiful, delicious fruit and vegetables. There are green and red apples—the most

gigantic apples you have ever seen! There are avocadoes and artichokes and pumpkins. But we cannot pick very much fruit because we do not live in permanent homes and cannot carry the fruit and vegetables with us. We live in movable booths and travel from place to place. We never know who our new neighbors will be.

Uh oh! Look up in the sky—there are large black clouds overhead, and heavy rains must be coming. A tribe of local people has threatened us—our father says we have to pack up and move, NOW! And the rain is beginning to come down hard.

3. Give students ten minutes to write freely. Encourage them to write what they are feeling, letting the words flow. Each student should write at least ten sentences, or about two paragraphs.

4. Ask for volunteers to share with the class what they have written. Identify the common themes that emerge, and discuss how they relate to the themes of Sukkot.

5. Create a bulletin board or other display of the students' writings to share with parents and the rest of the school. See the Introduction, page xxiii, for several display ideas.

Helpful Hints

- Read one or more Sukkot stories to invoke more images in the student's minds. See the "Resources" section below for one suggestion.
- Take students to sit in a sukkah to assist in the visualization process.

Resources

Goodman, Phillip. *The Sukkot and Simhat Torah Anthology*. Philadelphia, PA: The Jewish Publication Society, 1973.
Part of a series of books covering the history and celebration of the Jewish holidays. Includes selections from prose, poetry, and Scripture, as well as songs, recipes, and children's stories.

Youdovin, Susan Schaalman. *Why Does It Always Rain on Sukkot?* Morton Grove, IL: Albert Whitman & Co., 1991.
When the chief angel gave the Jewish holidays their gifts, Sukkot, fearing he was left out, cried. Each year, remembering that sadness, he weeps again. For younger children.

Holidays > Sukkot > Visual Arts

HIDDUR MITZVAH: MAKE BEFORE GOD A BEAUTIFUL SUKKAH
Grades 4–6

Inspiration
"If [one] has beautiful vessels, he should bring them up to the sukkah. If he has beautiful chairs, he should bring them up to the sukkah. He should eat and drink, pass his leisure, and study in the sukkah" (*Sukkah* 28b).

"Make before God a beautiful sukkah, a beautiful lulav" (*Shabbat* 133b).

While the details and guidelines for the construction of the sukkah are specified in the Mishnah, the Gemara provides references on how to beautify our sukkah, fulfilling the mitzvah of beautifying our celebration (*hiddur mitzvah*). By decorating the sukkah in our own unique manner, we bring our own beauty and meaning to our celebration.

Objective
Students will create a mobile to beautify their sukkah, fulfilling the mitzvah of *hiddur mitzvah*.

Materials
- Large flexible plastic plates, brightly colored and sturdy (found in any party store)
- String, wire, or pipe cleaners for hanging shapes
- Scissors
- Hole punch
- Fun Foam in a variety of colors
- Permanent markers for writing on plastic
- Scraps of plastic plates to make shapes

Process
1. Read the following aloud to the students as a basic introduction to the activity:

 Sukkot is a time to recognize circles and cycles. The sun comes to fullness as the harvest ripens and the moon is full, marking a new beginning or clean slate after Yom Kippur. This is a great time to make a mobile to hang in our sukkah. This mobile, which will move in the wind and interact with nature, is made from plastic and designed to withstand the weather changes so common during the fall season. Why make a mobile? Why make it circular?

 Use the quotes from the "Inspiration" section above to supplement your explanation of this activity.

2. Give each student a plastic plate. Have them cut off the edge, as they will only need to use the flat part of the plate to construct the mobile (see diagram #1 below).

3. Using scissors, cut a spiral from the plate by starting at the outer edge of the flat piece. Cut inward in a circular shape until you reach the center (see diagram #2 below).

4. Punch a hole in the middle of the small center circle, and thread a string, wire, or pipe cleaner through the hole for hanging. The plate should drop in a spiral (see diagram #3 below).

5. Cut Sukkot shapes out of plastic or Fun Foam. For example, cut out a green *lulav* and a yellow *etrog*. Punch a hole in the top of each shape and thread string through the hole. Tie the other end through a hole punched in the spiral. You can use permanent markers to draw designs directly on the plastic shapes, or on the spiral.

6. Another idea is to write the commandment to celebrate Sukkot on a piece of paper and punch a hole at one end. Thread string through the piece of paper and hang from the spiral.

Helpful Hints

The mobile can be as simple or elaborate as you wish. The more colorful the symbols are that hang from the spiral, the more beautiful your sukkah will be!

Resources

Groner, Judith, and Madeline Wikler. *All About Sukkot*. Rockville, MD: Kar-Ben, 1998.
Sukkot stories, explanations, blessings, and traditions.

Hirsh, Jody, and Idy Goodman. *Tastes of Jewish Traditions*. Milwaukee, WI: Jewish Community Center of Milwaukee, 2002.
Stories, recipes, information, and additional crafts for Sukkot.

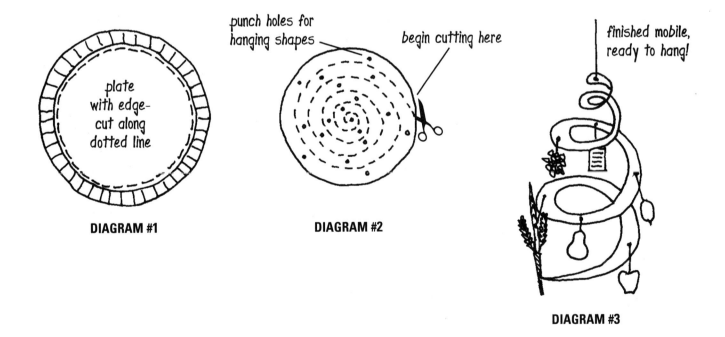

DIAGRAM #1

DIAGRAM #2

DIAGRAM #3

Holidays > Pesach

overcoming **SLAVERY**

celebrating **FREEDOM**

as if **YOU YOURSELF** had come out of **EGYPT**

The BIG IDEA

PESACH
Family Education

In every generation it is incumbent upon each one of us to see ourselves as though each one of us had actually been redeemed from Egypt, as it is said: "And you shall tell your children on that day saying, 'It is because of that which Adonai did for me when I came forth out of Egypt'"
(The Pesach Haggadah/Exodus 13:8).

The story of Pesach is like no other in our history. This story represents the ultimate example of the Jewish struggle for freedom. That is why the words that obligate us to pass on this story from generation to generation are at the heart of our celebration. We see the reflection of ourselves through the struggle of our ancestors, and are consequently reminded of our own personal obligation to connect to our Jewish heritage. Pesach has become a family holiday, one to be celebrated with new and personal traditions, each generation adding to the story as if it were their own.

COURAGE and **FAITH**

and I will **BRING YOU INTO** the **LAND**

INTEGRATING THE ARTS INTO JEWISH EDUCATION

Holidays > Pesach > Music

FROM SLAVERY TO FREEDOM: WE SHALL OVERCOME
Family Education

Inspiration
The Jewish people has been crying out for freedom for thousands of years. In 1883 the Jewish poet Emma Lazarus wrote "The New Colossus" as a beacon of hope to all those around the world seeking their freedom. Engraved on the Statue of Liberty, the words continue to influence the way we envision freedom and exile today:

Give me your tired, your poor,
Your huddled masses yearning to breathe free,
The wretched refuse of your teeming shore.
Send these, the homeless, tempest-tossed to me,
I lift my lamp beside the golden door!

Objective
Participants will write their own verses to the song "We Shall Overcome" as a way of understanding the freedoms they have as Americans and as Jews.

Materials
- Large writing surface (blackboard, flip chart, etc.)
- Markers/pens
- Writing paper
- Copies of lyrics to "We Shall Overcome" (available online at http://www.negrospirituals.com—click on "Songs" in the top menu bar, then on "choose among all the lyrics," then scroll down through the alphabetical listing to find "We Shall Overcome")

Process
1. Engage participants in a discussion of the significance of the Passover seder. Elicit from them the key concept of Passover, that once we were slaves in the land of Egypt and now we are free, and that we must retell the story in order to remember. Ask participants to fill in details and add their own thoughts. Refer to the "Big Idea" (page 31) as background for the discussion.

2. Ask the following questions:
 - Why is it important to tell the same story every year?
 - Why is it important to tell the story to our children?
 - Why do we tell the story reclining?
 - What is slavery?
 - What do you know about people in our world today who are still experiencing some form of slavery?

3. Read the Emma Lazarus poem from the "Inspiration" section above, and ask participants if they recognize it. What is its significance? Does the fact that it was written by a Jewish poet add to its meaning? How might this poem relate to the Passover story?

OPEN IT UP!

4. Direct each family to spend a few minutes brainstorming to come up with a list of the freedoms they have as Americans and as Jews. Ask them to reflect also on some of the freedoms our people did not have as slaves in Egypt. Have each family choose one person to be the group facilitator and one person to be the scribe and record the ideas on paper. Have the families use the following phrases as templates when listing their ideas:

 - "We are free to _____." (Some examples might include "pray," "vote," "speak.")
 - "We can _____ in _____." (Some examples might include "speak in public," "pray in our temple/synagogue.")

 Each family should come up with at least five ideas.

5. Come back together as a group and share the ideas of each family. Write these ideas on a list that the entire group can see.

6. Distribute the lyrics to the song "We Shall Overcome." Read the lyrics out loud as a group. Explain that this song became the anthem of the civil rights movement of the 1950s and 1960s. Excellent background information and a captivating history of "We Shall Overcome" and the civil rights movement can be found online at http://www.pipeline.com/~rgibson/overcomehistory.html.

7. Each family will create a new verse to be added to the song "We Shall Overcome," using the brainstormed ideas from step 4 above. Each family can share the words that they wrote and explain why they chose them. Write all the new verses on a blackboard or flip chart so that the entire group can see them. Sing all the new verses as a group.

8. Conclude the activity by reading the following statement and asking the following questions:
 It is important to always be cognizant of the freedoms we have as Americans and as Jews, and not to take them for granted. We retell the story of Passover each year to remind us that there are still people in our world who do not have the same freedoms we do.
 - What can we do to help others in their quest for freedom? Think about people in this country who are not yet fully free. Think about people in other countries who are not fully free.
 - How can we remember our freedoms at all times of the year, not just at Passover?
 - What other Jewish holidays commemorate freedom?

Helpful Hints
- Be sure that you are comfortable with the melody and lyrics of "We Shall Overcome." A sound file of the song can be found online at http://www.lib.virginia.edu (type "We Shall Overcome" in the "Search Library Web Site" box at lower right).

- If time allows, discuss why the song "We Shall Overcome" became the anthem of African Americans during the civil rights movement. Could this song have been written and sung as an anthem when the Israelites were crossing the Red Sea? What did those who struggled in the civil rights movement have in common with the Israelites who crossed the Red Sea? Why do so many African American spiritual songs have biblical themes?

Holidays > Pesach > Music

- Sing or read the lyrics to other spirituals or songs of freedom, such as:
 "Standing at the Sea" (Peter and Ellen Allard, from the CD *Bring the Sabbath Home,* www.peterandellen.com)
 "Not By Might, Not By Power" (Debbie Friedman, from the CD *In the Beginning,* www.soundswrite.com)
 "Pitchu Li" (Rabbi Joe Black, from the CD *Leave a Little Bit Undone,* www.rabbijoeblack.com)
 "Oh Freedom, Oh Freedom" (spiritual)
 "Go Down Moses, Let My People Go" (spiritual)
 "Michael Row the Boat Ashore" (spiritual)
 "Wade in the Water" (spiritual)

Resources

NegroSpirituals.com
http://www.negrospirituals.com
 The story of Negro spirituals and their link to African-American history. Click on "Songs" for a large database of lyrics, including the lyrics to "We Shall Overcome."

What Does the Statue of Liberty Have to Do with the Jewish National Fund?
http://www.jnf.org/site/PageServer?pagename=edu_statue_liberty
 A good children's activity including a word scramble that makes a connection between Emma Lazarus's poem and the JNF's work in support of freedom.

Holidays > Pesach > Drama

FROM GENERATION TO GENERATION: TELLING THE TALE
Family Education

Inspiration
"It is a positive commandment of the Law to narrate the miracles and wonders that happened to our ancestors in Egypt on the night of the fifteenth of Nisan, as it is said: 'Remember this day, in which you came out from Egypt' " (Maimonides, *Mishneh Torah, Hilchot Hametz U'matzah* 7.1 and Exodus 13:3).

It is an obligation every year during Passover for us to retell the story of the Israelites' Exodus from Egypt. We are commanded in the Torah to do so a total of four times: Exodus 12:26, Exodus 13:8, Exodus 13:14, and Deuteronomy 6:20. We are to relive the Exodus and experience it as if we ourselves had just come out of Egypt. Yet we are not the same people from year to year—we grow and learn, and see the world through different eyes. Through the telling and retelling of this story, we are able to add our own reflections and find new meaning in the ancient story of our people.

Objective
Participants will create their own dramatic interpretation of the Exodus story.

Materials
- Index cards
- Assorted costumes and simple props: colorful scarves, robes, sticks, etc.

Process
1. Begin by reading the story of the Exodus together, so that everyone is on the same page. You can pull an abridged copy from your favorite Passover Haggadah, or find a very simple version online at http://www.holidays.net/passover/story.html.

2. Ask the participants why we read this story every year. Read the "Inspiration" section above as a way of introducing the idea of a ritual retelling every year as a commandment from the Torah.

3. Explain that you are now going to bring the story of the Exodus to life by acting out several different scenes. Break into groups of about eight members; if necessary, combine families to form groups.

4. Hand each group an index card with the title of their scene. Suggestions include:
 - The Life of Baby Moses
 - Encounters in the Desert
 - Approaching Pharaoh—Let My People Go!
 - The Ten Plagues
 - Crossing the Sea to Freedom

Holidays > Pesach > Drama

5. Instruct each group to review the story and think about their scene. Who are the characters in it? What is the main "action" that happens? What is the conflict? Where does the scene take place? How does it resolve? Give each group a few minutes to discuss and plan.

6. Group members should now assume different parts and improvise their scene. Encourage them to use the simple props and costumes. Some group members may want to play non-human characters and share from that perspective. For example, imagine being a sheep out to pasture when Moses encounters the burning bush. What might the sheep add to the scene?

7. Each group should practice their scene at least twice. Then gather all groups together for "Exodus Theater."

8. Introduce each scene in order and be sure to applaud each group for their unique efforts!

Helpful Hints

It is important that each person take part in the creation of the drama. Suggest that some participants may have a nonspeaking role in the scene—holding up a sign, serving as the costume dresser, etc. There are many ways to involve every member of the group, even those who prefer not to be in the spotlight.

Resources

Beiner, Stan J. *Sedra Scenes: Skits for Every Torah Portion.* Rev. ed. Denver, CO: A.R.E., 2002.
 A short, hunorous skit for each of the fifty-four weekly Torah portions.

Wolfson, Ron. *Passover: The Family Guide to Spiritual Celebration.* 2nd ed. Woodstock, VT: Jewish Lights, 2003.
 A practical how-to guide that clearly explains the history, customs, and celebrations of Passover.

Holidays > Pesach > Creative Writing

NACHSHON TAKES A LEAP OF FAITH
Family Education

Inspiration
Rabbi Judah said to Rabbi Meir: This is how it happened: One tribe said, "I will not be the first to go into the sea"; and another tribe also said, "I will not be the first to go into the sea." While they were standing there deliberating, Nachshon the son of Amminadab (of the tribe of Judah) sprang forward and was the first to go down into the sea. Because it was Nachshon who sprang forward, Judah was to obtain a site that was sacred, as well as royal dominion in Israel, as is said, "Judah became [God's] sanctuary, Israel [God's] dominion" (Midrash: *Sotah* 36b; Tanach quote: Psalms 114:2).

The people of Israel are standing at a crossroads: the Sea of Reeds before them and Pharaoh's army chasing after them. When God commands Moses to split the sea in Exodus 14, the people are not able to move forward, unsure if the sea will truly part. Due to the courage and faith of Nachshon, who takes the first step into the Sea of Reeds, the sea parts and the Israelites cross to freedom.

Objective
Participants will write at least one paragraph from the point of view of a member of Nachshon's family.

Materials
- Writing paper
- Pens or pencils

Process
1. Distribute paper and writing instruments.
2. Ask a participant to recount the story of the Israelites when they were leaving Egypt on their way to freedom, specifically when the Israelites arrived at the Sea of Reeds (also known as the Red Sea).
3. Read the "Inspiration" section above to the participants. Remind the participants about what a midrash is and how the rabbis constructed these stories to "fill in the missing pieces" in the Torah narration.
4. Tell the participants they will now add their own voice to the midrashic process through a creative writing exercise.
5. "Set the scene" by reading aloud the following:

 As one of *b'nai Yisrael*, the children of Israel, you have been running for days since Pharaoh finally let you and your people go. You are still scared that Pharaoh will come and find everyone and make them return to Egypt, back into slavery. The journey has been long already, and it is hot and dry. All you've had to eat for days is the unleavened dough you carried on your back. It is crispy and bland.

 You begin to hear a low rumble, and suddenly behind you there is the thunderous sound of chariots coming. Pharaoh's army is racing to overtake the children of Israel! Pharaoh must

INTEGRATING THE ARTS INTO JEWISH EDUCATION

have changed his mind once again. Ahead of you, the Sea of Reeds lays ominous, the waters are raging, and it is really frightening. What will happen?

All of a sudden, Nachshon is jumping into the water, hurling himself against the waves! Why would he do such a thing? Suddenly, something amazing happens—as soon as Nachshon jumps into the water, God makes the sea split! You see two walls of water, with a path down the middle. There are thousands of people. Will it be possible for all the people to walk through safely? How was Nachshon so brave that he jumped in? He risked his life to save the children of Israel!

6. Instruct families that each member will write from a different perspective in this exercise:
 Fathers: Nachshon is your brother.
 Mothers: Nachshon is your brother-in-law (your husband's brother)
 Children: Nachshon is your uncle.
 Grandparents: Nachshon is your son.

7. Give family members ten minutes to write freely. Encourage them to write what they are feeling—their fears, their excitement, their feeling of triumph at leaving Egypt. Those too young to write can dictate to an adult. When everyone is finished, have family members share their writings with one another.

Helpful Hints

- There are several ways to extend the activity and create an exercise where the participants can combine their writings:
 - Each family can assemble their writings in a booklet and decorate the cover.
 - Create a drama/play from the writings and have participants act out their dialogue.
- You can add to the depth of Nachson's character by sharing the following background:
 A midrash gives an explanation of Nachshon's name, "Nachshon the son of Amminadab, a prince of the Tribe of Judah." Why was he called by the name of Nachshon? Because he was the first to plunge into the billow (*nachshol*) of the sea.

Resources

Black, Rabbi Joe. *Everybody's Got a Little Music* (compact disc). Albuquerque, NM: Lanitunes, 1992.
 Includes the song "Nachshon," a musical retelling of the midrash of Nachshon at the Sea of Reeds.

JewishEncyclopedia.com–NAHSHON
http://www.jewishencyclopedia.com
 Type "Nahshon" in the "search" box for information about Nachshon's life and genealogy.

Holidays > Pesach > Visual Arts

A PROMISE OF REDEMPTION: ELIJAH'S CUP
Family Education

Inspiration
There are five stages of deliverance alluded to in the Haggadah: slavery to freedom, sorrow to joy, mourning to festivity, darkness to great light, and enslavement to redemption. The first four cups of wine during the seder represent the fourfold promise of redemption stated in Exodus 6:6–7.

I will bring you out from under the burdens of the Egyptians (*V'hotzeiti*).
I will deliver you from their bondage (*V'hitzalti*).
I will redeem you with an outstretched arm (*V'ga'alti*).
I will take you to Me for a people (*V'lakachti*), and I will be to you a God.

The final stage of enslavement to redemption is represented by a fifth promise (*V'heiveiti*):
"*And I will bring you into the land, which I lifted up My hand to give to Abraham, to Isaac, and to Jacob; and I will give it to you for a heritage.*"

This final promise is seen as a reference to a future redemption, to be announced by Elijah the Prophet, when God will gather the Jews from the "four corners of the earth" and return them to their land. This redemption is represented in our seder by a special fifth cup of wine known as Elijah's cup. We fill this fifth cup but do not drink it; near the end of our seder we open the door and welcome the prophet Elijah in the hope that he will soon bring final redemption. This special cup is part of our seder more for our own sake than for Elijah's—it inspires us and gives our seder focus and direction.

Objective
Using familiar materials in a new way, participants will create a usable Elijah's cup that will reinforce the true meaning and symbolism of this Pesach ritual object.

Materials
- Sturdy clear plastic cups (found in any party store)
- Masking tape
- Scissors or X-acto knives
- Medium-textured sandpaper

Process
1. Engage the families in a brief discussion about Elijah's cup. Elicit from them what they know about its meaning and purpose.
2. Read the "Inspiration" section above with the families. Follow up with discussion to be sure that everyone understands the concept of Elijah's cup.
3. Brainstorm to generate a list of Pesach symbols. Write the list on the blackboard so all can see.
4. Remind the families of the various themes of Pesach alluded to in the "Inspiration" section above. Ask:

INTEGRATING THE ARTS INTO JEWISH EDUCATION

- What symbols from the list you created represent freedom, slavery, deliverance, redemption, the land of Israel?
- What symbols would be appropriate for decorating Elijah's cup?

You may wish to pass out a printed sheet with some examples of Pesach and Israel symbols.

5. Ask each family to choose several symbols they would like to use on an Elijah's cup that they will create for use at their own seder. Encourage participants to select symbols that are meaningful to their family and will help them recall the true meaning of Elijah's cup.

6. Pass out two plastic cups to each family. Instruct them to place one cup inside the other to give added strength while decorating the outer one.

7. Pass out masking tape. Using scissors or X-acto knives, participants will cut the tape in the shape of their chosen symbols and affix it to the outer surface of the plastic cup.

8. Pass out sandpaper and instruct participants to gently rub the bare sections of the plastic cup with the sandpaper, scratching the outside surface. The taped sections will remain smooth.

9. Remove the masking tape when all the bare sections of the cup have been textured with the sandpaper. Remove the inside plastic cup and throw away.

Helpful Hints

- Different effects can be achieved by sanding the plastic in a single direction or in a circular motion. Encourage participants to experiment with different techniques and create interesting patterns.
- Encourage families to use their Elijah's cup each year during their seder.

Resources

Musleah, Rahel. *Why on This Night? A Passover Haggadah for Family Celebration.* New York: Simon Pulse, 2000.
 Celebrates the rich traditions of Passover through stories, poems, and activities.

The Silent Cup
http://www.chabad.org/search
 This Chabad-Lubavitch Web site features an interesting, detailed article explaining the significance of Elijah's cup. Search using the phrase "The Silent Cup."

PART II
TORAH

Torah > Noah's Ark

God's **MERCY** to all **CREATURES**

TWO of **EVERY KIND**

The BIG IDEA

NOAH'S ARK
Grades K–1

And God said, "This is the sign that I set for the covenant between Me and you, and every living creature with you, for all ages to come. I have set My [rain]bow in the clouds, and it shall serve as a sign of the covenant between Me and the earth. When I bring clouds over the earth, and the [rain]bow appears in the clouds, I will remember My covenant between Me and you and every living creature among all flesh, so that the waters shall never again become a flood to destroy all flesh" (Genesis 9:12–15).

The rainbow is a symbol of God's promise to Noah's descendants that the world would never again be destroyed by a flood. The rainbow serves not only to remind God of this promise, but also to remind people of God's grace and mercy.

RESPECT for **ALL BEINGS**

the **VIBRANT COLORS** of **LIFE**

INTEGRATING THE ARTS INTO JEWISH EDUCATION

Torah > Noah's Ark > Music

THEY CAME ON BY TWOSIES, TWOSIES
Grades K–1

Inspiration
In the story of the flood, God appears to treat humans and animals with equal concern:
"And God remembered Noah and all the beasts and all the animals that were with him in the ark" (Genesis 8:1).

A midrash elaborates on this theme:
"Adonai is good to all, and God's mercies are over all God's works." R. Joshua b. Levi said: God is good to all [creatures], and God's mercies are over all, because they are all God's works. R. Joshua of Sakhnin said in R. Levi's name: Adonai is good to all, and God gives mercy to all creatures [so that they can be merciful to others] (*Genesis Rabbah* 33:3).

Could it be that one reason God required Noah to bring two of every animal into the ark was so that no creature, great or small, would be alone during the long journey?

Objective
Students will find their matching animal "partner" by using animal sounds.

Materials
- Pairs of animal cards
- Blindfold for each child (bandana, scarf, etc.)

Process
1. Create pairs of animal picture cards before class begins. Each card should have a picture of an animal, with the animal's name written below. Choose an assortment of different types of animals. Make two cards of each animal, and enough so that each student will get his or her own card. Many great animal pictures can be found online at http://animaltrial.com/animals/animalpictures.html.

2. Make sure that students are familiar with the story of Noah and the ark. Focus on a story that speaks about the many different animals that were on the ark. Ask students to name their favorite animals in the story. Incorporate into the discussion the ideas from the "Inspiration" section above, that God cared greatly about the animals, and that perhaps God told Noah to take two of every animal into the ark so that no creature would be lonely.

3. Describe the activity to the students by explaining that the animals have been scattered all over the ark, and the animal pairs have become separated. You will help the animals find their partners by using your voices, but not your eyes.

4. Show the set of animal cards to the students and ask them to help you remember what sound each animal makes. Be sure to cover every animal, so that when the cards are passed out each animal of a pair will be making the same sound!

5. Ask students to separate themselves around the room (preferably in a large room) so they are at least an arm's distance apart from one another. Distribute the animal picture cards, one

card to each student, making sure that each card handed to a student has its matching pair handed to another student. If there is an odd number of students, participate in the activity yourself.

6. Blindfold the students. Direct them to slowly and carefully walk around the room while making the sound of their animal. The objective is for the students find their matching animal using only their "animal voice." Once they find their matching animal, they should stand in their place until each pair is complete. Then they can take off their blindfolds.

7. Ask the following questions:
 - Was it easy or difficult to find your matching animal?
 - What made it easy? What made it difficult?
 - What senses did you use the most in finding your matching animal?
 - What was hard about not using your eyes?
 - What are the other senses that you used instead of your eyes (remind students of the five senses: sight, sound, taste, touch, smell)?

8. Collect the cards and redistribute them so that each person has a new animal. Repeat the activity as long as the students are having fun and enjoying themselves. Ask:
 - Was it easier the second or third time you repeated the activity? If so, what made it easier?

9. Describe what it might have been like for the animals living in the ark. It was probably crowded and smelly, maybe damp and cold. The waves may have caused the ark to rock back and forth. At night and on the lower levels of the ark (the Torah tells us that Noah built the ark with three decks), there probably wasn't much light. Therefore, the animals had to use their other senses. Ask:
 - Do you think the animals were scared?
 - Do you think they were comforted because Noah and his family took such good care of them?
 - Do you think they knew that God cared for them, too?

Helpful Hints
- Repeat the exercise as above, but use rhythm instruments instead of animal cards. Or, use body sounds made by the students (hands clapping, feet tapping, hands rubbing together, mouth clicks, finger snapping, tapping cheeks with mouth open, etc.) instead of animal cards or instruments, household objects (wooden spoons, metal pot lids) may also be used.
- Conclude by teaching and singing a fun song about the animals in the ark. A few suggestions include:
 - "Rise and Shine (The Arky, Arky Song)," traditional
 - "Who Built the Ark?" by Raffi (from the recording *More Sing-able Songs*)
 - "Uncle Noah's Ark" by Cathy Fink (from the recording *When the Rain Comes Down*)
 - "Open Up the Window, Noah" by Phil Rosenthal (from the recording *Turkey in the Straw*)

Resources

Walton, Rick. *Noah's Square Dance.* New York: Lothrop, Lee & Shepard, 1995.
 It's square dance night on Noah's ark. Things get a little wild as Noah calls the dance moves and his wife, sons, and daughters-in-law serve as musicians.

See also the "Resources" section in the drama activity for Noah's Ark (page 48).

Torah > Noah's Ark > Drama

THE SIGHTS AND SOUNDS OF NOAH'S ARK
Grades K–1

Inspiration
"But I will establish My covenant with you, and you shall enter the ark, with your sons, your wife, and your sons' wives. And of all that lives, of all flesh, you shall take two of each into the ark to keep alive with you; they shall be male and female. From birds of every kind, cattle of every kind, every kind of creeping thing on earth, two of each shall come to you to stay alive. For your part, take of everything that is eaten and store it away, to serve as food for you and for them. Noah did so; just as God commanded him, so he did" (Genesis 6:18–22).

With two of each type of animal on the ark, Noah and his family worked day and night feeding and taking care of them so that they would continue the species once the flood was over. One can imagine the sights, smells, and sounds that so many different animals created in such a confined space for forty days and forty nights!

Objective
Students will imagine and experience what it felt like to be an animal on Noah's ark through creative dress-up and movement.

Materials
- Scarves and pieces of fabric of different textures—woolly, furry, slick, soft, etc.
- Any type of noisemaker to be used for animal sounds
- Animal masks, ears, noses, etc.

Process
1. Read a simple version of the story of Noah's ark to the students. See the "Resources" section (page 48) for suggested versions. Make sure that everyone has a basic understanding of the story.

2. Ask the students to describe their houses: How many floors are there? How many rooms and bathrooms are there? How many people live there? Are there are any pets living there?

3. Describe the ark to the students. Most Bible scholars agree that the ark was about 450 feet long (as long as one and a half football fields), 75 feet wide, and 45 feet high—taller than a three-story building. How does that compare to their house? The Torah tells us that two of each animal were brought onto the ark. Ask the students how many types of animals they think could fit into their house. (Note that there is actually a contradiction in the Bible—not an unusual occurrence—concerning how many of each animal God instructed Noah to take into the ark. In two places, Genesis 6:19 and Genesis 7:8–9 and 7:15, the text says two of each kind, but in Genesis 7:2 the text says *seven* pairs of every kosher animal and one pair of every nonkosher animal! To add further confusion, the uncertain meaning of the original Hebrew text in Genesis 7:2 has led some scholars to suggest that God actually instructed Noah to take *seven pairs* of animals, or *fourteen* in all! In any case, with students at this age it is entirely appropriate to use the traditional count of two of every kind of animal, one male and one female.)

INTEGRATING THE ARTS INTO JEWISH EDUCATION

Torah > Noah's Ark > Drama

4. Continue the discussion by asking: What do you think it was like for so many different animals to live together on the ark for such a long time? How might a chicken feel? An elephant? A puppy? A tiger? How do you think the animals felt when they finally got to run off the ark onto dry land? Invite responses and encourage discussion. Ask the students to think about how they might feel if they had to sit inside for a whole day during a big rainstorm, and then how it would feel when they were able to go outside and play again.

5. Tell the students that they will each choose an animal, and together the animals will put on a special "animal play." Show them the collection of animal costumes and props, and ask them to choose an animal from Noah's ark that they would like to dress up as (they may also want to come up with imaginary animals). Help them to get into costume.

6. Instruct students to "become" their chosen animal—walk around the room and make the appropriate sounds! When you call "Freeze!" they are to completely stop, be silent, and stand very still. When you call "Go!" they can make their animal sounds and movements again.

7. During the freezes, walk up to individual animals and ask them about their experiences on the ark. "Mrs. Hippo, do you think you'll ever get to dry land?" "Mr. Giraffe, tell me what it was like when the dove came back with the olive branch." Make sure to get around to each student!

8. To conclude this activity, you can take a digital or Polaroid picture of each child in costume. Mount the picture in the middle of a sheet of paper, and let the students decorate the "frame" around the photo with a scene of Noah's ark.

Helpful Hints

- A large space such as a social hall can absorb the "animal" noises and provide maximum room for movement.
- Simple face paint like spots, colored noses, and whiskers drawn with eyebrow pencil will help the students really take on the role of their animal characters.

Resources

Emhardt, Erna, and Margrit Haubensak-Tellenbach. *The Story of Noah's Ark*. New York: Crown, 1983.
This version gives the full, detailed story of Noah, the only good man left on earth, whom God directs to build an ark so that his family and two of each species of animal may be saved when the Great Flood comes.

Gerstein, Mordicai. *Noah and the Great Flood*. New York: Simon & Schuster, 1999.
This colorful interpretation of the story is woven together from both biblical accounts of Noah and legends in the Jewish tradition, giving it a slightly different twist.

Pinkney, Jerry. *Noah's Ark*. New York: North-South Books, 2002.
This beautifully illustrated Caldecott Honor book tells a straightforward account of Noah's story of faith, stewardship, and obedience.

Reasoner, Charles. *Inside Noah's Ark*. New York: Price Stern Sloan, 2002.
This board book for young children offers an inside view of Noah's ark, with die-cut doors and windows allowing a peek at the floating menagerie.

Torah > Noah's Ark > Creative Writing

IF I COULD TALK TO THE ANIMALS
Grades K–1

Inspiration
And Adonai said to Noah, "Go into the ark, you and your whole family, because I have found you alone to be righteous before Me in this generation. . . . Noah, with his sons, his wife, and his son's wives, went into the ark. . . . Of the clean animals, of the unclean animals, of the birds, and of everything that creeps on the ground, two of each, male and female, came to Noah into the ark, as God had commanded Noah. And on the seventh day the waters of the Flood came upon the earth" (Genesis 7:1, 7–10).

Noah and his family worked day and night, feeding and taking care of the animals on the ark. A midrash (*Sanhedrin* 108b) tells us that Noah fed each and every animal what they were accustomed to eating. The dedication and responsibility that Noah and his family took upon themselves not only to keep the animals alive, but to do so in a way that made the animals as comfortable as possible, showed that Noah had respect and reverence for all beings—the mark of a truly righteous man.

Objective
Students will write or dictate a short paragraph imagining what it would be like to live on the ark with the animals.

Materials
- Writing paper
- Pens or pencils

Process
1. Engage the students in a discussion of the story of Noah and the ark. Make sure that everyone has a basic understanding of the story. For the purposes of this activity, emphasize the important responsibility that Noah and his family were given: taking care of the animals. It was up to them to make sure that every kind of animal survived the Flood, to live on the earth after the floodwaters were gone.

2. Distribute paper and writing instruments.

3. "Set the scene" by reading aloud the following (note that the Bible does not mention the presence of children on the ark, so the children will be writing their own midrash):
 You are Noah's six-year-old grandson/granddaughter, and you've been living on Noah's ark for many weeks now. It has finally stopped raining, but the ark is very crowded—not to mention noisy and smelly—and there aren't many other children for you to play with. The animals have become your close friends—you even talk to them! Right now you're sitting in the lower level of your grandfather's gigantic ark with two bunnies, two guinea pigs, two doves, and two cats. The doves have just been chosen for a very important trip—Noah is sending them out to see if the land is dry enough after the Flood for your family and the animals to leave the ark.

INTEGRATING THE ARTS INTO JEWISH EDUCATION

Torah > Noah's Ark > Creative Writing

"Fly to the land, little doves," you say. "Come back and bring us good news so that we can get off this big boat and walk on land once again." You've been afloat on the water so long that you've almost forgotten what trees looks like, and what the grass feels like between your toes.

You're a little sad that God had to cause the Great Flood and destroy all the people on earth except for your family. You're also a little worried about what to expect after the flood ends. Where will you live? Who will your friends be? Your grandfather comforts you and tells you that everything will be okay, that God has promised never to destroy the earth by flood again. But you're still a little worried.

4. Give students ten minutes to write freely. Encourage them to write what they are feeling—their fears, their sadness, their excitement at finally leaving the ark. Use the following guiding questions if students need help:
 - How do you feel about living on the ark with the animals?
 - What does it sound like?
 - What does it smell like?
 - What responsibilities do you have to care for the animals?
 - Why do you think the animals have been saved?
 - Which animal is your favorite?
 - When you talk to your animal friends, what do you tell them?

Those too young to write can dictate to an adult, or into a tape recorder. When everyone is finished, ask for volunteers to share their writings with the group.

Helpful Hints

The idea of the earth being destroyed can make this a difficult story for young children. Deal with that issue honestly, but make the story sweeter by focusing on the world of the animals and the important job of caring for them. Try to convey a sense of optimism and hope for a better future after the Flood.

Resources

Kuskin, Karla. *The Animals and the Ark.* New York: Atheneum Books for Young Readers, 2002.
Great illustrations complement a funny story about restless animals that leave Noah fearing a mutiny of biblical proportions.

Rouss, Sylvia. *The Littlest Pair.* New York: Pitspopany Press, 2001.
None of the animals wants the termites to come aboard Noah's ark. After all, termites eat arks! But when the rain starts pouring and the animals start slipping helter-skelter across the ark, the termites use their wood-munching abilities to save the day.

Torah > Noah's Ark > Visual Arts

ALL THE COLORS OF THE RAINBOW: PLAYING "PASS THE PAINT"
Grades K–1

Inspiration
"A rainbow is a single clear ray that has been broken down into seven colors. This is symbolic of the variety in mankind, from the darkest to the lightest color. All the different shades of mankind . . . are joined together in life" (Rabbi Samson Raphael Hirsch, in his commentary on the Chumash).

When we see a rainbow in the sky, the band of colors reminds us of God's promise to never again destroy the earth by flood. Colors represent the hope and joy that are so integral to a vibrant life. When we express ourselves through color, we express the uniqueness in each one of us.

Objective
The students will use the colors of the rainbow to create their own unique painting.

Materials
- Tempera paint in red, yellow, and blue. Mix colors to make orange, green, and violet.
- Large brushes
- Large pieces of paper
- Containers for water, paint, and mixing colors (be sure to have plenty!)

Process
1. Engage the students in a discussion of the story of Noah and the ark. Make sure that everyone has a basic understanding of the story. For the purposes of this activity, emphasize the significance of the rainbow as a sign of covenant between God and all the living creatures of the earth.

2. Ask the students to share what colors are found in the rainbow. A rainbow is made up of seven colors: red, orange, yellow, green, blue, indigo, and violet. (Actually, the rainbow is a whole continuum of colors from red to violet and even beyond the colors that the eye can see—ultraviolet and infrared. For the purposes of this activity, we will use six colors from the rainbow: the primary colors red, yellow, and blue, and the secondary colors green, orange, and violet.)

3. Tell the students that we are going to use the colors of the rainbow to play a painting game called "Pass the Paint."

4. Cover with newspaper or plastic the tables you will be using to paint. Set out six containers to demonstrate what happens when you mix primary colors. Pour one container of red paint, one of yellow paint, and one of blue paint. Three containers should be empty.

5. In the empty containers, demonstrate color mixing by combining equal quantities of yellow and red to make orange. Combine equal quantities of blue and yellow to make green, and combine equal quantities of red and blue to make violet.

INTEGRATING THE ARTS INTO JEWISH EDUCATION 51

6. Fill one container for each student in the classroom with a single color, distributing all six colors equally. Give each student one container of paint, one brush, and a large piece of paper.

7. Give the students three or four minutes to paint with their single color. They may paint whatever they like with the color they are using, but instruct them that the goal is to fill their page with shapes of many colors. Instruct them to begin when you say "Go!" When you call out "Pass the Paint!" they will pass their container and paintbrush to another student and receive a new color.

8. Continue painting and passing until everyone has painted with all six colors. When everyone is finished, have each student share what he/she has painted. Make special note of the beauty that is created when using the many colors of the rainbow.

Helpful Hints
- Make sure that each rotation is approximately the same amount of time. You can play music, set a timer, use an hourglass, or come up with another creative way to mark time while the students are painting.

- Older students can use their colors to represent the animals found on the ark: red monkeys, yellow lions, blue parrots, green alligators, orange butterflies, and violet peacocks.

Resources

Cousins, Lucy. *Noah's Ark*. Cambridge, MA: Candlewick, 1993.
 Bright, colorful, illustrations of pink flamingos, green alligators, gray elephants, and, of course, Noah, with his snowy white beard and his brown sandals.

Paul, Tony. *How to Mix & Use Color: The Artist's Guide to Achieving the Perfect Color in Every Medium*. London: North Holland, 2003.
 A reference book for artists that explains how to make color work. Includes everything from color basics and popular palette choices to detailed mixing charts and simple color wheels.

Torah > Three Righteous Women

IF NOT for MIRIAM

in PRAISE of the MIDWIVES

The BIG IDEA

THREE RIGHTEOUS WOMEN
Grades 2–3

"If you destroy a single life, it is as if you have destroyed the entire world; but if you save a single life, it is as if you have saved the entire world" (Baba Batra 11a).

A mother's plan to save her son's life, a sister's watchful eye, and a childless woman's compassion: all seemingly simple, even random acts. But combined, the actions of these three righteous women had an impact beyond measure. By saving the life of baby Moses, Miriam, Yocheved, and Bat Pharaoh saved the entire Jewish people—and changed the world forever.

COURAGE in the FACE of FEAR

the INSTRUMENT that SAVES LIFE

INTEGRATING THE ARTS INTO JEWISH EDUCATION

Torah > Three Righteous Women > Music

MIRIAM'S CUP, FULL OF HISTORY
Grades 2–3

Note: This activity will require two class periods, one for preparation and another for the activity itself. It can be integrated into the classroom curriculum not only when studying the three righteous women, but as an excellent accompaniment to a unit on Rosh Chodesh or on women's issues.

Inspiration

"The debt of gratitude that we owe Miriam is very great. After all, if it weren't for Miriam, there would be no Moses. If it weren't for Miriam, there would be no Jewish marriages in Egypt. If it weren't for Miriam, there would be no Hebrew nursemaid for Moses. If it weren't for Miriam, there would be no redemption. If it weren't for Miriam there would be no song for the women to sing at the crossing of the Red Sea. If it weren't for Miriam, there would be no water for the people to drink in the wilderness" (Rabbi Ephraim Buchwald, from the Web site of the National Jewish Outreach Program, http://www.njop.org).

Many new Jewish rituals have been developed by contemporary Jewish women seeking to build a religious identity consistent with feminist values. One of these rituals is the addition of "Miriam's cup" to the Passover seder, and to the celebration of Rosh Chodesh, the beginning of a new month in the Hebrew calendar. Miriam's cup is filled with water, symbolizing the miraculous well that followed the Israelites throughout their journey in the desert. Miriam's cup reminds us of the significance of Miriam and the important role women play in the life of the Jewish people.

Objective

Students will participate, through music and chanting, in a new ritual of Miriam's cup.

Materials

- Copies of a letter to parents inviting them to a Rosh Chodesh celebration
- Copies of the lyrics to the Miriam's cup chant and song (page 56)
- Pens, envelopes, and stamps
- A recording of "Miriam's Song" by Debbie Friedman
- A CD or cassette player
- Rhythm instruments

Process

1. Prior to class, use a Jewish calendar to identify a class date close to Rosh Chodesh, the start of a new Hebrew month. Write a letter inviting parents to participate in a special Rosh Chodesh ceremony on that date (for more information on Rosh Chodesh, see the listings in the "Resources" section for this activity, page 56). The letter should specifically ask mothers and daughters to know their Hebrew names, in the form "(name) bat (mother's name)"—for example, "Miriam bat Yocheved."

2. Have each student sign a copy of the invitation, fold it, seal it in an envelope, address the envelope to their parents, and put a stamp on it. The teacher will mail all the letters after class.

3. Teach the Miriam's cup chant and the blessing/song for the Miriam's cup celebration to all of the students in the class (for words see page 56). Though on the day of the celebration only the girls will be reciting the chant with their mothers, it is suggested that all students learn the words.

4. On the day of the celebration, welcome everyone and give a brief explanation of Rosh Chodesh, the tradition of Miriam's cup, and what today's celebration will involve. Ask the fathers and sons to stand (or sit) in a group in the middle of the room, facing out. Ask the daughters to form a circle surrounding the fathers and sons, also facing out. Ask the mothers to form a circle around the outside of the entire group, facing their daughters.

5. The teacher begins by holding Miriam's cup and reciting the blessing, asking the group to echo the words after him/her: "*N'vareich Yah Eloheinu Ru'ach Ha'olam*, Let us bless Yah, our God, Spirit of the World."

6. The teacher passes Miriam's cup to one of the mothers who will begin the next part of the ritual. Before reciting the chant, each mother–daughter pair introduces themselves using their Hebrew names, in the prescribed format (i.e., "Miriam bat Yocheved").

 Mother: "I am _____ bat _____."
 Daughter: "I am _____ bat _____."

 Mother and daughter then chant all of the words together:

 This is Miriam's cup, full of history (*mother holds Miriam's cup*).
 I will pass it to you (*mother passes Miriam's cup to daughter*),
 You will pass it to me (*daughter passes Miriam's cup to mother*).
 This is Miriam's cup, it is filled with water (*mother passes Miriam's cup to daughter*).
 I will pass it to my mother (*daughter passes Miriam's cup to mother*),
 I will pass it to my daughter (*mother passes Miriam's cup to daughter*).

7. After each mother–daughter pair has had a chance to hold Miriam's cup and before passing it to the next mother–daughter pair, the teacher will lead the group in singing the blessing/song for the Miriam's cup celebration. "*N'vareich Yah Eloheinu Ru'ach Ha'olam*, Let us bless Yah, our God, Spirit of the World." Fathers and sons can accompany the song with rhythm instruments, which should be kept still while each mother–daughter pair recites the chant.

8. At the conclusion of this ritual celebration, form a line for dancing to "Miriam's Song" by Debbie Friedman and/or other joyous songs (see a list in the "Resources" section, page 56). The line will more than likely snake around the room rather than being one long straight line.

9. End with a celebratory snack!

Helpful Hints
- Ask several fathers to be the "Drum Corps." They will be in charge of passing out and collecting the rhythm instruments. Before passing out the rhythm instruments, make sure to firmly establish some guidelines: the instruments are to remain on the floor or on one's lap, untouched, during the part of the ritual where mothers and daughters are passing the Miriam's cup and saying the chant.

- The rhythm instruments should be shared with the mothers and daughters while dancing to "Miriam's Song."
- For the celebratory snack, it might be fun to ask parents and students to bring in snacks made with recipes passed down from someone in their family.

Resources

Broner, E. M., and Naomi Nimrod. *The Women's Haggadah.* San Francisco, CA: HarperSanFrancisco, 1994.
This underground classic is the visionary Haggadah that has inspired top feminists and women everywhere for nearly two decades.

Friedman, Debbie. *The Journey Continues: Ma'yan Passover Haggadah in Song.* San Diego, CA: Sounds Write Productions, 1997.
Songs particularly suited for dancing include "The Journey Song," "Ha Lachma," "Avadim Hayinu," "Miriam's Song," "B'Chol Dor Vador," "B'Tzeit Yisraeil," "Ma L'Cha Hayam," "Shir Hamalot," and "Min Hameitzar." Available from www.soundswrite.com.

Goodman, Robert. *Teaching Jewish Holidays: History, Values, and Activities.* Rev. ed. Denver, CO: A.R.E., 1997.
Detailed information on the history and observance of all Jewish holidays, including Rosh Chodesh.

Hirschhorn, Linda (with Vocolot). *Gather Round: Songs of Celebration.* Compact disc. Cedarhurst, NY: Tara Publications, 1989.
Songs for Passover include "Miriam's Slow Snake Dance at the Riverside" and "Women Gathering Round."

Moise, Elaine, and Rebecca Schwartz. *The Dancing with Miriam Haggadah: A Jewish Women's Celebration of Passover.* Palo Alto, CA: Rikudei Miriam, 1997.
The Passover seder experienced and interpreted with a feminist understanding of life, history, and the earth.

Miriam's Cup Chant

This is Miriam's cup, full of history.
I will pass it to you,
You will pass it to me.
This is Miriam's cup, it is filled with water.
I will pass it to my mother,
I will pass it to my daughter.

Blessing/Song for the Miriam's Cup Celebration

N'vareich Yah Eloheinu Ru'ach Ha'olam
Let us bless Yah, our God, Spirit of the World.

Torah > Three Righteous Women > Drama

MOMENTS OF COURAGE
Grades 2–3

Inspiration

"The king of Egypt spoke to the Hebrew midwives, one of whom was named Shifrah and the other Pu'ah, saying, 'When you deliver the Hebrew women look at the birth stool. If it is a boy kill him; if it is a girl, let her live.' The midwives, fearing God, did not do as the king of Egypt had told them; they let the boys live" (Exodus 1:15–16).

"The praise of the midwives here goes beyond the praise given them in the first part of the verse. Not only did they not do what Pharaoh told them, but they even dared to do deeds of kindness for the children they saved. On behalf of poor mothers, the midwives would go to the houses of rich mothers and collect water and food, which they gave to the poor mothers and thus kept their children alive" (Exodus Rabbah 1:13 and 1:15).

The great scholar Rashi assumed that the midwives were actually Yocheved and Miriam, the mother and sister of Moses, respectively. He wrote that Shifrah was really Yocheved, so called because she made the children beautiful. (Shifrah is similar to *mishaperet*, meaning "making beautiful." She cleaned up and made the children presentable after they were born.) Pu'ah was actually Miriam, because she called aloud and spoke and murmured to soothe the crying infants. (Pu'ah is similar to the word *pa'ah*, meaning "to cry aloud.")

Mark Twain once said, "Courage is not the lack of fear. It is acting in spite of it." The great rabbis of the Talmud expressed their admiration of the midwives, recognizing that these courageous women not only risked their lives to save Israelite children but also helped them to sustain their lives during difficult times. Their actions are admired as an example of great courage.

Objective

Students will write and perform scenarios about their own acts of courage based on reflections from the courageous stories of Miriam, Yocheved, and Bat Pharaoh.

Materials
- Writing paper and pencils
- Cards that say "Miriam," "Yocheved," and "Bat Pharaoh"

Process
1. Read with the students the beginning of the Exodus story (Exodus, chapters 1 and 2). Emphasize the tremendous and unique courage of Miriam, Yocheved, and Bat Pharaoh as portrayed in the Torah text, and in additional commentaries such as the "Inspiration" section above. Elicit from the students a definition of the words "brave," "bravery," and "courage" (students will have a chance to share personal examples at the end of this lesson).

2. Show the students the cards with the names of Miriam, Yocheved, and Bat Pharaoh. Ask the students to cite from the texts specific examples of the courage of the three women. When answering, the students should speak in the first person (i.e., take on the persona of the woman they are using as an example). When a student is ready to share an example, he/she

INTEGRATING THE ARTS INTO JEWISH EDUCATION

can pick up the appropriate card and complete the following statement: "My name is Miriam/Yocheved/Bat Pharaoh and I acted courageously when . . ." See how many different responses the students can come up with. It is important to explain to the students that they should answer as if they themselves were the character. Note that it may take some encouragement for the boys to take on the role of a woman.

3. Hand out paper and pencil and ask the students to think about a time in their own lives when they acted courageously. Tell them to write down as many details as possible. Prompt them to think through their example by answering the following questions:
 - Where were you?
 - Who was involved?
 - What caused you to act bravely?
 - Did you feel fearful and act anyway?

4. When students finish writing, invite them to read their work out loud. You can also collect the papers and read the writings anonymously.

5. Choose one of the examples and have one student act out the "courage scenario." Cast other students as the characters in the scene and as the student reads his/her work, the other students can pantomime this action.

Helpful Hints

Many students love the active engagement of performance but have trouble controlling their energy during a drama activity. Before you begin, be sure to set parameters. Pantomime means acting out with no words. Try to listen and follow the writer's words as closely as possible. If students get too silly, you can tap them and ask them to sit out. This gesture makes a big impression and they may be more ready to engage in an appropriate way the next time.

Resources

Manushkin, Fran. *Miriam's Cup: A Passover Story.* New York: Scholastic, 1998.
 A beautifully illustrated story for grades 2–4, based on the Torah, Jewish commentaries, legends, and traditions surrounding Miriam.

Prenzlau, Sheryl. *The Jewish Children's Bible: Exodus.* New York: Pitspopany Press, 1997.
 The complete illustrated story of the Exodus, with interesting commentaries for parents.

Torah > Three Righteous Women > Creative Writing

MIRIAM SAVES A LIFE
Grades 2–3

Inspiration
"And his sister [Miriam] stood at a distance, to know what would befall him. The daughter of Pharaoh came down to bathe in the river . . . and she saw the basket among the reeds, and sent her handmaid to fetch it. When she opened it, she saw that it was a child, a boy crying. And she had compassion on him, and said: 'This is one of the Hebrews' children.' Then his sister [Miriam] said to Pharaoh's daughter, 'Shall I go and call for you a nurse of the Hebrew women, that she may nurse the child for you?' And Pharaoh's daughter answered, 'Go.' So the girl went and called the child's mother [Yocheved]. And Pharaoh's daughter said to her: 'Take this child and nurse it for me, and I will pay your wages.' So the woman took the child, and nursed it" (Exodus 2:4–9).

Miriam had no power, no influence in life—she was, after all, a slave girl, perhaps seven years old—but she did have courage. She had the courage to step out of the reeds along the riverbank, speak to the daughter of Pharaoh, and save her baby brother's life.

Objective
Students will relate to Miriam's emotions as an older sibling, and write their own thoughts and feelings as if they were in Miriam's place.

Students will describe how it felt for Miriam to help change the fate of her younger brother, Moses.

Materials
- Writing paper
- Pens or pencils

Process
1. Engage the students in a discussion about the beginning of the Exodus story from Exodus, chapters 1 and 2. Be sure that they understand Pharaoh's decree in chapter 1 that all Hebrew male children be killed, and emphasize the role of Yocheved (Moses's mother), Bat Pharaoh (the daughter of Pharaoh), and especially Miriam (Moses's sister) in saving Moses from death in chapter 2. Use the actual text or a different version of the story (see the "Resources" section, page 60), and make sure that the students understand the important role that all three women played.

2. Distribute paper and writing instruments.

3. Ask the students to imagine themselves in Miriam's place. "Set the scene" by reading aloud the following:

 Patience . . . you have needed to learn true patience as the big sister of baby Moses. You are Miriam, daughter of Yocheved and Amram, sister of Aaron and Moses. For three months since he was born, you have helped to hide Moses, to keep him quiet, knowing that if anyone found him he would be taken away and drowned in the Nile. But now he is growing, and your mother realizes that she can hide him no longer. But what a brilliant

INTEGRATING THE ARTS INTO JEWISH EDUCATION

Torah > Three Righteous Women > Creative Writing

plan she came up with! And now you have been crouched, hiding in the bulrushes, for what seems like forever, watching over the baby as he floats on the river in his little basket.

Look—right across the water on the riverbank a princess is taking off her robe to bathe with her handmaidens. You can tell from the beautiful fabric of her robe that she is Egyptian royalty. It must be Bat Pharaoh, the daughter of Pharaoh!

You stay ever so silent as she notices baby Moses in his tiny ark . . . your head becomes dizzy with excitement as you overhear Bat Pharaoh tell the handmaidens that this must be a Hebrew boy. Will your mother's plan work? Will Bat Pharaoh take Moses home to the palace and raise him as her own? Yes! She is swaddling the baby and bringing him up on land. Now is your chance to reveal yourself and tell Bat Pharaoh that you overheard her and you have a perfect nurse for the baby. If you can get your mother the nurse job then she can secretly help to raise Moses with loyalty to his Jewish heritage. Bat Pharaoh is turning to leave—you need to approach her now!

4. Give students ten minutes to write freely. Encourage them to write what they are feeling—their anxiety, their fears, their excitement at the apparent success of Yocheved's plan. Each student should write at least ten sentences, using the following guiding questions. You may wish to write these questions on the blackboard.
 - Are you frightened for your baby brother's life?
 - How does it feel to have such a great responsibility, watching over Moses to see what will happen to him?
 - Do you think that Bat Pharaoh will be kind? Are you worried about how she will treat Moses?
 - Do you think that Bat Pharaoh knows how to take care of a young child? Will she accept advice on how to take care of the baby from your mother? If not, will something terrible happen to Yocheved, or to you?

5. Ask for volunteers to share what they have written by reading aloud to the group. Wrap up the activity by identifying the recurring themes in the students' writing and making a connection once again to the "Big Idea" for this topic (page 53) and the themes expressed in the "Inspiration" section for this activity (page 59).

Helpful Hints
- Create a display of the students' writing to share with parents and the rest of the school. See the Introduction, page xxi, for several display ideas.
- If you have a large class, some students can write from the perspective of one of the other characters in the story: Yocheved, Bat Pharaoh, even baby Moses.

Resources
Beiner, Stan J. *Sedra Scenes: Skits for Every Torah Portion.* Rev. ed. Denver, CO: A.R.E., 2002.
A short, humorous skit for each of the fifty-four weekly Torah portions.

Manushkin, Fran. *Miriam's Cup: A Passover Story.* New York: Scholastic, 1998.
A beautifully illustrated story for grades 2–4, based on the Torah, Jewish commentaries, legends, and traditions surrounding Miriam.

Ritualwell.org—The Telling
http://www.ritualwell.org/holidays/passover
> *A contemporary midrash by Arielle Derby about many of the women important in Moses's life. At the Web site of Ritualwell, the source for innovative, contemporary Jewish ritual, sponsored by Kolot, The Center for Jewish Women's and Gender Studies. Click on "Parts of the Seder," then "Maggid: The Story."*

Torah > Three Righteous Women > Visual Arts

TEVAH: THE ARK OF LIFE
Grades 2–3

Note: This activity requires some advance preparation.

Inspiration
"And when she [Yocheved] could no longer hide him, she made for him an ark of bulrushes, and daubed it with bitumen and with pitch; and she put the child into it, and placed it among the reeds by the river's bank" (Exodus 2:3).

It is interesting to note that the Torah tells us that Yocheved placed Moses in a *tevah*, sometimes translated as "a basket" and sometimes as "an ark," and set him afloat on the River Nile. The Hebrew word *tevah* is used only one other time in the Torah—in reference to Noah's ark. In both these stories, the *tevah* is the instrument that saves life: Noah's ark carried the future of life on earth through the waters to safety, while Moses's ark carried the child who in the future would lead the children of Israel through the waters to freedom, and to nationhood.

Objective
Students will weave a basket using palm leaves.

Materials
- Palm leaves (enough for twenty-four to thirty-six strips per student)
- Scissors
- Masking tape
- String (jute or three-ply twine—any string that will hold a knot)

Note: See the "Helpful Hints" section below for comments about the use of real palm leaves and suggestions for alternative materials.

Process
1. Remind or introduce the students to the story of how Yocheved, Moses's mother, saved him when he was a baby. Read specifically the verse in which Yocheved makes a basket and places him in the river (Exodus 2:3; see the "Inspiration" section above).

2. Ask students to think about how Yocheved would have constructed a basket. Use the following questions to draw out their answers: What types of natural resources do you think the basket was made of? If Yocheved was living near a river, what could she use? How do you think she constructed a basket?

 Explain that today we will imagine that Yocheved used the process of weaving to construct the basket that saved Moses. We will construct our own baskets using this method.

3. Prepare the palm leaves for weaving. Depending on your time frame you can prepare these materials yourself, or include the students in the process.
 a. Strip the pointed leaves from the stalk of the palm.
 b. Cut off the stiff ends so that the leaves are more flexible.
 c. If the leaves are more than one inch wide, cut each leaf down the middle vertically to

make the strips narrower and easier to work with.
 d. Soak the strips for five minutes in warm water to restore flexibility.
4. Lay several strips flat on the table, vertically, with a very small space in between. Tape one side of the ends to the table to secure them and make weaving easier (see diagram #1, page 64).
5. Visually divide the woven area into five equal sections, four sides and a center. Begin creating the center section by weaving new palm strips horizontally through the vertical strips, alternately threading over and under. This center section will become the bottom of the basket. As you work keep squaring off the strips, making the spaces in between even (see diagram #1, page 64).
6. After you finish the center section or bottom, take a string and "twine" around the edge. Twining is when you take a long piece of string, fold it in two equal halves and wrap it around one strip. Then cross the strings, making an "X," and wrap the string around the next strip. When you have worked your way around to where you began, tie a knot to secure the shape. Cut off any excess string. This twining locks the weave in place (see diagram #2, page 64).
7. If necessary, drop the whole piece in water for a few seconds to restore flexibility—the strips dry as you work with them.
8. Weave in two more rows of strips above and below the completed bottom panel. Secure each side panel by twining around the edges (see diagram #3, page 64).
9. When all four sides are woven and twined, fold the sides up to form the basket. Stitch each side to the one next to it to make the basket hold its shape (see diagram #4, page 64).

Helpful Hints

- The palm leaves from a *lulav* after Sukkot are perfect for this project. Palm branches can also be found at floral shops in the spring, around Palm Sunday. Other times of the year they may be difficult to find; call local flower shops and inquire.

- If you are using real palm leaves, keep a bowl of water handy so the baskets can be dipped periodically. Natural materials tend to dry out quickly and become less flexible.

- Recently, there has been controversy about the ecological viability of harvesting millions of palm fronds each year for use in Jewish and Christian holiday celebrations. If you are unable to obtain real palm leaves for this activity, you can take that as an opportunity for a discussion about the ethics of using natural resources wisely. See interesting articles on this topic at http://www.rainforest-alliance.org and http://www.jta.org (type "lulav shortage" in the "search" box). If palm leaves are not available, other materials such as Fun Foam or thin sheets of Styrofoam packing material can be cut into strips and used to make a basket. Choose materials that are strong, flexible, and buoyant.

Resources

Manushkin, Fran. *Daughters of Fire: Heroines of the Bible*. Orlando, FL: Silver Whistle, 2001. *Brings to life the stories of the matriarchs and many other women of the Bible. See in particular the section "The Women of the Exodus."*

Swett, Sarah. *Kids Weaving: Projects for Kids of All Ages.* New York: Stewart, Tabori and Chang, 2005.

The only book on weaving written specifically for children provides clear, step-by-step instructions and bright, helpful illustrations, teaching children how to weave using simple supplies.

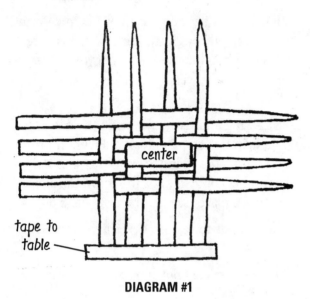

DIAGRAM #1

NOTE: These diagrams are simplified schematics and are not to scale! You will most likely need to use more strips of palm than shown here—twelve to eighteen strips in each direction.

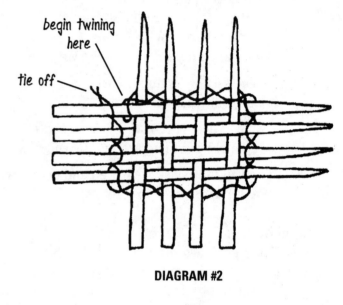

DIAGRAM #2

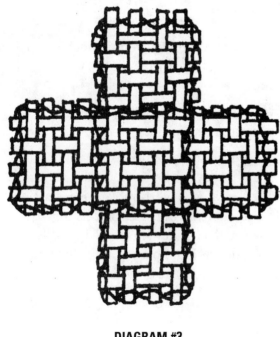

DIAGRAM #3

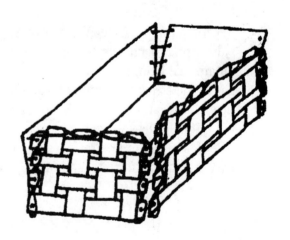

DIAGRAM #4

Torah > Moses and the Burning Bush

PAYING ATTENTION to

SIGNS and WONDERS

AWE and DISBELIEF

The BIG IDEA

MOSES AND THE BURNING BUSH
Grades 4–6

"Now Moses, tending the flock of his father-in-law Jethro, the priest of Midian, drove the flock into the wilderness, and came to Horeb, the mountain of God. An angel of Adonai appeared to him in a blazing fire out of a bush. He gazed, and there was a bush all aflame, yet the bush was not consumed. Moses said, 'I must turn aside to look at this marvelous sight; why doesn't the bush burn up?' When Adonai saw that he had turned aside to look, Adonai called to him out of the bush: 'Moses! Moses!' He answered, 'Hineini' " (Exodus 3:1–4).

Hineini most simply translated means "Here I am." Moses is physically present when God calls out to him. This particular phrase actually implies, "I am ready to do what You ask of me." When Moses responded without a hint of hesitation, he showed his willingness to take on the task God was about to ask of him, yet later his doubts emerged. Moses's path to leadership exemplifies the importance of recognizing the signs that lead us on the journey to accepting significant responsibility.

FEAR and DOUBT

CREATING a SACRED SPACE

INTEGRATING THE ARTS INTO JEWISH EDUCATION

SIGN, SIGNS, EVERYWHERE SIGNS
Grades 4–6

Inspiration
When the people of Israel crossed through the Red Sea, they witnessed a great miracle. Some say it was the greatest miracle that ever happened. On that day they saw a sight more awesome than all the visions of the prophets combined. The sea split and the waters stood like great walls, while Israel escaped to freedom on the distant shore. Awesome. But not for everyone. Two people, Reuven and Shimon, hurried along among the crowd crossing through the sea. They never once looked up. They noticed only that the ground under their feet was still a little muddy—like a beach at low tide.

"Yucch!" said Reuven. "There's mud all over this place!"

"Blecch!" said Shimon. "I have muck all over my feet!"

"This is terrible," answered Reuven. "When we were slaves in Egypt, we had to make bricks out of mud, just like this."

"Yeah," said Shimon. "There's no difference between being a slave in Egypt and being free here." And so it went, Reuven and Shimon whining and complaining all the way to freedom. For them there was no miracle. Only mud. Their eyes were closed. They might as well have been asleep (*Exodus Rabbah* 24:1, as interpreted by Lawrence Kushner in *The Book of Miracles*. New York: UAHC Press, 1987).

The wonder of the universe is hidden everywhere
If we only take the time to look around
The million tiny miracles that happen every moment
Are presents from the Holy One just waiting to be found
(Lyrics from "Round and Round" by Mah Tovu, 2001).

Many people wander through life on a straight and narrow path. However, those of us who are attentive to the signs and wonders that surround us can change the course of our lives. Paying attention to those signs may call us to accept more responsibility, but can also raise us to a level of greatness we never knew possible.

Objective
Students will understand the importance of recognizing the signs around them.
Students will create their own interpretive sign language to accompany the Sh'ma.

Materials
- Printed copies of the Sh'ma prayer in Hebrew, in transliteration, and in English translation

Process
1. Engage the students in a discussion about signs. Every day in our lives we see signs, both literal—for example, a stop sign or a school crossing sign—and metaphorical—like a rainbow or a sunset. Ask the students to share signs that they see every day. Then ask the students to share examples of signs they don't see every day. Identify which are literal and which are metaphorical, and classify the signs as important, less important, or not really important. Ask them to consider that there may be important signs that they pass by every day, but don't

recognize. What might these signs be trying to tell us? In what ways does Jewish life help us to stop and see these signs? Use the material in the "Big Idea" for this topic (page 65) and the "Inspiration" section (page 66) as background for this discussion.

2. Make sure that all students are familiar with the story of Moses and the burning bush. Use the skit for *parashat Sh'mot* from *Sedra Scenes,* or another simple retelling of the story (see the "Resources" section, page 68, for one suggestion). Emphasize the concept that the burning bush was a sign from God to Moses, a way of getting his attention and of conveying an important message. There are many times in the Torah where signs communicate the level of importance of a message. Ask:
 - Why did God use the burning bush as a sign to Moses?
 - Do you think this was an important sign?
 - Was Moses looking for a sign from God?
 - If Moses wasn't actively looking for a sign from God, how did he see it?
 - Can you think of other extraordinary signs God used to communicate to people in the Torah? What are they?
 - Can you think of any signs in your life that have helped you? What are they?

3. Ask students what they know about sign language. Sign language is a powerful method of communicating, and signing a prayer is another way to pray.

4. Give each student a copy of the Sh'ma in Hebrew, in transliteration, and in a word-by-word translation of the prayer.

5. Lead the class in singing the standard Sulzer melody of the Sh'ma. Sing each word slowly, with long held notes. Discuss the English translation of the prayer:
 - What do the six words mean?
 - Why is it an important Jewish prayer?
 - When is it said?
 - What happens when you sing it slowly?

6. Divide students into three groups. Each group will create a sign language to interpret the words of the Sh'ma. Give students enough time to learn their signs well enough to fluently sign the prayer.

7. Invite the groups to come back together. One at a time, have each group demonstrate their signed interpretation of the Sh'ma to the other students. Each group should demonstrate their signs for the Sh'ma twice, with the whole class singing the prayer.

8. Wrap up the activity by asking the students:
 - Which words did you find easy to sign and which words did you find hard to sign?
 - Which words had the most potential variations for signs?
 - Were there similarities between the signs that each group created for each word? Were there differences?

Helpful Hints
- Sing the Sh'ma slowly and with focus each time it is sung. Doing it slowly makes it easier for the students to do their signs to the words, and it slows them down so they show the proper respect for the prayer.

- Have the entire group sing each time a small group presents to help keep them focused and relieve stage fright.
- Extend this activity by discussing the story of Marissa Cohen, a profoundly deaf thirteen-year-old girl preparing to become a bat mitzvah and to lead the entire service in sign language. An article from The Jewish News Weekly of Northern California can be found at http://www.jewishsf.com (type "Marissa Cohen" in the search box). After reading the article with the students, discuss the challenges of leading a bar or bat mitzvah service using only sign language.

Resources

Beiner, Stan J. *Sedra Scenes: Skits for Every Torah Portion*. Rev. ed. Denver, CO: A.R.E., 2002.
A short, humorous skit for each of the fifty-four weekly Torah portions.

Ginsburgh, Judy Caplan. *Singing and Signing Hebrew Blessings and Songs*.
An instructional DVD featuring basic sign language tips and signs for eight easy blessings and songs, including the Sh'ma. Available from http://www.judymusic.com/.

Kushner, Lawrence. *The Book of Miracles: A Young Person's Guide to Jewish Spiritual Awareness*. New York: UAHC Press, 1987.
An introduction to spirituality that speaks directly to children's concrete way of thinking and their voracious curiosity.

Mah Tovu. *Turn It*. Compact disc. Denver, CO: Mah Tovu, 2001.
Includes the song "Round and Round." Available from http://www.mahtovu.com.

Segal, Lore, and Leonard Baskin. *The Book of Adam to Moses*. New York: Alfred A. Knopf, 1987.
A volume of stories from the Torah, Genesis to Deuteronomy, appropriate for older children.

STANDING ON HOLY GROUND
Grades 4–6

Note: This activity can easily be combined with the creative writing and visual arts lessons in this section (pages 71 and 73).

Inspiration
"So fearful was Moses at the sound of the voice from the burning bush, the Bible reports, that he buried his face in the folds of his cloak like a child who hopes that he can make the bogeyman go away by closing his eyes" (Jonathan Kirsch, *Moses: A Life.* New York: Ballantine Books, 1998, page 112).

Moses was overcome with disbelief when the burning bush was not consumed and when God's presence in the bush was revealed. Moses was unsure of his abilities and did not immediately think that he was up to the task God asked of him.

Objective
Students will act out the role of Moses, using simple props to imagine what it may have felt like to stand before the burning bush.

Materials
- Red, orange, and/or yellow scarves or blankets
- A pair of sandals
- Walking stick
- Robe (optional)

Process
1. Engage the students in a discussion about the story of Moses in the desert discovering the burning bush. Ask them to imagine what it would feel like to experience God's presence in that way. Would they feel scared, like Moses did at first? Shy? Shocked? Excited? Delighted? Explain that you are going to give them each a chance to imagine stepping onto the very holy ground on which Moses stood when he spoke to God through the burning bush.
2. Select one child to be the first "Moses." He/she can put on a robe, wear sandals, and carry a walking stick. Select several other students to be the bush—they will kneel down and cover up with the scarves/blankets. They can wave the material gently to make it appear like fire. You, as the facilitator, will speak the voice coming through the bush.
3. Have the other students sit in a semicircle on the floor so that they can closely watch what's going on.
4. Begin with some simple narration that Moses can act out. "One day, Moses was tending his flock of sheep in the wilderness when all of the sudden, he saw the strangest thing. He saw a bush burning and burning, but it didn't burn down. Moses, what do you think of that?" Allow him/her to respond.

5. Continue the narration. "Suddenly, God spoke to Moses through that burning bush. God said, 'Do not come closer. Take off your sandals, for the place on which you stand is holy ground.'" Moses then takes off his/her sandals.

6. Continue the narration. "Moses, I am the God of your fathers and mothers, the God of Abraham and Sarah, Isaac and Rebecca, Jacob, Rachel, and Leah. I have seen how the Israelites have become slaves and I want you to take them out of Egypt to the land of milk and honey." Pause. Ask Moses how he/she feels about this request. What is it like to stand on holy ground and hear God calling you?

7. Thank the student playing Moses and invite another student to take a turn. Once one or two students have tried being Moses, the students will understand the order of the role-play and it should be simple to guide them through.

8. When you are finished with the activity, take some time to debrief. Invite the students to share what were their most favorite and least favorite parts of being Moses. Compare the way different people reacted to being Moses.

Helpful Hints

There may be students who prefer to play the bush or watch the role-play rather than to participate as Moses. This is just fine. Some students will be quite able to internalize the experience by watching the others act it out, while other students need the hands-on opportunity of being Moses, taking off his sandals, and standing before the bush to really feel the moment. These are just examples of different learning styles in action.

Resources

Beiner, Stan J. *Sedra Scenes: Skits for Every Torah Portion.* Rev. ed. Denver, CO: A.R.E., 2002.
A short, humorous skit for each of the fifty-four weekly Torah portions.

Kirsch, Jonathan. *Moses: A Life.* New York: Ballantine Books, 1998.
A detailed examination of the wealth of secondary literature that has grown up around Moses, given the sparse details found in the Bible.

Sobel, Ileene Smith. *Moses and the Angels.* New York: Delacorte Press, 1999.
This look at Moses focuses on the many angels that accompanied him at all the crucial moments of his life.

Torah > Moses and the Burning Bush > Creative Writing

ME, GOD? YOU'RE SURE YOU WANT ME?
Grades 4–6

Note: This activity can easily be combined with the drama and visual arts lessons in this section (pages 69 and 73).

Inspiration

And Moses said to God: "Who am I, that I should go to Pharaoh, and that I should free the children of Israel from Egypt?" (Exodus 3:11).

But Moses spoke up and said, "What if they do not believe me, and do not listen to me, but say, 'God did not appear to you'?" (Exodus 4:1).

But Moses said to Adonai: "Please, God, I have never been a man of words, either in times past, or now that You have spoken to Your servant; I am slow of speech and slow of tongue" (Exodus 4:10).

But [Moses] said: "Please, God, make someone else Your agent" (Exodus 4:13).

Clearly, Moses was none too eager to accept the awesome responsibility that God was asking of him, trying several times to "get off the hook." He is filled with doubt, not only of his own abilities to carry out the mission that God is giving him, but most likely with doubts about the mission itself.

Objective
Students will express in writing what Moses was feeling when he observed the burning bush and his trepidation at the awesome responsibility God asked him to undertake.

Materials
- Writing paper
- Pens or pencils

Process
1. Engage the students in a discussion of Moses and the burning bush, making sure that everyone understands the basic story. For the purposes of this activity, emphasize the concepts of revelation (God appearing to Moses in the form of the burning bush) and Moses's readiness to serve God (exemplified by his response, "*Hineini*") juxtaposed against his self-doubt. Use the "Big Idea" for this topic (page 65) as well as the "Inspiration" section above as background.

2. Distribute paper and writing instruments.

3. "Set the scene" by reading aloud the following:

 Imagine that you are Moses. You were raised in Egypt as a prince in the palace, but knew secretly that you were an Israelite. For years you watched as your people were beaten and oppressed every day. One day, you became so angry watching an Egyptian taskmaster beat the Israelites that you attacked and killed him. Knowing that Pharaoh would be very angry, you ran and ran until you reached the city of Midian. Now you have completely left your life as an Egyptian prince, married a Midianite woman, and become a simple shepherd of your father-in-law's flock. God observes how you herd the sheep, treating each one as special to the whole. God knows that you have the special qualities needed to lead the Israelites from slavery to freedom.

Torah > Moses and the Burning Bush > Creative Writing

Midian, where you live, is far from the scenes of slavery and suffering in Egypt. It would take several days to make the journey. Your life is so quiet and calm that you have almost forgotten the horrible life your fellow Israelites are experiencing in Egypt—almost, but not quite.

On this day, you lead your flock to the edge of the wilderness. Suddenly you see a thornbush burst into flames, but the bush does not burn down—the fire continues to rage fiercely. You wonder to yourself, how is this happening? Out of the bush comes the voice of God: "Moses, Moses! Do not come any closer. Take your shoes off your feet, for you are standing on holy ground. Moses, Moses! I have seen the suffering of my people and I hear their cries. I am sending you back to Egypt, to Pharaoh, to bring the Israelites out of Egypt."

How do you feel when the bush bursts into flames? Can you believe that this is really God speaking to you? What should you say to God when God tells you you've been chosen to go to Pharaoh and demand the Israelites' freedom? Do you feel that you are qualified for this awesome task? What will your wife and family say when you tell them that a voice out of a bush assigned you to pack up and leave your quiet life in Midian and go back to Egypt? Be honest with God and say what you are feeling.

4. Give students ten minutes to write freely, as if they are Moses. Encourage them to write what they are feeling—their surprise, their fear, their doubts, their concerns about the weight of the responsibility that God has given them.

5. Ask for volunteers to share what they have written with the class. Identify the common themes that emerge, and discuss how they relate to the themes of the Moses story.

6. Create a bulletin board or other display of the students' writings to share with parents and the rest of the school. These "Moses Monologues" can also be compiled and sent home for reading at the Pesach seder. See the Introduction, page xxi, for several display ideas.

Helpful Hints

Suggest a variety of "voices" in which students can write: as if speaking directly to God, as if they are writing in a journal or diary, or as if they were telling the story to their children years later. Encourage them to be creative!

Resources

Beiner, Stan J. *Sedra Scenes: Skits for Every Torah Portion.* Rev. ed. Denver, CO: A.R.E., 2002.
A short, humorous skit for each of the fifty-four weekly Torah portions.

Chaiken, Miriam. *Exodus: Adapted from the Bible.* New York: Holiday House, 1987.
An age-appropriate telling of the story of Moses and the burning bush.

Gellman, Marc. *Does God Have a Big Toe? Stories About Stories in the Bible.* New York: Harper and Row, 1989.
A collection of short, funny midrashim *about well-known Bible stories.*

Meier, Rabbi Levi. *Moses: The Prince, the Prophet: His Life, Legend & Message for Our Lives.* Woodstock, VT: Jewish Lights, 1999.
A look at the struggles, failures, and triumphs that reveal the human side of Moses.

Torah > Moses and the Burning Bush > Visual Arts

A SPECIAL PLACE, A HOLY PLACE
Grades 4–6

Note: This activity can easily be combined with the drama and creative writing activities in this section (pages 69 and 71).

Inspiration
And God said, "Do not come closer. Remove your sandals from your feet, for the place on which you stand is holy ground" (Exodus 3:5).

God used the burning bush to call Moses's attention to a special place. According to Nahum Sarna in his book *Exploring Exodus,* "the holiness derives solely from the immediacy of the Divine Presence and does not outlast the experience." Therefore, this is a special place historically, but it is not a place that Jews visit specifically to re-create the feeling of experiencing God's presence.

In his book *Moses: The Prince, the Prophet*, Rabbi Levi Meier states that "just as God can appear at the summit of a mountain, God can make the Divine Presence known at the lowliest bush in the wilderness. God is everywhere and with everyone, protecting the mighty, the humble, the frail, and the vulnerable."

Objective
The students will create their own shadow puppets to use in a retelling of the story of Moses and the burning bush.

Materials
- Stiff poster board—one eight-and-one-half-by-eleven-inch piece per student
- Wire coat hanger, cut into twelve-inch straight sections—three per student
- Paper fasteners
- Scissors
- Hole punch
- Colored tissue paper
- Masking tape
- White bedsheet or frosted shower curtain
- Slide projector or bright flashlights

Process
1. Begin this activity with a discussion about special places in our lives. Ask the students:
 - Have you ever been in a place that felt special?
 - Do you have a special place where you feel closer to God?
 - What do you do there?
 - How can we create these special places and why would we want to do so?
2. Tell the story of Moses and the burning bush. Use the version suggested in the "Resources" section (page 75), or precede this activity with the drama or creative writing activity for this unit as a way of retelling the story. Be sure to emphasize the verse used in the "Inspiration" section above.

Torah > Moses and the Burning Bush > Visual Arts

3. Explain to the students that today they will create their our own "sacred space" through the use of shadow puppets. Shadow puppets are movable stick puppets that block the light shone on a screen, creating a distinction between dark and light. This created "environment" makes the shadow puppets come alive.

4. Give each student an eight-and-one-half-by-eleven-inch piece of poster board. On the board, have them outline the body of a puppet with a pencil. The outline (shape) of the puppet is very important because the audience will not be able to detect any details on the screen, just the shadow of the outline. The arms and legs should extend out from the body, and one arm and one leg should be drawn longer than usual, as they will be movable (see diagram #1, page 75). Have students cut out their puppet.

5. On one side of the puppet, cut off the longer arm at the elbow and the longer leg at the knee. Refasten these two portions with paper fasteners, creating a movable "joint" (see diagram #2, page 75).

6. Give each student three twelve-inch sections of wire coat hanger to use as rods. Instruct them to use masking tape to attach one rod to the body of the puppet and one rod each to the movable portion of the arm and foot (see diagram #2, page 75).

7. Hang a white sheet or frosted shower curtain in a doorway or from a clothesline strung across the room. Make sure there is room for the "puppeteers" on one side of the screen and the "audience" on the other.

8. Set up the slide projector on the puppeteer side of the screen, pointing toward the screen. Turn on the projector, turn off the lights, and have students hold their puppets in the projector's beam so that they cast a shadow on the screen. Show students how to use the metal rods to move the puppets and manipulate the arms and legs. Movement of the arms and legs will help the audience determine which character is speaking.

9. Use the puppets to tell the story of Moses and the burning bush, using either the script from *Sedra Scenes* (see the "Resources" section, page 75) or one that the students write themselves.

10. Ask the students:
 - How do light and dark transform the retelling of the story?
 - Were you able to expand and create your own *midrashim*?
 - Do you feel that you were able to create a sacred space for the retelling of this story?
 - How did the light vs. dark help or hinder this process?

Helpful Hints
- Try some variations on the cutout puppets to add interest:
 - Use a hole punch to add surface decoration—the light through the holes will create patterns on the screen.
 - Tape colored tissue paper behind cut-out shapes in the puppet to create color when the light shines through.
- Students can create a burning bush, a mountain, sheep, trees, etc., to assist in the retelling of this story.

- Shadow forms can be made from anything that will cast a shadow on a screen. Shadow forms placed close to the screen will create sharp shadows. If the form is moved away from the screen it will grow in size. Immobile objects such as scenery can be set behind the screen or hung from the top. Weeds and plants can be used for interesting effects.

Resources

Beiner, Stan J. *Sedra Scenes: Skits for Every Torah Portion.* Rev. ed. Denver, CO: A.R.E., 2002.
A short, humorous skit for each of the fifty-four weekly Torah portions.

Klagsbrun, Francine. *The Story of Moses.* New York: Franklin Watts, 1968.
A clear and age-appropriate retelling of the story of Moses.

Meier, Rabbi Levi. *Moses: The Prince, the Prophet.* Woodstock, VT: Jewish Lights, 1999.
A look at the struggles, failures, and triumphs that reveal the human side of Moses.

Sarna, Nachum. *Exploring Exodus: The Origins of Biblical Israel.* New York: Schocken, 1996.
A thorough examination of the Exodus narrative.

Silver, Daniel Jeremy. *Images of Moses.* New York: Basic Books, 1982.
An examination of the historical, literary, and artistic treatments of Moses.

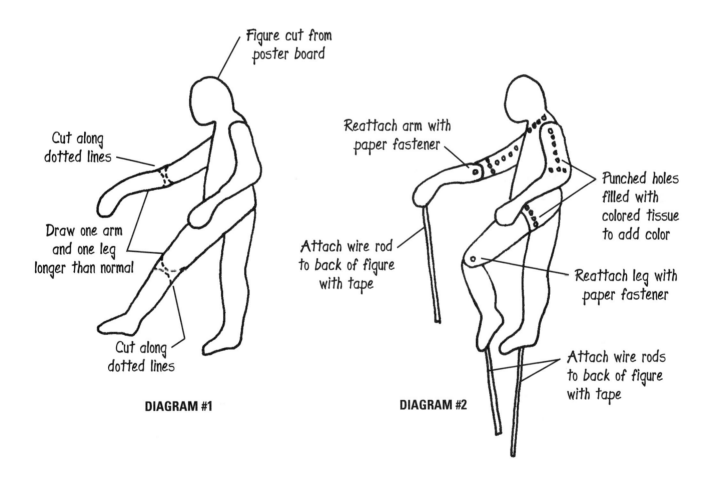

Torah > Jacob and Esau

CONFLICT and HARMONY

HONESTY
communication

The BIG IDEA

JACOB AND ESAU
Family Education

*"Two nations are in your womb,
Two separate peoples shall issue from your body;
One people shall be mightier than the other,
And the older shall serve the younger"*
(Genesis 25:23).

God warned Rebecca that the battle that was taking place in her womb was a sign of what was to come. The lifelong struggle between Jacob and Esau is a story of familial opposition and deception. In the end, the cycle of sibling rivalry that lingers for decades must be overcome in the name of family and continuity.

RESPONSIBILITY
family DYNAMICS

honoring DIFFERENCES
common THREADS

INTEGRATING THE ARTS INTO JEWISH EDUCATION

Torah > Jacob and Esau > Music

DISSONANCE AND ACCORD
Family Education

Inspiration
"Behold, how good and pleasant it is for brothers to dwell together in harmony" (Psalms 133:1).

Although we often face strife and conflict in our lives, Judaism teaches us to strive toward harmony and conflict resolution, especially between family members.

Objective
Participants will experience feelings of dissonance/discord and harmony/accord, and relate those feelings to the story of the relationship between Jacob and Esau.

Materials
None required

Process
1. Engage the students in a discussion of the story of Jacob and Esau. Elicit from them the key concepts that are included in the "Big Idea" (see page 77): sibling rivalry, familial opposition, deception, and overcoming conflict for the sake of family and continuity. Key words to focus on include dissonance, discord, conflict, rivalry, harmony, accord, and resolution. Some guiding questions might include:

 - Were Jacob and Esau very different from each other? If so, how? Are you like or different from your sibling(s)? Is it necessary to be like your sibling(s)?
 - Children: Do you ever feel that your sibling(s) get more than you, that your parents are unfair and show favoritism? How does that make you feel? Do you ever feel as though you are favored by your parents? How does that make you feel?
 - Parents: Do you ever feel that your children favor one parent over the other? How does that make you feel?
 - What were the events that deepened the conflict between Jacob and Esau? How did these events affect Jacob's future? Esau's? Did the brothers ever reconcile their differences?

2. Ask everyone to silently choose a song they can sing. It can be a very simple song, such as "Twinkle, Twinkle, Little Star" or "Row, Row, Row Your Boat." Instruct participants to keep the song title to themselves.

3. Instruct participants to stand in a circle, shoulder to shoulder. At the teacher's signal, participants should begin to sing their chosen song at the same time. Instruct them to sing loud enough so that each voice is heard and tell them to simultaneously try to listen to the singing of everyone else in order to hear what songs they are singing.

4. After the singing, discuss the experience of dissonance/discord. Ask:
 - How many different songs could you hear?
 - What was it like to sing your song while others sang different songs?

- Were you able to concentrate?
- Was it hard to focus on your own song?
- Were you able to hear other lyrics being sung while you were singing your own song?
- Did you feel like part of the group, or did you feel separate?
- Was the experience positive or negative?
- What does discord mean to you?

5. Now choose a song that everyone in the group knows. Lead the group in singing the same song in unison, with participants adding harmony if possible.

6. Discuss the experience of accord/harmony. Ask:
 - What was it like to sing the same song as everyone else in the group?
 - How was it different from the prior experience when everyone sang their own song at the same time?
 - What feelings did you experience after everyone sang the same song in unison?
 - Was it easier to concentrate?

7. Talk about both situations:
 - What were your feelings after each experience?
 - Which setting felt more productive and positive?
 - Which was a more pleasant experience? A more frustrating experience?
 - If you were asked to repeat the first exercise (everyone singing their own song), is there anything you could suggest to everyone in the group so that the experience might be less stressful?
 - When people have different opinions or lifestyles, how is it possible for them to live in the same house? Live and work in the same community? Live and work in the same country?
 - How has this exercise influenced your opinion about the relationship between Jacob and Esau? Does hearing how unity and togetherness can come out of disharmony and confusion between brothers give you hope for difficult relationships in your own life? What can you do in the future to ensure that harmony takes precedence over discord?

Helpful Hints

- Explore other biblical brothers during this discussion: Cain and Abel, Joseph and his brothers, Isaac and Ishmael, Aaron and Moses.
- Expand this activity by listening to the song "Brother on Brother" by Joel Sussman (from the recording *Sounds of Creation: Genesis in Song*). Discuss the lyrics of the song and how they shed light on the story of Jacob and Esau, or how they pertain to you as a sibling.

Resources

Freedman, Florence. *Brothers: A Hebrew Legend*. New York: Harper & Row, 1985.
A children's book about a unique relationship between two brothers.

Sounds of Creation: Genesis in Song. Various artists; produced by Sounds Write Productions
A collection of contemporary songs, one to accompany each weekly Torah portion in Genesis. Includes the song "Brother on Brother" by Joel Sussman. Available at www.soundswrite.com or 1-800-9SOUND9.

Torah > Jacob and Esau > Drama

JACOB AND ESAU: THE RIVALS SPEAK
Family Education

Inspiration
"Now Esau harbored a grudge against Jacob because of the blessing which his father had given him, and Esau said to himself, 'Let but the mourning period of my father come, and I will kill my brother Jacob.' When the words of her older son Esau were reported to Rebecca, she sent for her younger son Jacob and said to him, 'Your brother Esau is consoling himself by planning to kill you. Now, my son, listen to me. Flee at once to Haran, to my brother Laban. Stay with him a while, until your brother's fury subsides—until your brother's anger against you subsides—and he forgets what you have done to him. Then I will fetch you from there. Let me not lose you both in one day!'" (Genesis 27:41–45)

Jealousy and resentment are not typically the characteristics we like to mention when referring to our patriarchs. However, behind the flaws in Jacob's character this narrative presents a story that many people can relate to: children searching for the approval of their parents, and brothers at odds with each other.

Objective
Participants will role-play their own interpretation of the dynamics between Esau and Jacob, imagining what the brothers' "inner voices" might say to each other.

Materials
- Copies of texts relating the story of Jacob and Esau (Genesis 25:19–34 and Genesis 27:1–28:9)
- Paper and pencils
- Four chairs

Process
1. Students and parents should begin by sitting together and reading Genesis 25:19–34 and Genesis 27:1–28:9. For younger children, read a storybook on Jacob and Esau (see the "Resources" section, page 81, for one suggestion).

2. On a piece of paper, each family should make two columns: on one side a list of the physical and emotional traits that apply to Jacob, and on the other side the physical and emotional traits that apply to Esau. Come back together as a large group to share findings. Raise the question of how siblings can be so very different even though they have the same parents.

3. After sharing the various differences between Jacob and Esau, family members can share ways in which they are different from their own siblings. Ask: How many times have you wanted to act differently toward your sibling, but could not seem to break the cycle that you were in?

4. Explain that the texts that we have just read and discussed show how tragic the effects of sibling rivalry can be. Today, we are going to try an activity to discover what Jacob and Esau might have really liked to say to each other. Perhaps if they were able to communicate their true inner feelings, they might have been able to change their relationship.

5. Ask the questions:
 - How many times in your lives have you wished you could say something, but other words came out of your mouth?
 - Was it out of fear? Confusion? Anger?

 Ask participants for examples of times in their lives when they would have liked to communicate with someone differently than they actually did. It might be helpful to come up with a personal example before beginning this part of the discussion.

6. Explain that in today's activity, participants will be filling in the "blank spaces" from the conversations between Jacob and Esau. Invite up four people to play the various roles. You may want to encourage parent/child sets to participate together.

7. Set up four chairs so that two are facing toward each other, in a couples-therapy style. On the outside of each of those chairs, place an additional chair, facing straight out toward the group. In the outer chairs, two people playing Jacob and Esau's "outer voices" will sit facing out. In the inner chairs, two people playing Jacob and Esau's "inner voices" will sit, facing each other. Give participants an example of a outer voice–inner voice dialogue. For example, Outer Voice: "I'm not feeling so good." Inner Voice: "You made me so mad yesterday!"

8. Hand the actors the script "Jacob and Esau: The Rivals Speak" (page 82). Point out that there are no set lines for the inner voices. Rather, encourage the participants to say what they think Jacob or Esau is really feeling at the moment.

9. Following the reading, thank the participants and take some time for audience members to share their reactions. If you have time, repeat the script with two or three other sets of people. It will be surprising to see the way responses change, based on who is playing the characters.

10. You may wish to close the activity by having participants do some extemporaneous writing concerning what they discovered about sibling rivalry during today's program: Jacob and Esau's or their own experiences with siblings. Discuss the importance of sharing true feelings.

Helpful Hints

This activity will work best if the first participants are people who you know are generally emotionally open and willing to share. You may even want to ask them in advance if they would be willing to go first.

Resources

Auld, Mary. *Jacob and Esau*. New York: Franklin Watts, 2000.
 A children's book about Jacob and Esau.

Faber, Adele, and Elaine Mazlish. *Siblings Without Rivalry: How to Help Your Children Live Together So You Can Live Too*. New York: W. W. Norton, 1987.
 Guidelines for managing sibling rivalry with intelligence and compassion.

Harber, Frances. *The Brother's Promise*. Morton Grove, IL: Albert Whitman, 1998.
 A children's book about a unique relationship between two brothers.

Torah > Jacob and Esau > Drama

JACOB AND ESAU: THE RIVALS SPEAK

Jacob:	What a great stew I've made. Sure smells good!
Esau:	I am soooo hungry! I've just been out hunting. Give me some of that stew!
Jacob's Inner Voice:	(Responds)
Jacob:	First, sell me your birthright.
Esau's Inner Voice:	(Responds)
Esau:	I'm at the point of death, so what good is my birthright?
Jacob's Inner Voice:	(Responds)
Jacob:	You must swear to me.
Esau's Inner Voice:	(Responds)
Esau:	Okay, okay, I swear.
Jacob's Inner Voice:	(Responds)
Jacob:	Here's your stew.
Esau:	Thanks, thanks . . . uh, see you later.
Esau's Inner Voice:	(Responds)
Jacob:	Years later, my mother helped me to make sure I would get my father's blessing. One day when Esau was out hunting, my mother took animal skins and helped me to create a disguise so Father would think I was Esau. I went to him, told him I was Esau, and sure enough, he gave me his blessing. When Esau found out, he was so angry! I had to run away from home, afraid he might kill me. If I had stayed there, I wonder what he might have said to me?
Esau's Inner Voice:	(Responds)
Jacob:	I know it must have seemed like a terrible trick. But I had my reasons for doing it. If I could have explained it to Esau, this is what I would have said.
Jacob's Inner Voice:	(Responds)

OPEN IT UP!

Torah > Jacob and Esau > Creative Writing

ALL FOR A POT OF LENTIL SOUP
Family Education

Inspiration
Rebecca favored Jacob, not only because she knew that Esau possessed shortcomings like her brother Laban, but also because she wished to protect her husband, Isaac, from making a mistake by giving Esau and not Jacob his blessing. Rebecca's favoritism was a form of saving Isaac from his own stupidity and foolish decisions (Harvey J. Fields, *A Torah Commentary for Our Times: Volume I: Genesis,* page 66).

Within whom lies the responsibility? Who is to blame when such a fierce rivalry exists between two siblings? Do we look to the parents, or should the siblings take responsibility for their actions?

Objective
Families will create their own midrash about Isaac and Rebecca's family dynamic in biblical times. This family education activity should lead to provocative discussion and debate about one of our most controversial stories focusing on family ethics.

Materials
- Writing paper
- Pens or pencils

Process
1. Engage the participants in a discussion of the story of Jacob and Esau, making sure that they have a general working knowledge of the story. Emphasize the concept of sibling rivalry and its importance in the lives of these two brothers, as well as issues of family dynamics and the difficulties that often arise between parents and siblings. Use the "Big Idea" (page 77) as well as the "Inspiration" section above as background.

2. Distribute paper and writing instruments.

3. "Set the scene" by reading aloud the following:

 It is hard to accept that two brothers could be so different. Esau loves the outdoors—hunting and trapping—and Jacob likes staying inside. Esau comes in from the hunt so hungry, and the whole house smells fantastic from the lentil soup that Jacob has been cooking. Esau wants some lentil soup and he wants it *immediately*! But Jacob is willing to give it to him only if a trade takes place: Jacob will give Esau a big bowl of soup in exchange for the family birthright that Esau owns as the twin who came out of their mother's womb first.

 Rebecca, their mother, favors Jacob and has repeatedly told him how she wishes he could have the birthright. Isaac, their father, would be extremely upset if he were to know that Rebecca has pitted her two sons against each other.

4. In this family writing project, each member of the family will take on a different persona:
 - Moms and grandmothers will write as Rebecca.
 - Dads and grandfathers will write as Isaac.
 - Children will be divided into two groups, one writing as Jacob and the other as Esau.

Have participants use the following questions as guidelines for their writing:

- **Questions for Rebecca:** Why do you feel so strongly that Jacob should have that birthright? What risks do you think he should take to get it? How will you deal with Isaac once he realizes what you and Jacob have done?

- **Questions for Isaac:** You've just found out that the birthright ownership has been switched. How do you feel? Do you blame Rebecca, Jacob, or both?

- **Questions for Esau:** You've just realized that, although the lentil soup was delicious and you have a full belly, you've been tricked. You no longer own the family birthright, and you won't inherit the land and cattle that will now go to your brother. What are you feeling?

- **Questions for Jacob:** You're washing out the pots from the lentil soup and are so happy that you now own the family birthright and will inherit the land and cattle. But your thoughts keep going back and forth about what you have done. Your mom told you that the birthright was important to have at any cost, but was she right? Can you live the rest of your life with your brother as your enemy, knowing that you tricked him?

Participants should spend ten minutes writing in character. Encourage a free flow of ideas and thoughts. Those too young to write can dictate to an adult.

5. Encourage families to share their writings together. Ask for volunteer families to share as a group, or choose one member from each family, creating a "new" biblical family. If time allows, families can combine their writings and create their own dialogue to share with other participants.

Helpful Hints

Format the writing pieces for display by creating a montage on one piece of foam board per family. Make a display for public viewing in the congregation or school lobby.

Resources

Cohen, Norman J. *Self, Struggle, and Change: Family Conflict Stories in Genesis and Their Healing Insights for Our Lives.* Woodstock, VT: Jewish Lights, 1995.
 Engaging and insightful midrashim on the stories of key families from the book of Genesis, with an eye toward insight into contemporary family relationships.

Danan, Julie Hilton. *The Jewish Parent's Almanac.* Northvale, NJ: Jason Aronson, 1993.
 A comprehensive guide to Jewish parenting, filled with practical ideas, wise advice, and excellent resources.

Fields, Harvey J. *A Torah Commentary for Our Times: Volume I: Genesis.* New York: UAHC Press, 1990.
 A study of the weekly Torah portion, examining the insights of ancient, medieval, and modern commentators.

Rosenblatt, Naomi H. *Wrestling with Angels: What the First Family of Genesis Teaches Us About Our Spiritual Identity, Sexuality, and Personal Relationships.* New York: Delacorte Press, 1995.
 Examines Genesis as a series of lessons about the nature of human character, including such themes as guilt, sibling rivalry, sexual temptation, midlife crisis, blended families, and surrogate parentage.

Torah > Jacob and Esau > Visual Arts

HONORING DIFFERENCES: MAKING A FAMILY TREE
Family Education

Inspiration
The differences between Jacob and Esau were tangible far before they were ever born. A famous midrash on Genesis 25:22 alludes to the strong differences between the two boys, still in utero:

> *"'And the children struggled together within her.' They sought to run within her. When Rebecca passed synagogues or houses of study, Jacob struggled to get out, and when she passed buildings that housed idolatry, Esau struggled in his eagerness to get out"* (Genesis Rabbah 63:6).

The struggle that Jacob and Esau faced in utero continued to haunt them throughout their lives. Despite their vastly different goals and paths both Jacob and Esau had the desire to please their parents. Even though we human beings are inherently unique and different from one another, common threads bind us together in a variety of ways.

Objective
Participants will create a visual representation of their family tree that will illustrate both the differences among family members and the common threads that bind them together.

Materials
- Four-ply rope—one five-foot section per family
- A variety of straight materials such as string, ribbon, lace, colored yarn, aluminum foil, leather strips. Select materials that can be bound, wrapped, or tied around the four-ply rope. Choose materials that have a variety of color, texture, and thickness.
- Writing paper
- Pens and pencils
- Scissors

Process
1. Engage the group in a short discussion about the state of families today. Traditionally, a family was defined as a group of individuals who can trace their ancestry back to one common individual. Today, the definition of a family is vastly different. Ask participants to share their family makeup if they feel comfortable doing so. Families today consist of blood relatives, adopted children, single parents, grandparents, same-sex parents, and many other combinations. Familial bonds are often strong, but families don't always get along. Just look at the first families in the world, from the Torah—we see that disagreements among family members have been going on for thousands of years. Ask participants to share examples of family conflict within Torah stories. Ask participants to share examples of families getting along. In each instance, the people in the stories have certain characteristics in common with one another, as well as certain characteristics that are different. Weaving those characteristics together is what makes each family unique.

2. This Family Tree Sculpture project is an opportunity for participants to create a visual representation of their families, in both a linear and a vertical fashion. Discuss with participants the distinction between these two forms of representation: linear (the sense of the passage of time, with one generation following another, parents raising children, etc.) and vertical (each generation "standing on the shoulders" of those that came before, children inheriting values from parents, etc.). Brainstorm with participants ideas for ways of representing both the linear and the vertical in their family tree sculpture.

3. Give each family a piece of paper and a pencil, and ask them to create a list of family members. They can choose to concentrate on their immediate family or trace their roots back a few generations. Each family's list should include five to eight names.

4. Ask participants to think of a color, texture, or shape that best describes each person on their family list. Each family member will be visually represented by a piece of string, ribbon, lace, or other material that will be attached to the sculpture. Encourage participants to think outside of "traditional" descriptions for people, and experiment with other forms of description using artistic materials. These materials will be attached to the sculpture using a method called wrapping—participants will tie, twist, and attach this material (or a variety of materials) to the central core of the sculpture. Each creation should represent how and what participants feel about each family member.

5. Hand each family a five foot section of four-ply rope. Lay the rope on the table—it will form the "trunk" of the tree (see diagram #1, page 87). Choose a family member from the list, and begin wrapping the rope with the chosen materials. Encourage participants to ask themselves if they fully represented that person with artistic materials. Did their ideas change as they worked? Each member in the family can create his or her own visual representation for another family member, or families can work on each visual representation together. Make sure that throughout the process family members share their ideas and reasons why each "tie" to the "trunk" looks like it does (see diagram #2, page 87).

6. Once each family member has a "tie" to the rope "trunk," create "roots" by separating the strands of rope at the bottom of the tree. Wrap them with your choice of colors and textures (see diagram #3, page 87).

7. Each family should present their completed family tree sculpture and discuss the similarities and differences between their family members and why they chose the particular materials to represent them.

8. Close the lesson by pointing out similarities as well as differences within each family tree. Why is it important not only to recognize the differences, but to look for the similarities? Ask participants to discuss and visualize what they think a family tree with Isaac, Rebecca, Jacob and Esau's family would look like. If there is time, create one as a group.

Helpful Hints
- Before handing out the rope, tie a loop at one end so that the completed family tree sculpture can be hung for display.
- Discussion is an important part of the process in this creation. You can continue this exploration by discussing how families honor the differences among family members.

Resources

Bell, Roselyn, ed. *The Hadassah Magazine Jewish Parenting Book.* New York: Free Press, 1989. *A collection of essays formerly printed in* Hadassah *magazine. See in particular the articles "The Blended Family" by Harlene Appelman and "The Single Parent and the Community" by Sheila Peltz Weinberg.*

My Jewish Learning.com—History and Community: Contemporary Jewish Family
http://www.myjewishlearning.com/history_community/Jewish_World_Today/JewishFamily.htm
An overview of the American Jewish family today.

DIAGRAM #1 **DIAGRAM #2** **DIAGRAM #3**

PART III
MITZVOT AND *MIDDOT*

Mitzvot and Middot > Tza'ar Ba'alay Chayim

no MATTER how SMALL

proper CARE for your ANIMALS

The BIG IDEA

TZA'AR BA'ALAY CHAYIM: KINDNESS TO ANIMALS
Grades K–1

"The righteous person regards the life of his beast"
(Proverbs 12:10).

Perhaps this statement from Proverbs best summarizes the Jewish attitude toward the treatment of animals. Jewish tradition places great emphasis on treating animals with compassion and mercy, and obligates human beings to refrain from *tza'ar ba'alay chayim,* "causing pain to any living creature." Unnecessary destruction of animals is forbidden, as the Talmud teaches: "Of all that God created in the world, God did not create a single thing that is useless" (*Shabbat* 77b).

to CARE and PROTECT

to CAUSE no SUFFERING

INTEGRATING THE ARTS INTO JEWISH EDUCATION

HEY, LITTLE ANT!
Grades K–1

Note: This music activity for *tza'ar ba'alay chayim* can easily be integrated with the creative writing activity for the same topic on page 98.

Inspiration
"Even those things that you may hold superfluous in the world, such as fleas, gnats, and flies, even they are part of the creation of the world. God carries out God's purpose through everything, even through a snake, even through a gnat, even through a frog" (*Genesis Rabbah* 10:7).

"Compassion should be extended to all creatures, neither destroying nor despising any of them. For God's wisdom is extended to all created things: minerals, plants, animals and humans" (Moses Cordovero, *The Palm Tree of Deborah*).

Throughout our history, Jews have understood the notion of refraining from causing pain to any living thing. No matter how small or seemingly insignificant a creature might appear to be, it is our responsibility to take care of all God's creatures on Earth.

Objective
Children will verbalize their understanding of the responsibility Jews have to respect and care for all other creatures after listening to the song "Hey, Little Ant."

Materials
- CD, cassette, or MP3 recording of the song "Hey, Little Ant" (the melody is the same as the children's song "Five Little Ducks Went Out to Play")
- Copies of lyrics to the song "Hey, Little Ant" (see page 95)
- Optional: A copy of the picture book *Hey, Little Ant*

Process
1. Engage the students in a discussion about *tza'ar ba'alay chayim*, the mitzvah of caring for all creatures with respect and not causing them harm. Use the material found in the "Big Idea" (page 87) as well as the "Inspiration" section above. Two excellent Web sites are also listed in the "Resources" section on page 93.

2. Play the recording of "Hey, Little Ant" for the students. Alternatively, the teacher can read the lyrics aloud to the students.

3. Divide the group in half. Hand out the song lyrics to all students. Perform the song with one group acting as the kid (with big voices) and the other group acting as the ant (with squeaky voices).

4. Ask the following:
 - How did it feel to be the ant?
 - How did it feel to be the kid?
 - Which would you rather be? Why?
 - Have you ever felt like the ant?

- Have you ever felt like the kid?
- What examples in everyday life are similar to the kid and the ant?
- What would you do at the end of the song if you were the kid?
- Why is it important to care for animals and other creatures?
- Do the strong have an obligation to take care of the weak?

5. Ask the groups to switch roles (so that each group has a chance to be both the kid and the ant) and perform the song again. Ask the same questions as before. How was it different being the ant? The kid?

6. Wrap up by emphasizing that caring for all creatures is a specifically Jewish virtue and that *tza'ar ba'alay chayim* is a mitzvah, a commandment from God. Share with them the quote from *Baba Batra* 11a: If you destroy a single life, it is if you have destroyed the entire world; but if you save a single life, it is as if you have saved the entire world.

If students are not able to read, follow the same process as above without passing out the lyrics to the song. Have them play the role of their character (ant or kid) while you play the recording or read the lyrics to the students. Students should stand when their character is speaking (or singing) and sit when their character is not speaking (or singing).

Helpful Hints

- There is an impulse within some children to want to squish the ant at the end of the story. Until empathy for the situation of the ant is felt, the insignificant size of the ant makes it tough for some children to resist. Helping them feel empathy for smaller and weaker people or creatures teaches them to be more compassionate. According to clinical psychologist and child behavior expert Dr. Lawrence Kutner, "By the time a child is about four years old he begins to associate his emotions with the feelings of others. When a child is about five, he can learn about empathy by talking about hypothetical problems ('How would you feel if someone took a toy away from you? How do you think your friend feels when you take a toy away from him?') By the time a child is eight, he can grapple with more complex moral decisions in which he must realize that someone else's feelings may be different from his own" (Lawrence Kutner, Ph.D., "How Children Develop Empathy").

- Extend this activity by bringing an ant farm display into the classroom. As a class, observe the ants' complex and sophisticated society and discuss how they work together.

- Listen to other songs about beasts and insects. One example is "I Like Ants" by John Farrell on his recording *How About You?* available at www.johnfarrell.net.

Resources

Feinberg, Miriam P., and Rena Rotenberg. *Lively Legends—Jewish Values: An Early Childhood Teaching Guide.* Denver, CO: A.R.E., 1993.
 A collection of activities for young children built around Jewish legends, including two that deal with the value of treating animals kindly.

Frequently Asked Questions about Judaism and Animal Issues
http://www.jewishveg.com/schwartz/faq_animals.html
 Excellent background on the Jewish viewpoint of animal issues, a meat vs. vegetarian diet, animal experimentation, and the wearing of fur.

Hoose, Phillip, and Hannah Hoose. *Hey, Little Ant.* Berkeley, CA: Tricycle Press, 1999.
> *This children's book, based on the song, asks the question: To squish, or not to squish.*

Hoose, Phillip, and Hannah Hoose. *Hey, Little Ant.* Audiocassette. Portland, ME: Precious Pie Music, 1992.
> *The song "Hey, Little Ant" is available on a cassette of the same name from the artist at http://www.heylittleant.com. It is also available as a single download for $0.99 from the Apple Music Store, which can be accessed only using iTunes software.*

How Children Develop Empathy
http://www.drkutner.com/parenting/articles/develop_empathy.html
> *An article by Dr. Lawrence Kutner, a nationally known clinical psychologist, that helps parents and professionals understand children's behavior.*

Judaism 101: Treatment of Animals
http://www.jewfaq.org/animals.htm
> *An interesting explanation of the Jewish laws prohibiting cruelty to animals, as well as viewpoints on Jews owning pets.*

HEY, LITTLE ANT
Words and music by Phil and Hannah Hoose

Hey, Little Ant, down in that crack
Can you hear me? Can you talk back?
See my shoe? Can you see that?
Oh now it's gonna squish you flat.

(Gasp)! Please oh please do not squish me
Spare my life and let me be
I'm on my way home with a crumb of pie
Please don't squish me, don't make me die.

Oh anyone knows that an ant can't feel,
You're so tiny you don't seem real.
I'm so big and you're so small
I don't think it'll hurt at all.

Yeah, well you are a giant and giants can't
Know how it feels to be an ant.
Come down close and you will see
That you are quite a lot like me.

Are you crazy? Me? Like you?
Why I've got a home and a family too.
You're just a speck that runs around.
No one'll care if my foot comes down.

Oh, big friend, you are so wrong
My nest mates need me because I am strong.
I dig our nest, feed baby ants too,
I must not die beneath your shoe.

Yeah, well my mother says that ants are rude.
They carry off our picnic food.
They steal our chips and our breadcrumbs too.
Who cares if I kill a crook like you?

Hey I'm not a crook, kid, read my lips.
Sometimes ants need crumbs and chips.
Why, one of your chips feeds my whole town
You must not let your foot come down.

Yeah, but all my friends squish ants each day
Squishing ants is a game we play.
They're looking at us, they're listening too.
They all say—I should squish you!

Well I can see you're big and strong
Decide for yourself what's right and wrong.
But if you were me and I were you
What would you want me to do?

Should the ant get squished?
Should the ant go free?
It's up to the kid, not up to me.
So we'll leave that kid with the raised-up shoe
What do you think that kid should do?

Mitzvot and Middot > Tza'a Ba'alay Chayim > Drama

PET PLAY
Grades K–1

Inspiration
"You must not eat your own meal until you have seen to it that all of your animals are properly fed" (Berachot 40a).

"No person may buy a beast, an animal, or a bird until that person has provided food for it" (Yevamot 15:3).

These instructions from the Talmud communicate the level of importance of taking care of our animals. When we take on the responsibility to care for pets that are unable to take care of themselves, it is our obligation to feed and care for them, even before we do so for ourselves. The Talmud presumes that animals suffer more from hunger than humans do, as they do not know the next time they will receive food. The principal of properly caring for animals is so important that the Talmud addresses it numerous times.

Objective
Students will take turns playing both animals and pet owners to demonstrate how animals communicate and how pet owners can respond to their wishes and needs in order to take care of the animals.

Materials
- Simple animal costumes (dog and cat ears, noses, whiskers, tails, etc.)
- Pet food bowls
- Pitcher of water
- Balls, other pet toys

Process
1. Begin by engaging the students in a conversation about their pets. Ask:
 - What kinds of pets do you have?
 - What do you do to help take care of them?
 - How can you tell what your pet wants/needs?

 Talk about the different levels of care required for a dog vs. a goldfish, for example. See the "Helpful Hints" section, page 97, regarding students who don't have pets.

2. Introduce to students the *middah* (Jewish virtue) of *tza'ar ba'alay chayim,* not causing harm to animals. Be sure to highlight the Talmudic teachings found in the "Big Idea" (page 91) and in the "Inspiration" section above. Be sure that all students have a basic understanding of this *middah*.

3. Explain to students that you are going to do a short drama activity in which they will get to show the class the kinds of things they do to take care of their pet. In each role-play, one student will play the pet and another student will play the owner.

4. Explain that the students playing the pets are not allowed to speak, although they are allowed to make appropriate animal sounds. Tell the students playing the pets that they need to show that they want something from their owners: a walk outside, more food or water, or just some attention. The students playing the owners will try to figure out what their pets want. They can use all of the props (toys, ball, food bowl, etc.) in the role-play. When the "owners" figure out what their "pets" want, the "pets" can then say, "Yes!"

5. Invite two students up at a time and let them give it a try. Each role-play should only take a minute or two. If time allows, let every student try being both a pet and an owner.

6. A certain amount of laughter and silliness is inherent in this activity, but you can draw out the serious points as well. To wrap up, talk about what it felt like to be an animal trying to communicate. Ask:
 - How did it feel to be a pet owner trying to understand what it was that your pet wanted?
 - Why is it important to pay attention to your animals?
 - Why do you think Judaism goes to such great lengths to impress upon us the importance of taking care of our animals?

For additional background, see the "Inspiration" sections in the music, creative writing, and visual arts activities for this topic (pages 92, 98, and 100).

7. A follow-up activity may include each student drawing (or bringing in pictures of) animals and writing on construction paper what they will do to show kindness to animals, exemplifying the virtue of *tza'ar ba'alay chayim*.

Helpful Hints

- Many students will have some level of responsibility for taking care of the animals in their home. Students at this age generally have the ability to feed and give water to their pets, to walk and play with them, and to show them love and affection. This role-play will help demonstrate responsible ways to care for pets.

- Of course, not every student will have a pet. You can expand the range of the role-playing to include a farmer taking care of his farm animals, a zookeeper caring for animals at the zoo, or even Noah caring for the animals in the Ark.

Resources

Bogot, Howard, and Mary K. Bogot. *Seven Animal Stories for Children.* New York: Pitspopany Press, 1997.
 Seven stories that teach young children basic values such as respect, honesty, modesty, gratitude, and friendship.

CHAI—Concern for Helping Animals in Israel—Home Page
http://www.chai-online.org
 CHAI is a nonprofit organization formed in the United States in 1984 to improve the condition and treatment of Israel's animals. See in particular the section called "Judaism and Animals."

Mitzvot and Middot > Tza'ar Ba'alay Chayim > Creative Writing

THE ANTS GO MARCHING ONE BY ONE
Grades K–1

Note: This creative writing activity for *tza'ar ba'alay chayim* can easily be integrated with the music activity for the same topic on page 92.

Inspiration
"God tested Moses through sheep. When Moses tended the flock of his father-in-law, Jethro, one young kid ran away. Moses followed it until it reached a shaded area where it found a pool of water. There it stopped to drink. Moses approached it and said, 'I did not know you ran away because you were thirsty. Now you must be weary.' So he placed the kid on his shoulders and carried it back. Then God said, 'Because you showed mercy in leading the flock of a mortal, you will surely show mercy when tending my flock, Israel' " (*Exodus Rabbah* 2:2).

Judaism has always recognized a link between how people treat animals and how they treat human beings. Moses, one of our greatest leaders, was exemplary in fulfilling the mitzvah of *tza'ar ba'alay chayim*, not harming animals. God placed ultimate responsibility for the future of the Jewish people in Moses's hands because of his genuine compassion for the animals in his care. Just as Moses exemplified compassion toward those in his care, it is our obligation to care for and protect all animals.

Objective
The students will demonstrate their understanding of the principle of *tza'ar ba'alay chayim* by writing or narrating a paragraph describing how they will protect an anthill about to be destroyed.

Materials
- Writing paper
- Pens or pencils

Process
1. Engage the students in a discussion about *tza'ar ba'alay chayim,* the mitzvah of caring for all creatures with respect and not causing them harm. Use the material found in the "Big Idea" (page 91) as well as the "Inspiration" section above and the additional text pieces found in the other activities in this unit (pages 92, 96, and 100). You may wish to use the music activity (page 92), which asks children to make their own decision about how to treat living creatures, as a good introduction to the topic. The writing activity here extends the concept by asking children to justify their beliefs to others.

2. Distribute paper and writing instruments.

3. "Set the scene" by reading aloud the following:

 The Torah teaches that we must be sensitive to all living things. This is called *tza'ar ba'alay chayim*—not harming animals. *Tza'ar ba'alay chayim* means that we are not supposed to hurt or kill any living creature if we don't need to.

 Close your eyes and imagine that you are sitting on the sidewalk watching an anthill with hundreds of ants. You notice that the ants are such hard workers. Did you know that there are worker ants and soldier ants? The worker ants find food and take care of the young ants, and the soldier ants are like Teenage Mutant Ninja Warrior Ants—they have bigger jaws and protect the colony from intruders. Other ants serve as special servants to the queen ant, helping to feed her and take care of her.

 These guys are amazing to watch! They are very smart and very cooperative, doing whatever it takes to help one another. When they need to cross a puddle of water, they form an "ant bridge" with their bodies so that all can cross.

 Oh-oh—a group of grown-ups is walking along the sidewalk toward you and they don't see the ants building their nest! Remember the mitzvah of *tza'ar ba'alay chayim*—you must tell the grown-ups to walk around and not crush the ants. What will you say to the grown-ups to stop them from hurting the ants? How can you explain the importance of *tza'ar ba'alay chayim* to them?

4. Give students ten minutes to write freely. Encourage them to express themselves fully—this is a chance to teach the adults something new and important. Those too young to write can dictate to an adult, or into a tape recorder. When everyone is finished, ask for volunteers to share their writings with the group.

Helpful Hints

- Create a bulletin board or other display of the children's writing to share with parents and the rest of the school. See the Introduction, page xxi, for several display ideas.

- Also see the section on creative writing in the Introduction, page xx-xxi, for tips on working with beginning writers.

Resources

Parramon, Jose M., and Maria Angels Julivert. *The Fascinating World of Ants*. Hauppauge, NY: Barron's Educational Series, 1991.
 Describes the appearance, life cycle, activities, and social habits of ants.

All About Ants
http://www.infowest.com/life/aants.htm
 Lots of interesting facts about the sociology and anatomy of ants.

Judaism and the Treatment of Animals
http://www.jewishvirtuallibrary.org
 An explanation of the Jewish laws prohibiting cruelty to animals. Click on "Search," then type "animals" in the search box.

Mitzvot and Middot > Tza'ar Ba'alay Chaim > Visual Arts

THIS MITZVAH IS FOR THE BIRDS!
Grades K–1

Inspiration

"If you come across a bird's nest on any tree or on the ground, and it contains baby birds or eggs, and if the mother is sitting with her young, you must not take the mother along with her young. You must first chase away the mother, and only then may you take the young" (Deuteronomy 22:6–7).

Why does the Torah specify this unusual mitzvah? Maimonides suggests that sending away the mother bird teaches us compassion. He insists that animal mothers, just as human mothers, suffer when their offspring are harmed:

"As far as pain is concerned, there is no real distinction between the pain of humans and the pain of animals, because the love and compassion of the mother for her young is not reasoned intellectually, but has only to do with emotions and instincts, which are found among animals no less than among human beings. If the law provides that such grief not be caused to [cattle or] birds, how much more careful must we be not to cause grief to our fellow man" (Maimonides, *The Guide for the Perplexed* 3:48).

Objective
Students will demonstrate their understanding of the importance of caring for animals by constructing a birdhouse to provide food and shelter for wild birds.

Materials
- Coffee can with a plastic cover
- Can opener
- Wood dowel, six inches longer than the height of the coffee can
- Hole punch
- Craft knife or scissors
- String

Process
1. Read and discuss with students the "Inspiration" section above. Make sure all students have a basic understanding of the concept of *tza'ar ba'alay chayim*, to not cause pain to any living creature. Explain that today the students will be making a birdhouse as one way of showing kindness to animals and fulfilling the mitzvah of *tza'ar ba'alay chayim*.

2. Remove the plastic top from the coffee can, and cut it in half across the center (see diagram #1, page 101). Lay the two parts of the lid down in front of you, the straight side of the lid facing upward. Find the center of each half of the lid, and mark the spot with a pen or marker. Using a hole punch, make a hole at your mark that is large enough for a dowel to go through from one side to the other (see diagram #2, page 101).

3. Using a can opener, remove the sealed end of the coffee can so that both sides are open. Make sure that there are no sharp edges.

4. Place each half of the lid on opposite ends of the can. Insert the dowel through the hole on one side of the can, and feed it through the opposite side so that there is about three inches of dowel sticking through on each end. This provides a perch where birds can stand.

5. Take a long piece of string and run it through the open sides of the can. Tie the ends together to make a loop, and tie another string to the loop for hanging the birdhouse from a branch (see diagram #3 below).

6. Fill the bottom of the birdhouse with wild birdseed, and wait for your feathered friends to find it!

Helpful Hints

- As an option, have students paint their cans. To make sure that the paint will not come off when it rains, use latex house paint or spray paint. Other decorations can be added as well.

- Extend the activity by hanging a birdhouse outside the classroom window and filling it regularly with birdseed. Keep a log of which birds visit the feeder, and see how many different species of birds the students can identify.

- This can also be a good opportunity for the children to learn about birds (especially in a day school setting). What do birds eat? Where do they live? How many different species of birds are there? (With older children:) What does Jewish law say about eating birds? Which birds are kosher, which are not, and why?

Resources

Aroner, Miriam. *The Kingdom of Singing Birds.* Rockdale, MD: Kar-Ben Copies, 1993.
A Chasidic folktale about Rabbi Zusya and the royal aviary, filled with rare, exotic, and beautiful birds—but the king cannot get them to sing.

Judaism and Vegetarianism—Schwartz Collection: Can Compassion to a Bird Help Bring Moshiach?
http://www.jewishveg.com
This Web site features wonderful text sources and commentaries on the Jewish views of the treatment of animals.

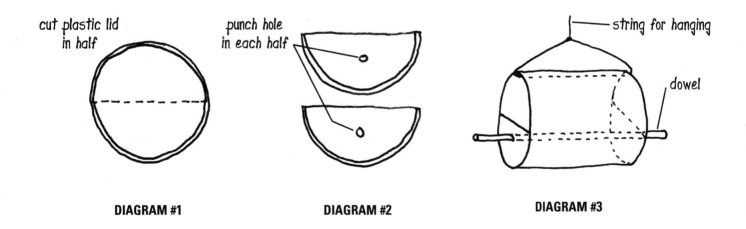

DIAGRAM #1 **DIAGRAM #2** **DIAGRAM #3**

Mitzvot and Middot > Hachnasat Orchim

The BIG IDEA

communal RESPONSIBILITY

HOSPITALITY with **GRACIOUSNESS**

HACHNASAT ORCHIM: WELCOMING GUESTS
Grades 2–3

Welcoming guests into our houses and lives is a sacred obligation within Jewish tradition:

"Rav Dimi of Nehardea said: Hachnasat orchim—*the welcoming of guests—takes precedence over the* beit midrash, *the house of study. . . . Rav Judah said in Rav's name:* Hachnasat orchim—*the welcoming of guests—takes precedence over welcoming the divine presence, the* Shechinah" (*Shabbat* 127a).

"When Rav Huna had a meal, he would open the doors of his house and say, 'Let whoever is in need come and eat'" (*Ta'anit* 20b–21a).

The message we send to our children should be simple: it is our obligation to open our homes, hands, and hearts to those who are in need. As the Talmud states, it is considered a higher value to welcome a guest first, then to pray and study. *Hachnasat orchim* obliges us not only to welcome guests, but also to go out and look for people who need to be welcomed.

a HIGHER LEVEL of HOLINESS

GOING to GREAT LENGTHS

INTEGRATING THE ARTS INTO JEWISH EDUCATION

Mitzvot and Middot > Hachnasat Orchim > Music

A MUSICAL MITZVAH
Grades 2–3

Inspiration
"All Israel is responsible for one another" (*Shevuot* 39a).

Jewish tradition is clear on the priority of including guests and outsiders in our homes and communities. The Talmud even states that if necessary, it is permitted to clear a warehouse full of straw on Shabbat in order to make room for guests (*Shabbat* 126b). The Jewish perspective on the world is based not on individual priorities, but rather on communal responsibility.

Objective
Students will understand the mitzvah of *hachnasat orchim* (welcoming guests) by playing two different versions of the game Musical Chairs.

Materials
- Chairs—one for every student
- CD player
- CD recording of any upbeat music

Process
1. Begin this activity with several rounds of the familiar game Musical Chairs. Set up two rows of chairs, back to back, with one fewer chair than the number of students in the class. Play music on the CD player as the students march in a circle around the chairs. When the music stops, each student must find a seat. The one student left without a chair is "out," and must sit off to the side.

2. Remove one chair, and start the music. Again, when the music stops, the one student without a seat is "out" and must sit off to the side.

3. After three or four rounds, engage the students in a discussion about the game. Specifically, ask those students who were "out" to talk about how it felt to be the only one without a seat, and how it felt to not be participating with the rest of the class once they were "out."

4. Explain that now the class will play a slightly different version of the game. Set the chairs up again, with one fewer chair than the number of students in the class. Play music on the CD player as the students march in a circle around the chairs. When the music stops, each student must find a seat. This time, however, the class does whatever it can to welcome and make room for the one student without a chair: squeeze together to make room, sit on laps, etc.

5. Continue playing this alternate version, removing chairs as long as the students are able to continue making room. Encourage them to be creative and to work together to make sure every class member has a place to sit. The best result would be for them to find a way to have everyone "seated" on the very last chair.

6. Have the students return to their seats and discuss this experience. Ask:
 - What were the major differences in the two versions of the game?
 - Was this an activity that required teamwork? Why?

OPEN IT UP!

- Did the game require any planning? Cooperation? Respect? Welcoming?
- How did those of you who were "out" feel when the rest of the group made room for you?

Ask individual students what they did to make sure that everyone felt included.

7. Introduce the mitzvah of *hachnasat orchim* by sharing material from the "Big Idea" (page 103) and the "Inspiration" section, page 104. Include also the story of Abraham welcoming the three strangers into his tent (Genesis 18:2–3), using either the original text or a simplified version of the story (see the "Resources" section below). Emphasize the importance that the rabbis of the Talmud placed on the performance of this mitzvah, so much so that in order to fulfill it, it was permissible to violate the laws of Shabbat. Also, emphasize Abraham's stature in Jewish life as the best example of fulfilling the mitzvah of *hachnasat orchim*. Ask:
 - What did Abraham do to make his guests feel welcome and comfortable?
 - Do you know of other examples from Jewish tradition of people who invited guests into their homes and communities?

Broaden the discussion to include ways that contemporary Jewish communities welcome and provide for guests and newcomers.

8. Wrap up the discussion by connecting the story of Abraham, the mitzvah of *hachnasat orchim*, and the students' experience of playing Musical Chairs. Ask:
 - Do you think you were as welcoming as Abraham?
 - Could you have done anything differently?

Helpful Hints

- Expand the discussion of *hachnasat orchim* to include specific examples of ways to perform this mitzvah in school, at home, or in the community.

- Discuss in class: Suppose a new family with children moved close to your home. How could you perform the mitzvah of *hachnasat orchim*?

Resources

Chubara, Yona, Miriam P. Feinberg, and Rena Rotenberg. *Torah Talk: An Early Childhood Teaching Guide.* Denver, CO: A.R.E., 1989.
 A collection of nineteen Bible stories from Abraham through Moses, retold in simple language for young children. Includes the story "Abraham Receives Guests."

Feinberg, Miriam P. *Just Enough Room.* New York: United Synagogue, 1991.
 An illustrated storybook for nursery school children that tells of the joys of Shabbat and hachnasat orchim.

Learn@jts Monthly Mitzvah
http://learn.jtsa.edu
 This Web site investigates the Jewish view of hachnasat orchim, *with much background information, text sources, questions for discussion, and suggested activities. Click on "search," then type "hachnasat orchim" in the search box.*

Mitzvot and Middot > Hachnasat Orchim > Drama

WELCOME TO ABRAHAM AND SARAH'S TENT
Grades 2–3

Inspiration

The mitzvah of *hachnasat orchim*, "bringing in the guests," is exemplified in the Torah by Abraham, who provides us with one of the first examples of hospitality, warmth, and graciousness:

"Looking up, [Abraham] saw three men standing near him. As soon as he saw them, he ran from the entrance of the tent to greet them and, bowing to the ground, he said, "My lords, if it please you, do not go on past your servant. Let a little water be brought; bathe your feet and recline under the tree. And let me fetch a morsel of bread that you may refresh yourselves. . . . Abraham hastened into the tent to Sarah, and said, 'Quick, three measures of choice flour! Knead and make cakes!' Then Abraham ran to the herd, took a calf, tender and choice, and gave it to a servant-boy, who hastened to prepare it. He took curds and milk and the calf that had been prepared, and set these before them; and he waited on them under the tree as they ate" (Genesis 18:2–8).

Abraham tends to his guests with a swiftness and graciousness of someone who truly believed in the value of the obligation of *hachnasat orchim*.

Objective
Students will reenact the story of Abraham and Sarah welcoming the three guests.

Materials
- A representation of Abraham's tent (use a real tent, assembled, or you can create a tent using big sheets or blankets, strung from a clothesline).
- Middle Eastern food and drink: pita bread, hummus, olives, milk or water
- Plates and cups
- Simple costume items: robes, scarves, shawls, sandals, etc.

Process
1. Set up the tent in advance of class. Students will naturally be curious about it when they enter the classroom. Let them take a look inside and explain that they will be imagining what it was like to be in Abraham and Sarah's tent.

2. Review or introduce the story of Abraham welcoming the three strangers into his tent (Genesis 18:2–8), using either the original text from the "Inspiration" section above, or a simplified version of the story (see the "Resources" section, page 107). Talk about the things that Sarah and Abraham do to make the three strangers feel welcome and at ease in their home. Ask the students how they would feel if they were walking in the hot desert and arrived at Abraham and Sarah's tent.

3. Select five students at a time to reenact the scene, in the roles of Abraham, Sarah, and the three strangers/angels. Give the students a couple of moments to dress in costume, to help them get into character.

4. Place Sarah inside the tent and Abraham sitting just outside. Have the three strangers stand at a far end of the room.

5. Narrate the following story as students act it out. Encourage them to be creative and improvise. Prompt the students to respond in character as you ask the questions in italics:

> One hot day, Abraham sat outside his tent while Sarah sat inside. Just ahead on the horizon, Abraham noticed three men approaching his tent. He ran out to greet them, and invited them to his tent for food and drink.
> *Abraham, what do you say to these three strangers? What kind of hospitality will you offer them? Strangers, what do you think of Abraham's invitation?*
>
> The men accepted Abraham's invitation and approached the tent. Abraham rushed into the tent and said to Sarah . . .
> *Abraham, what do you ask Sarah to do? Sarah, how do you feel about Abraham inviting three strange men into your tent?*
>
> Abraham brought the guests cold delicious goat's milk while Sarah prepared them bread and other wonderful things. Abraham and Sarah made sure that the guests had everything they needed to eat and drink, and the guests ate until they were full. (Invite students to actually eat the food.)
> *Guests, how do you feel about the way Abraham and Sarah have treated you? Have they extended their hospitality? Abraham and Sarah, how does it feel to be so kind to these travelers?*

6. Repeat the scene so that other students have the opportunity to reenact it.

7. To wrap up, sit in a circle (or, if all can fit, sit inside the tent) and talk about how it felt to be either the guest or the host. Ask:
 - Why were Abraham and Sarah so friendly to the guests?
 - Why did they prepare food for them? (You may want to talk about special foods from the Middle East.)
 - What things do you do when a friend or special guest comes to your house to make them feel welcome?

Emphasize the point that this story of Abraham serves as the prime example in Jewish life of *hachnasat orchim*, the mitzvah of welcoming strangers. Through his actions, Abraham set an example that we strive to live up to today.

Helpful Hints

Make sure to check with parents in advance to see if students have any food allergies. Some who are allergic to peanuts may have a problem with all legumes (hummus is made from chickpeas, a legume).

Resources

Beiner, Stan J. *Sedra Scenes: Skits for Every Torah Portion.* Rev. ed. Denver, CO: A.R.E., 2002. *A short, humorous skit for each of the fifty-four weekly Torah portions. See the portion "Vayera."*

Fisher, Adam. *God's Garden: Children's Stories Grown from the Bible.* Springfield, NJ: Behrman House, 1999.

A collection of modern stories that complement each weekly Torah portion, filling in details, elaborating on biblical figures, and highlighting Jewish values.

Jewish Education and Lookstein Center and Nechama Leibowitz
http://www.lookstein.org/nechama_parasha8_vayera.htm

A fascinating, detailed analysis of Abraham's actions by noted scholar Nechama Leibowitz.

Mitzvot and Middot > Hachnasat Orchim > Creative Writing

LET YOUR HOUSE BE OPENED WIDE
Grades 2–3

Inspiration
"Let your house be opened wide and let the poor be members of your household" (*Pirkei Avot* 1:5).

Hachnasat orchim was a great mitzvah for our rabbis, who maintained that it involved a higher level of holiness than seeing the Divine Presence. It was considered a wicked act to eat without inviting the poor to join, and, we are told, people in Jerusalem would set up a flag to notify the needy that a meal was in progress. It became the custom throughout our history to invite a stranger home for Shabbat, and frequently people vied for the mitzvah. *Hachnasat orchim*, opening our homes to the stranger and the needy, remains a primary mitzvah. It is ritualized on Pesach during the seder when we say, "Let all who are hungry come and eat."

Objective
The students will write a letter to an imaginary child in need, exemplifying the mitzvah of *hachnasat orchim* by expressing their hopes and desires to help such a child.

Materials
- Writing paper
- Pens or pencils

Process
1. Review or introduce the concept of *hachnasat orchim*, the welcoming of guests. Use the "Big Idea" (page 103) and the material from the "Inspiration" section above (as well as the "Inspiration" material from the music, drama, and visual arts activities in this unit, pages 104, 106, and 111) as background. Ask the students to share their ideas of how to welcome guests into their homes. What have they observed their parents doing to welcome guests? Who are the guests that come into their homes?

2. Explain that in Jewish life, the mitzvah of *hachnasat orchim* is very important. There are many examples in our Torah and in rabbinic texts that teach us about how to be gracious hosts, welcoming guests into our homes and our lives. The fulfillment of this mitzvah is so important, in fact, that the rabbis tell us it should take precedence over study, or even the worship of God. As a mitzvah, it is something that God has commanded us to do.

3. Distribute paper and writing instruments.

4. "Set the scene" by reading aloud the following:
 Our Jewish texts provide us with many examples of the mitzvah of *hachnasat orchim*, welcoming guests. One example comes from the Torah, the Book of Genesis, where we learn of Abraham's actions as he welcomes guests into his home (Genesis 18:2–8). Some Torah commentators have suggested that the strangers were actually angels, but Abraham welcomed them exactly as he would have welcomed any strangers who came to his door—with kindness and hospitality. Abraham performed the mitzvah of *hachnasat orchim*—"bringing in the guests."

Mitzvot and Middot > Hachnasat Orchim > Creative Writing

> At our Pesach seder we are commanded to open our door and invite strangers to join us at our seder table: in the Haggadah we read, "*Ha lachma anya*—let all who are hungry come and eat." We may not know anything about such a stranger, but the mitzvah of *hachnasat orchim* commands us to make him or her feel perfectly welcome.
>
> Perhaps you have seen homeless people in the streets, asking for money on corners or lining up to get food from food banks. Officials estimate that families with children make up about forty percent of the homeless population in the United States. If they are lucky these families are able to find space in a homeless shelter to stay, but for the children nothing is permanent. A common rule among homeless parents is that everything a child owns must fit into a small plastic bag for fast packing. These children do not have a nice house, nice clothes, or good food as you do.
>
> Imagine that you could invite one of these children to your home for Thanksgiving dinner or Pesach seder. How would you make this child feel welcome in your home? How would you include this child in your activities?
>
> Write a letter to an imaginary child inviting him or her to your home. Begin your letter with "Dear Homeless Child," "Dear Foodless Child," or "Dear Clothingless Child," and focus on what you can do to help.

5. Allow students to write freely for ten minutes.
6. Ask for volunteers to share what they have written by reading aloud to the group.

Helpful Hints

- This activity is particularly appropriate to do around the Thanksgiving holiday since the Torah portion *Vayera*, which includes the story of Abraham welcoming the angels, is read at that time. It also ties in well with the celebration of Pesach in the spring and the teaching of the *ha lachma anya* text.

- Create a display of the students' writing to share with parents and the rest of the school. Alternately, the students' individual writings can be sent home to be inserted into the family *haggadah*, or the writings of the class can be combined into a booklet that can be sent home. Such a booklet makes a great addition to the Pesach seder, and excerpts from it can be read by participants as it is passed around the table. See the Introduction, page xxi, for additional display ideas.

Resources

Children of Shelters
http://www.childrenofshelters.org
> *The opening page of this Web site includes interesting facts and figures about homeless children.*

Shulevitz, Uri. *The Magician: An Adaptation from the Yiddish of I. L. Peretz.* London: MacMillan, 1985.
> *An old couple with neither food nor candles to celebrate Passover receives a mysterious visitor who supplies everything they need.*

Mitzvot and Middot > Hachnasat Orchim > Visual Arts

WELCOMING GUESTS TO A SPECIAL PLACE
Grades 2–3

Inspiration
"Rabbi Chiya the Elder went to Darom where he stayed as the guest of Rabbi Joshua ben Levi. [At dinner] when twenty-four courses were set before him, Rabbi Chiya asked: 'What on earth do you do on the Sabbath?' Rabbi Joshua replied: 'We double the number of courses' " (Lamentations Rabbah 3:17).

Rabbi Joshua exemplifies the value of *hachnasat orchim* by not only feeding his guests, but by going to great lengths to make sure they are satiated. Jewish law insists that a host be as hospitable and as generous as possible.

Objective
The student will create a place mat for guests using stencils to create an interesting design.

Materials
- Clear plastic sheeting on a roll (available from fabric stores)
- Permanent markers
- Acrylic paint
- Thin cardboard
- Masking tape
- Scissors
- Small painting sponges
- Paintbrushes in various sizes

Process
1. Before class, cut the clear plastic sheeting into individual eleven-by-seventeen-inch placemats, one for each student.

2. Engage the students in a discussion about guests. Ask them to recall a time when they had guests join them at their table for a special meal, or when they were welcomed as a guest in someone else's home. Were there any special table decorations? Flowers? Special foods? In what other ways were the guests made to feel welcome? Use the "Big Idea" (page 103) and the "Inspiration" section above, as well as material from the music, drama, and creative writing lessons in this section (pages 104, 106, and 109) as background. Emphasize that *hachnasat orchim* involves not just inviting guests into your home or feeding them, but also going out of your way to make the experience special for them. Explain that today each student will make a special place mat to help welcome guests to their table.

3. Hand out blank sheets of paper and pencils and ask the students to draw a design for their place mat on the paper. Ask them to think about symbols that are representative of welcoming someone into your home.

INTEGRATING THE ARTS INTO JEWISH EDUCATION 111

4. Explain and demonstrate the following two techniques.
 a. To create resist, cut several large pieces of masking tape and create a line drawing using the masking tape. Then paint or sponge-paint over and around the tape and wait for the paint to dry. Remove the tape and notice what happens in the places where the tape was.
 b. To create a stencil, cut shapes in the center of a piece of thin cardboard and lay the cardboard with the open shapes on top of the plastic. Sponge or brush-paint in the openings and carefully remove the cardboard. The painted shape will remain.
5. Hand out the plastic sheets and ask the students to create their designs on the sheets using one of the two techniques demonstrated.
6. When the paint is dry, flip the place mats over and they are ready to be used.

Helpful Hints
- Permanent markers can also be used if paint is not available because it works well on non-porous surfaces like plastic.
- Remind students that the design that will show on the front of the place mat will be a mirror image of what they paint of draw. Therefore, if the students choose to write phrases or words, they must be written in mirror image.

Resources
Davis, Aubrey. *Bone Button Borscht.* New York: Kids Can Press, 1997.
A delightful tale of how important it is for people to work together and how neighbors can build community through cooperation.

Glaser, Linda. *The Borrowed Chanukah Latkes.* Morton Grove, IL: Albert Whitman, 1997.
A sweet story about giving, sharing, and welcoming guests.

Mitzvot and Middot > Derech Eretz

LISTENING with RESPECT

GUIDING our ACTIONS

The BIG IDEA

DERECH ERETZ: PROPER BEHAVIOR
Grades 4–6

*"What does God demand of you? Only this:
Do justly, love mercy, and walk humbly with your God"*
(Micah 6:8).

In an age of ethical ambiguity, it is important to turn to the teachings of our traditions for direction as to what is right and wrong. The value of *derech eretz* (literally, "the way of the land," commonly translated as "proper behavior" or "good manners") teaches us an honorable system of ethics and morals, guiding us on how to treat other human beings properly.

the POWER of WORDS

greet EACH PERSON with a PLEASANT FACE

INTEGRATING THE ARTS INTO JEWISH EDUCATION 113

ARE YOU LISTENING?
Grades 4–6

Inspiration
"Listening is a hugely underrated skill. By improving your listening skills, you can radically improve your relationships with the people around you. Conflictive relationships can become productive, difficulties can be smoothed over, and otherwise escalating problems can be 'nipped in the bud.' And just think of the wasted time, energy, and resources that you can save if you understand messages fully, the first time you hear them" (James Manktelow, founder and CEO of Mind Tools, from the Introduction to *Mind Tools on Active Listening*).

Objective
Students will practice active listening and present to the class important information about their fellow classmates in a respectful manner.

Materials
- Paper
- Pens
- Basket
- Copies of lyrics to the song "*S'licha, Todah, B'vakasha*" (see page 116)

Process
1. Introduce the concept of *derech eretz*, defining it for the purposes of this activity as "proper behavior" or "good manners." Refer to the "Big Idea" (page 113) and the "Inspiration" section above for background. Engage the students in a discussion about proper behavior and good manners, asking them to cite examples from everyday life. Ask:
 - Why does Jewish tradition have a particular name for good manners?
 - Does that mean it is an important concept within Jewish tradition?

 You may wish to emphasize here that *derech eretz* is not a mitzvah (commandment) but a *middah* (virtue or character trait).

2. Brainstorm with students to come up with a list of examples of good manners (i.e., saying please and thank you, listening, holding doors, letting others go first). Write the list on the blackboard, on a flip chart, or on a large sheet of butcher paper so all can see.

3. Divide the students into pairs. Instruct them to take turns telling each other about a favorite song and why it is a favorite song. Emphasize the importance of listening carefully and focusing on what their partner is telling them, as they will be reporting to the class later.

4. Bring the group back together, and have each student introduce their partner, name their partner's song, and explain to the group why it is their partner's favorite song. Instruct the rest of the class to listen carefully and try to remember what they are hearing.

5. After each student has introduced their partner and his/her song, discuss as a class the similarities and differences of the songs chosen by each pair. Are they similar in style? By the same artists? Old songs? New songs? Similar themes?

6. Ask the students:
 - What was it like to listen and then interpret for the class what was said by your partner?
 - Was it hard to pay attention?
 - Was it hard to remember what was said?
 - Did your partner accurately remember what you said? If so, how did that make you feel? If not, how did that feel?

7. Ask each student to write the title of their song on a slip of paper, then fold the paper in half and put it into a basket.

8. In turn, students will pick a piece of paper from the basket. If they get a slip of paper with their own song or with their partner's, they should put the slip of paper back in the basket and pick again. When they've picked a slip of paper with someone's song on it, they introduce the person who belongs to the song and state why it is that person's favorite song. If necessary, they can ask the rest of the class for help. This is an exercise in remembering and listening to the presentations by their classmates.

9. Conclude the discussion by relating the experience to *derech eretz*. Ask the students for their opinion as to what skills they used to model the middah of *derech eretz*. Ask:
 - How is listening attentively to one another an example of this virtue?
 - How is respecting another's choices in music an example of *derech eretz*?
 - What is an example of a time that you have disagreed with someone on their taste in music? How did you react? What did you say?
 - Did you model the virtue of *derech eretz*?
 - If not, how could you have acted differently to exemplify *derech eretz* in a more effective manner?

10. Learn and sing together the song "*S'lichah, Todah, B'vakashah*" by Judy Caplan Ginsburgh (see page 116 for the lyrics), from the recording *My Jewish World*. Discuss how saying "please," "thank you," "excuse me," and "I'm sorry" in Hebrew or in English exemplifies the virtue of *derech eretz*.

Helpful Hints

- This can be a challenging activity because it requires careful listening and remembering, skills that students at this age are still developing. As another way of modeling *derech eretz*, encourage the students to recognize and appreciate one another's efforts, even if some of the details are forgotten. Note also that *sh'mi'at ha'ozen* (attentiveness, or being a good listener) is recognized as a Jewish virtue in its own right.

- If inappropriate songs are suggested by students, take the opportunity to talk about a different aspect of *derech eretz*: respecting others by being sensitive to one's surroundings and not using foul language, sexually suggestive lyrics, etc.

Resources

Ginsburgh, Judy Caplan. *My Jewish World: Kids Songs for Everyday Living*. New York: Transcontinental Music Publications, 2002.
 Includes the song, "Slichah, Todah, B'vakashah." Available from www.judymusic.com.

Isaacs, Rabbi Ronald. *Derech Eretz: The Path to an Ethical Life.* New York: United Synagogue of Conservative Judaism Department of Youth Activities, 1998.
 A text-based, interactive guide to discussing the value of derech eretz *with students.*

Mind Tools on Active Listening
http://www.mindtools.com
 This Web site features excellent articles on developing better listening skills. Type "listening" in the search box.

Quotes to Inspire—The Josephson Institute of Ethics
http://www.josephsoninstitute.org
 A collection of thought-provoking quotes about character. Click on "more quotes" at the upper left for an index.

SLICHAH, TODAH, B'VAKASHAH
© 2001 Judy Caplan Ginsburgh

S'lichah, Todah, B'vakashah
Are words that you should know.
S'lichah, Todah, B'vakashah
You'll use them as you grow.
S'lichah, Todah, B'vakashah (2x)

S'lichah means I'm sorry
It's a word that you should know
S'lichah means I'm sorry
You'll use it as you grow.

S'lichah, Todah, B'vakashah (2x)

Todah means thank you
It's a word that you should know
Todah means thank you
You'll use it as you grow.

S'lichah, Todah, B'vakashah (2x)

B'vakashah means please
It's a word that you should know
B'vakashah means please
You'll use it as you grow.

S'lichah, Todah, B'vakashah (2x)

Mitzvot and Middot > Derech Eretz > Drama

DERECH ERETZ: RULES TO LIVE BY
Grades 4–6

Inspiration
The concept of *derech eretz* is so important that two tractates in the Talmud are devoted to it, *Derech Eretz Zutah* and *Derech Eretz Rabbah*. Exemplifying the lives of various sages, *Derech Eretz Rabbah* is a list of rules to live by. *Derech Eretz Zutah* is a collection of ethical teachings originally intended for scholars. Both tractates guide us in our actions toward others. The following three rules are excerpted from these tractates:

"A person should overlook an insult and not glorify himself by his fellow person's humiliation" (*Derech Eretz Zutah,* chapter 6).

"Concerning those who suffer insults but do not insult, who hear themselves reviled and do not answer back . . . the Bible declares, 'But they that love God be as the sun when he goes forth in his might' (Judges 5:31)" (*Derech Eretz Rabbah* 56a).

"No person should sit down at a table to eat before his elders have taken their seats" (*Derech Eretz Zutah,* chapter 6).

Objective
Students will find creative solutions to scenarios that can challenge the way we treat one another by playing a creative game of Freeze.

Materials
- Blackboard and chalk
- A few chairs
- Paper and pens

Process
1. Introduce the concept of *derech eretz,* defining it for the purposes of this activity as "proper behavior" or "good manners." Refer to the "Big Idea" (page 113) and the "Inspiration" section above for background. Engage the students in a discussion about proper behavior and good manners. Ask students to brainstorm to come up with examples of times in their lives when they found it challenging to treat people the right way or times when people did not treat them the right way. You might use categories such as "At School," "At Home," and "During Sports." List their responses on the blackboard, on a flip chart, or on a large sheet of butcher paper so all can see.

2. Explain to the students that they will be using open-ended improvisational drama ("improv") to explore the value of *derech eretz.* Tell them that there are two important rules to follow during the improv:
 a. "Yes, and . . ." This classic rule of improv states that you are not allowed to contradict what your partner says. In other words, when one actor says, "Hello, Mom," the other actor can't say, "I'm not your Mom." Instead, the other actor must take that idea and go with it. The actor could respond. "Hello, dear, how are you?" or "What do you want?" or simply, "Hi," as long as the actor doesn't contradict what his or her partner said.

b. "Freeze." When someone calls, "Freeze!" both actors stop in their action and speaking.

3. Invite two students to come to the front of the class and improvise a scene from the list of examples that the class created. Have the pair of students decide together which situation they would like to act out.

4. Allow them to improvise for a few minutes, until they come to the point when the mistreating happens. At that point, call, "Freeze!"

5. Ask the entire class to imagine that they are the two characters in this moment. What could each one do to show *derech eretz*?

6. Ask the actors to improvise the scene again, this time showing an alternative ending where the characters exemplify *derech eretz* as suggested by their classmates.

7. When they finish, invite two more students to pick another scenario and repeat the process above.

Helpful Hints

The technique of improvisation can be very engaging for students this age. However, depending on the size and energy of your class, you may need to set some very firm ground rules before the improv begins. For example, anyone in the audience who is talking and not listening doesn't get a chance to participate. If you have a co-teacher or parent volunteer, you might want to be proactive and divide the class into smaller groups, which makes doing improv activities easier.

Resources

Borowitz, Eugene B., and Frances Weinman Schwartz. *The Jewish Moral Virtues.* Philadelphia, PA: Jewish Publication Society, 1999.
> *This work is based on* Sefer Ma'alot Hamidot *(The Book of the Choicest Virtues) by the thirteenth-century scholar Yechiel ben Yekutiel, the first systematic, comprehensive, and analytic treatment of the virtues that Judaism esteems. The authors have effectively rewritten that book for contemporary Jews, providing practical ethical wisdom applied to contemporary life.*

Isaacs, Ron. *Exploring Jewish Ethics and Values.* Hoboken, NJ: Ktav, 1999.
> *A collection of quotations and sayings from rabbinic and biblical sources on a variety of ethical topics.*

Telushkin, Joseph. *The Book of Jewish Values: A Day-by-Day Guide to Ethical Living.* New York: Harmony/Bell Tower, 2000.
> *A volume of ancient and modern advice on how to live an ethical life in an ethically ambiguous world.*

A JAR FULL OF COMPLIMENTS
Grades 4–6

Inspiration
"Death and life are in the power of the tongue" (Proverbs 18:21).

"One who publicly shames his neighbor is as though that person shed blood. . . . One who whitens a friend's face [embarrasses a friend] in public has no share in the World to Come" (*Baba Metzia* 58b–59a).

In discussing *middot,* the rabbis often used exaggeration or hyperbole to catch our attention, to make us aware of just how seriously we need to consider our actions. When you embarrass someone with your words, it is said that you have stolen their soul. Words can be poisonous when used incorrectly, but they can also be powerful tools of positive energy when used correctly.

Objective
Students will write a paragraph complimenting a fellow student, thereby creating a culture within the classroom of support and encouragement for other students.

Materials
- Popsicle sticks
- Writing paper
- Pens or pencils
- Thin markers for decorating and putting names on Popsicle sticks

Process
Note to teachers: It is important to set the ground rules for this activity early in the lesson. Leave no room to tolerate negative and harmful comments. This activity can be extremely important as a confidence builder for all students involved, but it can also have a negative impact if not managed correctly and students have the opportunity to use harmful words. This activity is designed to build community and create bridges between students that might not have existed beforehand.

1. Engage the students in a discussion about *derech eretz,* defining it for the purposes of this activity as "proper behavior" or "good manners." Focus the discussion specifically on the notion of embarrassing others (refer to the "Big Idea," page 113, and the "Inspiration" section above for background). Ask:
 - Is embarrassing another person in public an example of *derech eretz*?
 - Why do you think the rabbis of the Talmud placed such emphasis on the importance of not embarrassing others?
 - How does it feel when someone embarrasses you in public?

 Encourage students to share their personal experiences.

Special thanks to Susan Tecktiel for the concept of the Compliment Jar.

Mitzvot and Middot > Derech Eretz > Creative Writing

2. Talk about the opposite of embarrassment: How does it feel to be complimented publicly? Again, encourage students to share their personal experiences.

3. Explain that as a way of experiencing *derech eretz,* you will try to create a culture within the classroom where students support, encourage, and compliment one another. Brainstorm with the students to come up with a list of ways that they can accomplish this—specifically, compliments they can give to one another. Write this list on the blackboard, on a flip chart, or on a large sheet of butcher paper so all can see.

4. Read the following quote from Genesis 1:27 to further this discussion: "So God created man in God's own image, in the image of God was he created; male and female God created them." Discuss the idea that everyone is created in the image of God (*b'tzelem Elohim*). Connect this idea to the concepts of *derech eretz* and not embarrassing others. Ask:
 - If we are created in God's image, then how are we expected to treat others?
 - Does this include the words that we use when speaking to and about others?

5. Pass out one Popsicle stick to each student. Instruct students to write their name at the bottom end of the stick and to decorate their Popsicle stick with a smiley face at the top end and decorations down the length of the stick. The decorations can represent different activities that the student likes to do or describe artistically who the student is. Encourage students to make their stick as colorful as they like.

6. Collect the Popsicle sticks and put them in a can or a jar so that the smiley faces show at the top but the students' names are down inside the container and cannot be seen.

7. Distribute paper and writing instruments.

8. "Set the scene" by reading aloud the following:

 Judaism places great value on acting kindly toward others. This Jewish value is called *derech eretz,* literally, "the way of the land." We commonly translate it as "proper behavior" or "good manners." This applies especially to the way we talk to one another. To be ethical Jews, we are expected not to gossip, not to tell tales about others or embarrass them, and to always look for the good in someone. As beings created *b'tzelem Elohim,* in the image of God, we are expected to recognize the holiness in everyone and look for the good in each individual.

 Today in our classroom we are introducing a "compliment jar." This is a fun activity to do at the end of a busy school week. Each of you will pull a decorated stick with someone's name on it out of the jar. You'll be writing a paragraph to the person whose name you draw, complimenting that person on something special or unique about him or her, or something you admire about that person. You can use the list of compliments that we came up with as a class at the beginning of this activity if you need help with specific ideas. Do not write negative comments or use harmful words in any way—remember, we are all created *b'tzelem Elohim,* in the image of God. Please stay silent throughout this process until you have completed writing your paragraph and we have come to the end of the activity, and please do not share with anyone the name that you draw out of the jar.

9. Invite students to come up and choose a stick, or walk around the room and have students choose one stick each. If they happen to choose their own stick, have them replace it and choose again.

10. Continue to set the scene by reading the following:

 > Close your eyes and begin to think about what you might write to compliment the student whose name you chose. What special qualities can you think of that this student has, perhaps qualities that not too many others possess? What do you admire about this student? Has the student ever done an act of kindness that you can write about? Is the student talented in any particular school subject or outside activity? Is the student kind, compassionate, a good listener, a quick problem-solver? Compliments can be general or specific. For example, a general compliment would be, "You are friendly" while a more specific compliment would be, "I like the way you said hi to me this morning!"
 >
 > When people receive compliments, they often feel very good and special. Think about what you can write that will make the person receiving the compliment feel good and special.
 >
 > You might begin with: Dear _____, I like the way you _____.

11. Allow students to write freely for ten minutes. Make sure that at the top of the paper they write the name of the student who is to receive the compliment.

12. Collect the paragraphs. Continue with another activity in order to give yourself time to read the paragraphs to make sure each paragraph is appropriate. Tell the students that you will hand out the compliments at the end of the lesson/day.

Helpful Hints

- Other helpful Jewish value terms to use when discussing *derech eretz* include *kavod* (honor), *bushah* (shame, dishonor), *anavah* (humility), *lo levayesh* (not embarrassing others), *ohev zeh et zeh* (loving others), and *m'chabed zeh et zeh* (honoring others).

- If you plan on using this activity throughout the year (more than one time), you can decorate the can with a collage or other decorations.

- The compliment letters are not really appropriate for bulletin board displays as they are personal and private. But there are many lovely ways for students to collect and save their compliment pages. Each student might create a decorated folder or a painted or decoupaged box, or the compliment pages can be glued onto a piece of cardstock or tagboard with a hole punched in the top left corner. Connect the various pages with a large ring.

- Writing compliment letters is a culture that can develop quickly among students in grades 4–6. Once the students begin the project at the beginning of the school year, it will become more than routine—ideally, it will be something they look forward to and expect each week.

- Extend this activity with a discussion on the right way to receive a compliment. Some people try to shy away from receiving compliments ("No, I really don't deserve your praise."). Others feel that they deserve the compliment and act entitled ("You're right, I know I'm good at that!"). Emphasize that *derech eretz* not only applies to giving compliments, but to receiving them as well. Both are important! Ask the students: What are appropriate words to use after someone gives you a compliment?

Resources

Freeman, Susan. *Teaching Jewish Virtues: Sacred Sources and Arts Activities.* Denver, CO: A.R.E., 1999.
Explanations, text sources, and activities related to twenty-three Jewish virtues, including several of those mentioned in this activity.

Klagsbrun, Francine. *Voices of Wisdom: Jewish Ideals and Ethics for Everyday Living.* New York: Jonathan David, Inc., 1980.
Includes a section on "Relating to Others" in Jewish tradition.

Telushkin, Rabbi Joseph. *Jewish Wisdom.* New York: William Morrow, 1994.
A collection of teachings and quotations from the Talmud, the Bible, rabbinical commentaries, and ancient and modern religious and secular writings.

Mitzvot and Middot > Derech Eretz > Visual Arts

SUCH A FACE!
Grades 4–6

Note: This activity will require two class periods, one for preparation and photography and a second for assembling the project. See the "Helpful Hints" section (page 124) for suggestions on how to modify the activity so that it can be completed in a single class session.

Inspiration
"*Greet every person with a pleasant face. . . . Receive every person in a cheerful manner*" (*Pirkei Avot* 1:15, 3:16).

"*If you give your fellow person all the best gifts in the world with a grumpy face, Scripture regards it as if you had given the person nothing. But when you receive your fellow person with a cheerful face, Scripture credits you as though you had given the person all the best gifts in the world*" (*Avot de Rabbi Natan* 13, 29a).

Judaism cares not only about how we speak to one another, but also about nonverbal communication. Our body language, gestures, facial expressions, and even an extended silence can communicate strong messages to those around us. Our texts offer guidance in the importance of nonverbal communication and how it impacts our interactions with others.

Objective
Students will create a montage of photographs of faces, demonstrating nonverbal communication through facial expressions.

Materials
- Individual disposable cameras (one for each pair of students)
- Scissors
- Glue sticks
- Eleven-by-seventeen-inch sheet of sturdy paper (one for each student)

Process
Class session 1:
1. Engage the students in a discussion about *derech eretz,* defining it for the purposes of this activity as "proper behavior" or "good manners." Focus the discussion specifically on the notion of how nonverbal communication—body language, gestures, and facial expressions—can be even more powerful than words when we interact with others. Refer to the "Big Idea," page 113, and the "Inspiration" section above for background.
2. Ask the students to share stories of times in their own lives when they were treated with *derech eretz* (for example, when they met a friend's parents for the first time and were greeted warmly) and of times when they were not (for example, a salesperson in a store with a sour facial expression). Ask:
 - What specific actions, facial expressions, or body movements gave you an understanding of the other person's true feelings?

- How did the "positive" expressions make you feel?
- How did the "negative" expressions make you feel?

3. Ask the students to think of a particular emotion and how they would express it on their face. Go around the classroom and have the students share examples.

4. Explain that the students will be creating a photo montage of various facial expressions. Photography is a great way to record emotions because very often we are not aware of how we look when we have certain feelings. Those expressions often speak louder than words.

5. Divide the class into pairs and instruct them to take turns photographing each other showing various facial expressions. The students should photograph all areas of the face including eyes, nose, forehead, mouth, ears, chin, and hair. Take both front and side views. For best results, the photographer should hold the camera steady while shooting and the model should sit in one place while being photographed.

6. Send the cameras home with the students and ask them to develop their photos and bring them to the next class session.

Class session 2:
1. Have students review their photographs and choose the pictures they like best for their face montages. Instruct them to cut out the pictures and lay them out on their eleven-by-seventeen-inch paper to create an interesting image containing many emotions in one face.

2. Once satisfied, glue the photographs to the paper, starting with the ones on the bottom and overlaying on top.

3. Ask for volunteers to present their montage to the class, explaining the various facial expressions they included. Which ones communicate the message of *derech eretz*?

Helpful Hints
- A Polaroid camera, or a digital camera and photo printer brought to class, will provide instant prints and allow the completion of the project in a single class session.
- Having students photograph each other and using their own photos in their montage are the best way of personalizing this activity. However, if photography is not an option, provide the students with a variety of magazines and have them cut out photos of faces with different expressions and paste them into a montage.

Resources
Creative Therapy Associates, Inc.
http://www.ctherapy.com
> *Posters, cards, and resources that help people identify and describe their feelings. Their well-known "How Are You Feeling Today?" poster comes in various languages, including Hebrew.*

Freeman, Susan. *Teaching Jewish Virtues: Sacred Sources and Arts Activities.* Denver, CO: A.R.E., 1999.
> *Explanations, text sources, and activities related to twenty-three* middot. *See in particular Chapter Sixteen, "Sayver Panim Yafot: A Pleasant Demeanor."*

Mitzvot and Middot > Bal Tashchit

do not
WASTE
or **DESTROY**

REDUCE
REUSE **RECYCLE**

The BIG IDEA

BAL TASHCHIT: DO NOT DESTROY
Family Education

"When, in your war against a city, you have to besiege it a long time in order to capture it, you must not destroy its trees, wielding the ax against them. You may eat of them, but you must not cut them down. Are the trees of the field human to withdraw before you into the besieged city? Only trees that you know do not yield food may be destroyed" (Deuteronomy 20:19–20).

Bal tashchit (most commonly translated to mean "do not destroy") is based on this biblical passage that forbids unnecessary destruction. Our responsibility is to find a balance between the resources we use and what we do to preserve and replenish what we deplete. Performing the mitzvah of *bal tashchit* assumes that everything in this world belongs to God and we are but caretakers of the earth.

avoid
ALL
that is
EVIL
and
DESTRUCTIVE

a
SPECIAL RESPONSIBILITY

INTEGRATING THE ARTS INTO JEWISH EDUCATION

MAKING TRASHY MUSIC
Family Education

Inspiration

"Whoever breaks vessels, or tears garments, or destroys a building, or clogs a well, or does away with food in a destructive manner violates the negative mitzvah of bal tashchit—do not waste or destroy*"* (Kiddushin 32a).

Environmentally aware consumers can observe *bal tashchit* and produce less waste by practicing the "Three R's": reduce, reuse, recycle. There are many creative ways to reuse materials that exist in our homes and our communities.

Objective

Participants will reuse objects and materials found at home to make musical instruments. Participants will understand the concept of *bal tashchit* and explore what can be done to minimize waste and respect limited resources.

Materials
- Instruments made from scrap materials, brought from home by each participant (see "Process," step 1 below).
- CD player
- CD with the song "*Mayim, Mayim*"
- Scale (step-on bathroom type, or one used for weighing large packages)

Process
1. Send a notice home before the program asking each family member to create some type of musical instrument from materials that would otherwise be thrown away or wasted. The instrument can be modeled on a traditional musical or rhythm instrument, but must be made entirely from trash or scrap materials. You may wish to provide participants with the addresses of a couple of Internet sites where they can find ideas and suggestions for instruments (see the "Resources" section, page 127), or provide the following suggestions for types of instruments:
 - An instrument that makes a sound when you shake it
 - An instrument that makes a sound when you rub it against another object
 - An instrument that makes a sound when you bang on it
 - An instrument that makes a sound when you bang it on something else
 - An instrument that makes a sound when you blow into it

 Each participating family member should create and bring one instrument. Encourage them to "think outside the box" and be as creative as possible!

2. When families arrive for the program, give participants an opportunity to show their instruments and demonstrate the sounds that they make for the entire group. Have the participants explain what materials they reused or recycled to make their instruments, where they found the materials, and how they created their instrument.

3. Ask participants to divide themselves into an "orchestra" according to how their objects make sounds. For example, those with objects that make a sound when they shake it are in the percussion group, those with objects that make a sound when they bang on it are in the drum group, etc. Have each group stand or sit together, creating the various sections of the orchestra (percussion, strings, wind instruments, etc.).

4. Listen once through to the recording of "*Mayim, Mayim.*" Explain that in Israel, water is a very precious resource, not to be wasted. Due to an ongoing drought in the Middle East and ever-increasing demands for water, the shortage in Israel is the worst in recorded history, threatening not only Israel's water resources, but her environment and quality of life as well. (For background information on this topic, visit the Jewish National Fund Web site [see the "Resources" section below].) In both ancient and modern times, finding a well, spring, or other source of fresh water was a cause for great joy.

5. Play the recording of "*Mayim, Mayim*" a second time, this time with the orchestra of trash instruments as an accompaniment. Some of the participants may also perform the traditional Israeli folk dance that goes with the song. If time permits, have participants suggest other songs for the orchestra to accompany.

6. Using the scale, determine how many pounds of trash were saved by the creation of the recycled instruments. You can either put all the instruments in a box and weigh it, or have one or more participants weigh themselves, then hold as many instruments in their arms as they can and weigh themselves a second time. Subtract the person's weight to determine the weight of the instruments.

7. Wrap up with a discussion of ways that families can reduce, reuse, and recycle. As suggested in the creative writing activity for this topic, have each family write a "Family Code of *Bal Tashchit*," guidelines for implementing a reduce/reuse/recycle policy in their home, and have all family members sign it. (See the creative writing activity for this topic, page 131, for background information and additional resources.)

Helpful Hints

If time permits, divide participants into nonfamily groups. Make sure that each group has at least one adult. Ask each group to create a sound symphony using their objects. Give them five minutes to create the piece. Ask each group to perform their sound symphony for the other groups. In creating their musical piece, ask them to consider the following musical elements:
- Rest(s)—silent beats in the music when no sound is made for a specified period of time
- Tempo—the speed of the music
- Staccato—short and detached sounds, made with distinct precision
- Legato—smooth and connected sounds, in a flowing manner
- Dynamics—sound ranging from very soft to very loud

Resources

Bash the Trash
http://home.earthlink.net/~jbertles/front.html
A Web site about building musical instruments from recycled and reused materials, including instructions for building a number of different instruments.

Jewish National Fund: Water in Israel
http://www.jnf.org/site/PageServer?pagename=Water
> Information about how the Jewish National Fund is helping to tackle the current catastrophic water crisis in Israel.

Kadden, Barbara Binder, and Bruce Kadden. *Teaching Mitzvot: Concepts, Values, and Activities.* Denver, CO: A.R.E., 2003.
> *Includes a chapter of the mitzvah of bal tashchit.*

Mayim, Mayim (Water, Water): Israeli Folk Song Lyrics and Sound Clip
http://www.songsforteaching.com
> *Type "mayim" in the "search" box for a link to an MP3 recording of the song.*

Scrap Arts Music
http://www.mondaviarts.org/education_pdfs/scrap_arts.pdf
> *Includes descriptions of various instruments made from scrap materials, and ideas for making them.*

Mitzvot and Middot > Bal Tashchit > Drama

THE MORE YOU KNOW: THE THREE R'S
Family Education

Inspiration
"We regard with reverence all of God's creation and recognize our human responsibility for its preservation and protection" (Central Conference of American Rabbis, Statement of Principles, 1999).

Not one of us is exempt from the obligation to take care of our planet. Environmental statistics are staggering. The Environmental Protection Agency stated that in 2001, U.S. residents, businesses, and institutions produced more than 229 million tons of garbage (consisting of everyday items such as product packaging, grass clippings, furniture, clothing, bottles, food scraps, newspapers, appliances, paint, and batteries). This adds up to approximately 4.4 pounds of waste per person per day, up from 2.7 pounds per person per day in 1960.

On the other hand, EPA statistics also state that recycling, including composting, diverted 68 million tons of material away from landfills and incinerators in 2001, up from 34 million tons in 1990. In fulfilling the commandment of *bal tashchit*, is our obligation to practice the "Three R's:" *reduce* the amount and toxicity of trash you discard; *reuse* containers and products, and repair what is broken or give it to someone who can repair it; *recycle* as much as possible, which includes buying products with recycled content.

Objective
Each family will create a public service announcement about the importance of not wasting resources.

Materials
- Poster board
- Markers
- Video camera (if possible)

Process
1. Begin this family education session by using materials from *It's a Mitzvah* and/or *Let the Earth Teach You Torah* to learn about the mitzvah of *bal tashchit* (see the "Resources" section, page 130). Have each family read and discuss the texts together.

2. Come back together in a large group and share what each family learned about *bal tashchit*.

3. Engage the group in a discussion about the ways in which our culture is wasteful, and brainstorm about how we can become less so. On the blackboard, a flip chart, or a large piece of butcher paper, make a chart with two columns. In the left column list materials that people use on a daily basis. In the right column, list suggestions from the families for ways to reduce, reuse, and recycle these materials. The objective is for the families to come up with ideas of ways to be less wasteful. If you like, supply families with a page of facts and statistics about waste and recycling. One example is provided in the "Inspiration" section above. See also suggested Web sites in the "Resources" section on page 130.

INTEGRATING THE ARTS INTO JEWISH EDUCATION

Mitzvot and Middot > Bal Tashchit > Drama

4. Divide the participants into small groups of two or three families. Explain that each group is going to create an original public service announcement to promote the value of *bal tashchit*. If possible, have one or two volunteers give examples.

5. Encourage the families to think about how to make the announcement engaging and exciting. Will it feature a catchy jingle? A dance? Visuals? Families can use poster board and markers if they wish, and should rehearse their announcement together.

6. Have each group present their announcement to the large group. After each performance, make a list of the ideas that were presented and review at the end of the lesson.

Helpful Hints

If you have access to a video camera, record each family's presentation, then create a DVD or videocassette to give to each family.

Resources

Artson, Bradley Shavit. *It's a Mitzvah: Step-by-Step to Jewish Living.* Springfield, NJ: Behrman House, 1995.
Simple steps to incorporating the rich tradition of Jewish values into everyday life.

Bernstein, Ellen, and Dan Fink. *Let the Earth Teach You Torah.* Wyncote, PA: Shomrei Adamah, 1992.
A guidebook for teens and adults on Judaism's relationship with nature.

U.S. Environmental Protection Agency—Municipal Solid Waste
http://www.epa.gov
Click on "Recycling" in the "Quick Finder" section at the top of this Web page for an overview of the recycling process, including facts and figures and many links to additional information.

U.S. Environmental Protection Agency—Recycle City
http://www.epa.gov/recyclecity
Recycling facts, activities, and an interactive game where the player becomes the City Manager of Dumptown, with the job of cleaning up the city.

Mitzvot and Middot > Bal Tashchit > Creative Writing

THAT NOTHING SHOULD BE LOST
Family Education

Inspiration
"The purpose of this mitzvah [bal tashchit] is to teach us to love that which is good and worthwhile and to cling to it, so that good becomes a part of us and we will avoid all that is evil and destructive. This is the way of the righteous and those who improve society, who love peace and rejoice in the good in people and bring them close to Torah: that nothing, not even a grain of mustard, should be lost to the world, that they should regret any loss or destruction that they see, and if possible they will prevent any destruction that they can" (*Sefer Hachinuch*, #529).

Objective
Family members will demonstrate their understanding of the mitzvah of *bal tashchit* by writing or narrating a paragraph from the point of view of an inanimate object item that is making a difference in saving our planet.

Materials
- Writing paper
- Pens or pencils

Process
1. Engage participants in a discussion about the mitzvah of *bal tashchit*, making sure that everyone has a basic understanding of the concept. Use the "Big Idea" (page 125) and the "Inspiration" section above as background.

2. Distribute paper and writing instruments.

3. "Set the scene" by reading aloud the following:

 The earth ultimately belongs to God: we are here to take care of it and to enjoy its fruits. While living in a constant balance with the earth and all it provides, we must be careful not to destroy what we are given. This partnership is supported by our ancient Jewish texts that teach us how to fulfill the mitzvah of *bal tashchit*, not destroying.

 In ancient times we were commanded not to cut down fruit trees during wartime. According to Deuteronomy 20:19, "When in your war against a city you have to besiege it a long time in order to capture it, you must not destroy its trees, wielding the ax against them. You may eat of them, but you must not cut them down." This idea of not being wasteful was extended in Jewish law to include the prohibition of covering oil lamps because covering the lamps would make them burn wastefully (*Shabbat* 67b). We were not even allowed to waste clothing or something as small as a mustard seed (from *Sefer Hachinuch*, a thirteenth-century text—see the "Inspiration" section above).

 You are here today as a family to learn about the commandment to guard the earth and the environment. Imagine for a moment an ideal, environmentally sound classroom, a place where everything is reused and recycled. Imagine large recycling bins in the front of the room, one for paper and one for cans and aluminum foil. In this classroom, we learn about and are inspired to begin a composting project where each of our families builds a compost bin out of wire mesh in our own backyards. Imagine if each family begins in its

INTEGRATING THE ARTS INTO JEWISH EDUCATION

own way to observe the mitzvah of *bal tashchit*. Imagine *Ima Adamah*, Mother Earth, smiling proudly at us for reducing, reusing, and recycling. And finally, begin to imagine the world from the perspective of each item that is on its way to being reused and recycled.

Parents: Imagine that you are a stack of newspapers and magazines being bundled and tied, on your way to the paper recycling plant. A whole classroom of kids recycling their newspapers every day for a year would save about fifteen trees!

Children: Imagine that you are the bottles and cans making an orchestra of sounds in the recycling bin. A typical North American family recycles about nine hundred aluminum cans a year. Nearly four billion plastic bottles and about five billion glass containers are being recycled each year. You will soon have a new life as new bottles and cans.

Grandparents: Imagine that you are a new hybrid car that uses more electricity than gasoline. A typical hybrid engine gets ten to fifteen miles more per gallon than a regular gas engine in the same car, and produces 90 percent fewer harmful emissions. You are saving oil and keeping the air clean at the same time!

Each of us will write for fifteen minutes, expressing our thoughts and feelings as newspapers and magazines, bottles and cans, or the hybrid car. Write what you would like to say to *Ima Adamah*. Express your pride, your hopes, your fears, your wishes for the future, a future where everyone practices the mitzvah of *bal tashchit* and nothing is wasted.

Allow everyone to write freely for fifteen minutes. Those too young to write can dictate to an adult.

4. Encourage family members to share their writing with one another. If there is time, ask for a volunteer family to share their writings with the entire group.

Helpful Hints

- After writing fom their individual perspectives, families can turn their thoughts and ideas into a "Family Code of *Bal Tashchit*," setting guidelines for how they will be less wasteful.

- These writing pieces make a great display for accompanying art projects made out of recycled/reusable materials. Projects can range from a sculpture of bottles and cans to a giant collage of excerpts from newspapers and magazines.

Resources

Artson, Bradley Shavit. *Making a Difference: Putting Jewish Spirituality into Action, One Mitzvah at a Time.* Springfield, NJ: Behrman House, Inc. 2001.
Designed for bar and bat mitzvah–age students and their families, this book encourages students to see how they can make a difference. Text studies and thought-provoking questions are included throughout the activities.

Berry, Joy. *Every Kid's Guide to Saving the Earth.* Lake Forest, IL: Forest House, 1992.
This book is a guide for implementing measures to protect our earth, its environment, and its resources. It is intended for kids interested in saving the environment.

Trivia, Facts, and Other Stuff
http://www.uoregon.edu
This Web site, sponsored by the University of Oregon Campus Recycling Program, gives amazing statistics about resource use and recycling. Type "trivia" in the "search" box.

Mitzvot and Middot > Bal Tashchit > Visual Arts

PICTURE THIS!
Family Education

Inspiration
"A Jewish ecology . . . [is] not based on the assumption that we are no different from other living creatures. It [begins] with the opposite idea: We have a special responsibility precisely because we are different, because we know what we are doing" (Rabbi Harold Kushner, *To Life!*, page 59).

Ecology is an interdependent system of living things. Each one of us is commanded to find ways to preserve energy, recycle, and care for the environment with the hopes that the earth will benefit from our unique human awareness of our surroundings.

Objective
Students will create their own picture frame using recycled materials.

Materials
- Plastic CD case with paper inserts (minus CD)
- Junk mail, old magazines
- Scissors
- Tape
- Glue

Process
1. In preparation for this activity, send home an information sheet asking families to bring with them to the program junk mail, old magazines, and one empty CD case per family. In addition, ask each family to bring a favorite family photograph that is four inches by six inches or smaller. If you do not have time to notify families, look through your school building in recycling bins and trash cans, or bring in old magazines to find enough materials for families to choose from.

2. Engage the group in a discussion about recycling and reusing materials, and how doing so fulfills the mitzvah of *bal tashchit*. For background, see the "Big Idea" (page 125) as well as the "Inspiration" section above and the same section in the music, drama, and creative writing activities for this topic (pages 126, 129, and 131). For the purposes of this activity, emphasize the point that we can have a positive impact on our environment by reusing old materials in new ways rather than wasting them by throwing them away.

3. Ask families to place on a center table all the magazines and junk mail that they brought in. Instruct them to sort through the materials to find colorful, interesting images that they would like to use in creating a unique picture frame for their family photo.

4. Instruct each family to open their CD case and remove the paper liner notes from the front and back of the CD case. They will need to remove the plastic insert that holds the disk (usually black or gray, with a round indent and prongs in the middle) to access the printed tray card—it should snap out easily (see diagram #1, page 134).

INTEGRATING THE ARTS INTO JEWISH EDUCATION

5. Show participants how to use the old CD booklet or front insert card as a template to measure and cut a new paper insert from the junk mail or magazine photos. Have them lay the old booklet on top of the new image they have selected, trace around it with a pen or pencil, then cut out the traced portion with scissors. If the old insert is missing, have them cut out a new insert that is four and three-fourths inches square.

6. Instruct participants to cut an opening in their new paper insert so that it acts as a matte or frame for their family photo. The opening can be rectangular, oval, round, or any shape they choose. Have them line up the photo behind the paper matte and tape it to the back.

7. Show participants how to separate the two halves of the CD case by removing the clear front panel, flipping it over, and reconnecting the two plastic tabs (see diagram #2 below).

8. Have participants place the CD tray half of the case facedown on the table and lift the clear cover so that it stands upright, leaning back at an angle. Show them how to insert their photo and paper frame into the cover, using the small plastic tabs to hold it in place (see diagram #3 below).

Helpful Hints
- Permanent markers can be used to write or draw directly on the clear plastic cover.
- Participants can write a quote about recycling from Jewish tradition or from their own hearts on the picture frame so it will remind them of the mitzvah of *bal tashchit*.

Resources

COEJL: Coalition on the Environment and Jewish Life
http://www.coejl.org/learn/je_tashchit.shtml
From the Web site of the premier Jewish environmental organization, several text sources and commentaries related to the mitzvah of bal tashchit.

Kushner, Harold S. *To Life!: A Celebration of Jewish Being and Thinking.* New York: Little Brown, 1993.
A lucid analysis of Jewish life, thought, and customs.

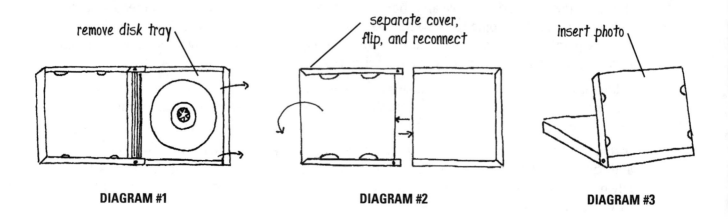

DIAGRAM #1 **DIAGRAM #2** **DIAGRAM #3**

PART IV
JEWISH LIFE CYCLE

Jewish Life Cycle > Baby Naming

an **EXERCISE** of **POWER** and **CREATIVITY**

the **MOST PRECIOUS** crown of **ALL**

The BIG IDEA

BABY NAMING
Grades K–1

*"Every man has three names:
one that a father and mother give him,
one that others call him,
and one that he acquires for himself"*
(*Ecclesiastes Rabbah* 7:13).

According to Jewish tradition, the name that is given to us communicates much about who we will become. As we enter into the first rite of passage in Judaism, receiving a name, we become part of the covenant, connected forever to the generations that came before us.

the **STORY** of **WHO** we **ARE**

NAMES reveal **SO MUCH**

INTEGRATING THE ARTS INTO JEWISH EDUCATION

MY HEBREW NAME
Grades K–1

Note: This activity can easily be combined with the drama, creative writing, and visual arts activities for this topic (pages 141, 143, and 145).

Inspiration

"And God formed out of the earth all the wild beasts and all the birds of the sky, and brought them to the man to see what he would call them; and whatever the man called each living creature, that would be its name. And the man gave names to all the cattle and to the birds of the sky and to all the wild beasts." (Genesis 2:19–20).

"Like Adam's appointed task of giving names to all living things in Eden, naming is an exercise of power and creativity" (Anita Diamant, *What to Name Your Jewish Baby*).

When parents name children, each individual name carries with it great hopes and dreams. Parents spend hours upon hours thinking of how names sound, what they represent, and who their children will become with these names. Before children have even said their first words, their names have given them an identity. It then becomes the responsibility of the children to take on this identity and create their own unique personality, building upon the hopes of the generations that preceded them.

Objective

Students will know and share their full name in both English and Hebrew, and understand the importance of their Hebrew name.

Materials

- Blackboard and chalk (or flip chart, butcher paper, etc.)
- Copies of lyrics to the song "My Hebrew Name" (page 140)

Process

1. In preparation for this activity, send home a request for parents to provide the full English and Hebrew name of their child, in the following format:

 Boys: (English) Jacob Daniel Cohen, son of Adam Cohen and Miriam Schwartz Cohen
 (Hebrew) Ya'akov Dani'el ben Adam v'Miriam

 Girls: (English) Abigail Suzanne Goldberg, daughter of Joseph and Deborah Goldberg
 (Hebrew) Avital Shoshanah bat Yosef v'Devorah

 Ask also for any nicknames, and information about whom the child is named after and why. Instruct parents to send this information with their child to class on the day of the activity.

2. Begin this lesson with an explanation of Jewish rituals of baby naming and *brit milah* (see suggested background material in the "Resources" section, page 139). Make sure that students have a general understanding of *brit milah* (ritual circumcision for a boy) and *simchat bat* (a naming ceremony for a girl), and the understanding that during these celebrations a new baby is formally named and blessed. Emphasize that in Jewish tradition names are a way of honoring our ancestors. Most Jewish babies in North America will receive both an English

(secular) and Hebrew name, and one or both of these names (or the initial letter of the name) may be given in honor of a family member. Names are important, a source of pride and blessing.

3. Allow each student to share their names with the class—English, Hebrew, and any nicknames they might have. Write the names in three columns on the blackboard, on a flip chart, or on a large piece of butcher paper for the entire class to see. Ask the students to also share any information about whom they were named after, and why.

4. Have the students sit in a circle on the floor. Go around the circle and ask each child to say their name (English or Hebrew), and say something Jewish that they like that begins with the same letter or sound. For example, "My name is Michael, and I like matzah." "My name is Hannah, and I like Chanukah." This can be done in a chanting style, with students keeping the rhythm by clapping or patting their knees.

5. Teach the class the song "My Hebrew Name" (for the lyrics, see page 140) by Larry Milder (from the recording *Bible & Beyond*). If students are unable to read, they can sing on the chorus only and the teacher can sing the verses. Be sure to discuss the words of the song with the students, emphasizing the concepts found in the "Big Idea" (page 137) and in the "Inspiration" section (page 138). Each time you sing the chorus, insert a different child's Hebrew name, and the last time through list the names of all the children in the class.

Helpful Hints

Extend this lesson by making a class "Big Book of Names." Give each child two side-by-side pages. On one side, have them write their English and Hebrew names, as well as any nicknames, and the meaning of their name from the information provided by parents (the teacher will most likely have to do the writing, or perhaps assist the student in writing if they so choose). On the other side, have them paste a photo of themselves or a drawn self-portrait, a photo of and information about the person for whom they were named, a list of favorite things, a drawing that they create to represent themselves, etc. Be creative! Put all the pages together in a three-ring binder.

Resources

Diamant, Anita. *What to Name Your Jewish Baby*. New York: Summit Books, 1989.
Out of print. Limited used copies are available from http://www.amazon.com.

Hebrew Names—Naming a Jewish Baby
http://judaism.about.com/library/3_lifecycles/names/bl_names.htm
This Web site provides an introduction to the customs and rituals of naming a Jewish child. It also includes a listing of several hundred Hebrew names and their meanings.

Kadden, Barbara Binder, and Bruce Kadden. *Teaching Jewish Life Cycle: Traditions and Activities*. Denver, CO: A.R.E., 1997.
Includes a chapter titled "Beginnings: Birth, Brit Milah, and Naming."

Milder, Larry. *Bible & Beyond*. Compact disc.
Includes the song "My Hebrew Name." Available from www.soundswrite.com.

Sidi, Smadar S. *The Complete Book of Hebrew Baby Names*. San Francisco: Harper, 1989.
A comprehensive Hebrew baby name book, with thousands of listings, advice on choosing names, naming ceremonies, and more.

MY HEBREW NAME

Words and music by Larry Milder
© 1993 Laurence Elis Milder

When I was just a little kid and wasn't very old,
My parents gave to me a name, at least that's what I'm told.
They thought about it long and hard before they could decide,
A name they'd hold in high regard and always say with pride.

Chorus: My name is (Avi*), that's my Hebrew name.
 (Avi*), it's a name I'm proud to claim.
 And if anyone should question me I'll tell them without shame:
 (Avi*), that's my Hebrew name.

My teachers call me by my name whenever I'm in school.
The rabbi and the cantor say my Hebrew name is cool.
And on that Shabbos morning when they call on me to pray,
I'll stand and hold the Torah and to everyone I'll say . . .

Chorus

A name can tell you lots of things you never thought you knew.
Some names you earn by what you like and some by what you do.
Some names are silly, some are long, some make your face turn red.
But I always stand up proud and strong whenever this is said:

Chorus

Ending: (Avi), (insert all other names)
 That's my Hebrew name!

Insert a different child's name each time the chorus is sung.

THE CROWN OF A GOOD NAME
Grades K–1

Note: This activity can easily be combined with the music, creative writing, and visual arts activities for this topic (pages 138, 143, and 145).

Inspiration
"R. Shimon said: There are three crowns: the crown of Torah, the crown of priesthood, and the crown of kingship. But the crown of a good name rises above them all" (*Pirkei Avot* 4:17).

Rabbi Samson Raphael Hirsch is quoted as saying in response to this statement in *Pirkei Avot*, "The crown of a good name excels the other three, first by virtue of the fact that it is within the reach of all, without exception, and secondly, because all the others are without value unless they are linked with the crown of a good name. It may also be that 'rises above them all' means that the 'crown of a good name' must be linked with them all."

In Jewish tradition, a baby is usually given a name that has significance—often named for a beloved relative who has died, or in the Sephardic tradition, named in honor of a living relative. As we grow, we may take on some of the qualities of that person, even as we become our own people. Our tradition teaches that the "crown of a good name"—the way in which we are known for being a good person—is the most precious crown that we can wear.

Objective
Students will use a simple prop (the "Crown of a Good Name") to express the qualities that make them into a good person.

Materials
One crown—either made out of cardboard and wrapped with foil, or bought from a costume shop.

Process
1. In preparation for this activity, send a request for parents to identify and provide information about the person(s) for whom or after whom their child is named. Also, ask them to write about any special qualities of that person. For example, were they especially charitable? athletic? kind? funny? intelligent? Ask parents to talk with their child before class about the person for whom they were named. If the child was not named for anyone in particular, ask the parents to talk with him/her about the qualities that make the child special.

2. During class, have children sit in a circle on the floor. Show them the crown and explain that this is called "the Crown of a Good Name."

3. One at a time, have students come sit in the middle of the circle. Students will put on the crown and share their name and the name of the person for whom or after whom they were named, and the qualities that made that person special. The teacher can help students read the notes sent in by parents.

Jewish Life Cycle > Baby Naming > Drama

4. Say to the child, "Sarah, I know that you have many, many wonderful qualities that make you unique and special. They are the Crown of Your Good Name." Then say to the other children, "What do you think makes Sarah special?"

5. When the children have shared, you can ask the child in the middle if he/she wants to add any other qualities. You might point out similarities between the namesake and the child. For example, "Your parents wrote that your great-aunt Miriam was a very caring person, and I notice that you are also always very considerate of other people's feelings."

6. Continue until each child has had a chance to sit in the center of the circle and wear the crown.

Helpful Hints

- Be sure to guide the discussion toward only positive comments. Spend a little time beforehand explaining the proper way to compliment one another.

- Make sure to explain that although being named in someone's honor or memory is part of Jewish tradition, it is okay if a student wasn't named in that way. You can emphasize the second part of the activity for students who don't have a namesake or don't know much about their namesake.

Resources

Diamant, Anita. *The New Jewish Baby Book: Names, Ceremonies & Customs—A Guide for Today's Families.* 2nd ed. Woodstock, VT: Jewish Lights, 1994.
 A complete guide to the traditions and rituals for welcoming a new child into the world and into the Jewish community.

Jewish Heritage Online Magazine—Crown—Pirkei Avot
http://www.jhom.com/topics/crowns/pirkei.html
 This Web site provides an in-depth look into the meaning of the quotation from Pirkei Avot, "the Crown of a Good Name."

Jewish Life Cycle > Baby Naming > Creative Writing

WHAT'S IN A NAME?
Grades K–1

Inspiration
"For Jews a name is a complicated gift, one that bestows identity and generational connection. It can also reflect religious and spiritual dimensions, while giving a voice to parental aspirations. . . . Naming begins the process of shaping the person—hopefully the mensch— your child will become" (Anita Diamant, *The Jewish Baby Book,* page 39).

Names tell others the story of who we are. There are many reasons why we are given particular names depending on a variety of Jewish family and cultural traditions. However, one thing is for certain: each one of us has the opportunity to build our own identity and give new meaning to our given name.

Objectives
Students will write or dictate hopes and wishes for a newborn baby.

Materials
- Writing paper
- Pens or pencils

Process
1. Introduce the topic of naming a Jewish baby, and make sure that all students have a general understanding of the concepts. Use the material found in the "Big Idea" (page 137), the "Inspiration" section above, and the "Inspiration" material for the music, drama, and visual arts activities for this topic (pages 138, 141, and 145).

2. Distribute paper and writing instruments.

3. "Set the scene" by reading aloud the following:

 A new baby has just been born—a brother or sister, a cousin, a friend, or a neighbor. The new baby is about to receive his or her name. Some babies get an English name and a Hebrew name. Some parents just choose a Hebrew name. Sometimes a baby gets a first name and a middle name, and sometimes just one name. In certain Jewish communities it is a custom to give a baby the name of a relative who is no longer alive—the baby carries on that person's name. In other communities it's the custom to give a baby the name of a living relative—we honor that relative with the baby's name. Names are very important— there's a midrash (*Leviticus Rabbah* 32:5) that tells us that the reason God took us out of Egypt is that we didn't change our names while we were living as slaves!

 Now it's time to think about what it is like to know someone who has a baby. This new baby needs a new name. You're the big sister or brother or cousin or friend. This is a very special time for the family, and since you are an important part of the family you want to welcome the new baby into the world. What will you say? What will you wish for him or her? Write or tell a teacher your wish for the new baby. Write or tell a teacher something

nice you'd like to say to welcome the new baby. Write or tell a teacher two things you'd like to teach the new baby, since you're the big kid. If you know the baby's name and story of the name, write about that too. Welcome to the world, new little one!

4. Give students ten minutes to write freely. Encourage them to express themselves fully—this is an opportunity to tell the new baby some very important things! Those too young to write can dictate to an adult, or into a tape recorder. When everyone is finished, ask for volunteers to share with the group what they have written.

Helpful Hints

- Create a bulletin board or other display of the children's writing to share with parents and the rest of the school. See the Introduction, page xxi, for several display ideas.

- See the section on creative writing in the Introduction for tips on working with beginning writers.

Resources

Gellman, Ellie. *Justin's Hebrew Name.* Minneapolis, MN: Kar-Ben, 1988.
When Justin begins Hebrew school without a Hebrew name, his friends and the rabbi help him pick the perfect one.

Rouss, Sylvia A. *My Baby Brother: What a Miracle!* New York: Jonathan David, 2002.
When Sarah Leah's baby brother Daniel arrives, she doesn't see what all the fuss is about. But Sarah comes to love her baby brother and realizes what a miracle he truly is.

Jewish Life Cycle > Baby Naming > Visual Arts

A NEW NAME, A NEW IDENTITY
Grades K–1

Note: This activity can easily be combined with the music, drama, and creative writing activities for this topic (pages 138, 141, and 143).

Inspiration
"The ancients believed that one's essence was inextricably bound to one's name. If you changed your name, you were, in effect, changing who you were. In a modern sense, we understand this well. The European immigrants who quickly Americanized their names strove to discard their heritage. And those of the Diaspora who Hebraized their names upon immigrating to Israel also wanted to shed the baggage of their past" (Lawrence Kushner and Kerry Olitsky, *Sparks Beneath the Surface,* page 42).

Our names reveal so much about our personalities. As a teacher, one of the most important goals is to learn the names of the students. Connecting to young students through the use of their names shows the students that you have entered into an important relationship that involves being caring and compassionate toward their needs.

Objective
Students will create their own colorful nameplates in Hebrew and English.

Materials
- Black construction paper, cut in three-by-four-inch pieces
- Masking tape
- White glue
- Pencils
- Colored pastels
- Hole punch
- Yarn

Process
1. In preparation for this activity, send home a request for parents to provide the full English and Hebrew name of their child, in the following format:

 Boys: (English) Jacob Daniel Cohen, son of Adam Cohen and Miriam Schwartz Cohen
 (Hebrew) Ya'akov Dani'el ben Adam v'Miriam

 Girls: (English) Abigail Suzanne Goldberg, daughter of Joseph and Deborah Goldberg
 (Hebrew) Avital Shoshanah bat Yosef v'Devorah

 Instruct parents to send this information with their child to class on the day of the activity. If the Hebrew name is not known or the student does not have one, ask the parent if the student would like to receive one.

2. Begin this lesson with an explanation of Jewish rituals of baby naming and *brit milah* (see suggested background material in the "Resources" section, page 146). Make sure that students have a general understanding of *brit milah* (ritual circumcision for a boy) and *simchat bat* (a naming ceremony for a girl), and the understanding that during these celebrations a new

INTEGRATING THE ARTS INTO JEWISH EDUCATION

baby is formally named and blessed. Emphasize that in Jewish tradition names are a way of honoring our ancestors. Most Jewish babies in North America will receive both an English (secular) and Hebrew name, and one or both of these names (or the initial letter of the name) may be given in honor of a family member. Names are important, a source of pride and blessing.

3. Give each student an opportunity to talk about the significance of his or her name. Who were they named after and why? Some students may have been named in memory of a special relative. Others may have been named after a great hero or heroine in the Torah. Be sure to explain that if neither is the case it's okay: some names are chosen simply because the parents like them.

4. Give each student two pieces of black construction paper cut into three-by-four-inch rectangles. One piece will be for the student's Hebrew name and the other for their English name. With a pencil, have the students write their name(s) on the pieces of construction paper. Encourage them to make their letters large and easy to read with ample space between letters. Assist them with writing their Hebrew name, either in Hebrew characters or in transliteration. If the Hebrew name is not known or the student does not have one, ask a rabbi for help in giving the student a Hebrew name (be sure to have parental permission before doing so).

5. Tape each nameplate to the table to make sure it doesn't move.

6. Demonstrate for students how to carefully trace the outline of each letter using a squeeze bottle of white glue. After both names are outlined in glue, set them aside to dry (allow several hours).

7. When the glue is dry, take colored pastels and draw over the raised glue lines, blending the colors. Encourage students to use a variety of their favorite colors. The glue lines outlining the names will stand out against the dark background.

8. Glue or staple the English and Hebrew names back-to-back. Then, punch holes in the two upper corners and thread string through the holes to make a hanging nameplate for students to wear around their necks.

Helpful Hints

New, clean squeeze bottles of glue will work best for outlining the letters. Let the students practice on scrap paper before working on the black paper.

Resources

Diamant, Anita. *The New Jewish Baby Book: Names, Ceremonies & Customs—A Guide for Today's Families.* 2nd ed. Woodstock, VT: Jewish Lights, 1994.
 A complete guide to the traditions and rituals for welcoming a new child to the world and into the Jewish community.

Kolatch, Alfred J. *The Complete Dictionary of Hebrew and English First Names.* New York: Jonathan David, 1984.
 More than 11,000 Hebrew and English names, including an analysis of their meanings and origins.

Kushner, Lawrence S., and Kerry Olitsky. *Sparks Beneath the Surface: A Spiritual Commentary on the Torah.* Northvale, NJ: Jason Aronson, 1993. O.P.
 Numerous articles, sources, and topics for every verse in the Torah.

Jewish Life Cycle > Growing Older

a
SENSE
of
CONNECTION
and PURPOSE

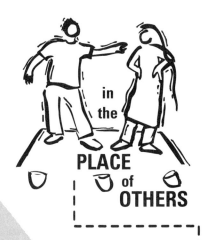

in the
PLACE
of
OTHERS

The BIG IDEA

GROWING OLDER
Grades 2–3

"Gray hair is a crown of splendor: it is attained by a righteous life"
(Proverbs 16:31).

"You shall rise before the aged and show deference to the old; you shall fear your God" (Leviticus 19:32).

The great Jewish philosopher Rabbi Abraham Joshua Heschel said that the test of a people is how it behaves toward its old. Every generation of Jews has a responsibility to their elders not only to care for them, but to assist them in continuing to feel valued and capable. The honor we show our elders becomes a lesson to those who come after us. When we model this behavior, we imbue the next generation with the understanding of the importance of this mitzvah.

LISTENING
and
LEARNING

let the
BEAUTY
and
GLORY
shine
THROUGH

INTEGRATING THE ARTS INTO JEWISH EDUCATION **147**

Jewish Life Cycle > Growing Older > Music

MUSICAL MEMORIES
Grades 2–3

Note: The four activities for this topic can easily be integrated into a multisession unit on aging. This music activity will require advance preparation.

Inspiration

"Joining in communal activities of any sort allows older people to feel their place among their community and people. The importance of this sense of connectedness amid lives of disconnection and discontinuity makes it incumbent upon those involved in the Jewish community to forge connection with older adults in their midst" (Rela M. Geffen, *Celebration and Renewal: Rites of Passage in Judaism,* page 220).

Providing older adults with a sense of connection and purpose within the Jewish community is one of the greatest responsibilities we have. Music is a powerful medium to transmit ideas and memories, and a meaningful way to dialogue and connect with older members of the community.

Objective

Students will dialogue with older adults, learn about their favorite songs and the memories they evoke, and create a "Musical Memory Book" for their new "senior" friends.

Materials

- Paper and pen/pencils
- Materials to create "Musical Memory Books" (cardstock for covers, paper)
- Crayons, markers, paint

Process

1. Several weeks in advance, follow the procedure for inviting senior visitors to visit the classroom as outlined in the creative writing activity for this topic (page 153).

2. In preparation for this activity, make sure that students have a basic understanding of the Jewish attitude toward aging. Use as background the "Big Idea" (page 147), the "Inspiration" section above, and the "Inspiration" sections from the drama, creative writing, and visual arts activities for this topic (pages 151, 153, and 156). You may also wish to do the drama activity for this topic (page 151) with students as an introduction and a way of preparing them to meet their senior guests.

3. Discuss with the students the power of music. Ask the following: Does anyone in the class enjoy listening to music? Why? When you hear certain music, does it remind you of people, places, and events in your life? Play for the class some samples of Jewish folk music, klezmer music, and other forms of traditional and contemporary Jewish music (for example, selections from the sound track of *Fiddler on the Roof*). Ask the students if listening to this music evokes any memories for them.

4. Explain to the students that as people get older, the "sound tracks" of their lives become richer and more varied. Music can be an important connection to one's memories of specific

times, places, people, and events. Similarly, the music of Jewish holidays, worship, and life-cycle events can be a powerful connection to the Jewish community for seniors. Emphasize why this connection is so important to seniors.

5. On the day of the seniors' visit, give each student or team of students a copy of the Musical Memory Questions (page 150). Match them up with their senior guests and have them spend twenty to thirty minutes discussing the questions and taking careful notes of the responses. If possible, take a Polaroid or digital photo of each team of students and seniors.

6. Following the interviews, have students and seniors work together to create a Musical Memory Book using the information they gathered in the interview. They can draw or paint a cover (be sure to include the photograph of the student–senior team if there is one), write or type out the lyrics to the song, and include any other information that was learned in the interview. Send the book home with the senior guests as a thank-you for their participation.

7. If time allows, have student–senior teams perform their song for the group.

Helpful Hints

- This activity lends itself particularly well to integration with the creative writing activity for this topic (page 153). Add the Musical Memory Questions (page 150) to the sheet of Interview Questions found with that activity (page 155), and have the student–senior teams spend more time conducting the interview. Then create the Musical Memory Books as a thank-you gift for visitors to take home with them. If time is short, the students can create their books independently and send or deliver them to their senior guests at a later time.

- Find a musician who would be willing and able to accompany the student–senior teams when they sing their song to the class.

Resources

Geffen, Rela M., ed. *Celebration and Renewal: Rites of Passage in Judaism.* Philadelphia, PA: Jewish Publication Society, 1993.
Explains such life-cycle events as birth, marriage, midlife, sickness, religious conversion, and mourning as viewed, experienced, and treated from a Jewish perspective.

Morris, Ann. *Grandma Esther Remembers: A Jewish-American Family Story.* Minneapolis, MN: Lerner Publishing Group, 2002.
An introduction to the idea of family stories, with an emphasis on how grandmothers and grandchildren interact with one another.

MUSICAL MEMORY QUESTIONS

1. Name a favorite song from your childhood or from your later life that you can remember and sing. It should be a song that evokes memories and feelings or reminds you of a specific time, place, person, or event.

2. What are the lyrics to the song? Provide as many as you remember.

3. At what age do you remember first learning the song? Do you remember where you were, who you were with, or any other details?

4. Does the song make you remember a specific time, place, person, or event?

5. How does the song make you feel when you sing or hear it today?

BECOMING OLDER
Grades 2–3

Note: The four activities for this topic can easily be integrated into a multisession unit on aging.

Inspiration
"Do not treat a man with disrespect when he is old, for some of us are growing old . . .
Do not neglect the discourse of wise men, but busy yourself with their proverbs,
For from them you will gain instruction, and learn to serve great men.
Do not miss the discourse of old men, for they learnt it from their fathers.
From them you will gain understanding, and learn to return an answer in your time of need . . .
How beautiful is the wisdom of old men . . .
Rich experience is the crown of old men, and their boast is the fear of the Lord"
(Ben Sira 8:6–9; 25:5–6).

From time to time, each one of us imagines growing older. We need only to put ourselves in the place of others to begin to understand how important it is to treat our elders with respect and dignity.

Objective
Students will experience, through creative dress-up and role-play, what it feels like to be a senior citizen.

Materials
- Sunglasses
- Cotton balls
- Canes, crutches, walker, wheelchair
- Gray wigs/beards
- Shawls, sweaters, scarves, etc.
- Hand mirrors

Process
1. Engage the students in a discussion about aging. Elicit from them words and phrases that they associate with "growing older" or being a "senior citizen." Write their responses on a blackboard, a flip chart, or a large sheet of butcher paper so that all can see.

2. Ask students to name people in their lives who are senior citizens (grandparents, great-granparents, great-aunts and -uncles, etc.). Ask students to share some of the wonderful qualities of those people.

3. Ask students what they think might be hard about becoming an older person. Do they know any older people who have special challenges?

4. Tell students that as people age, they sometimes lose parts of their basic abilities, including the ability to see, hear, and walk. Today, we will try to experience and understand what it feels like to lose those important abilities. Explain to students that they are going to use some costumes and props to help them imagine what it feels like to grow older. Share that the activity

INTEGRATING THE ARTS INTO JEWISH EDUCATION

may feel silly at times, but that you want them to try to be serious and really use their imaginations.

5. To have some fun with the activity, you can invite students to put on some costume pieces—sweaters, shawls, gray wigs and beards—to help them become "older." You may wish to invite parents to come to school to help apply makeup to make the students look older. Keep hand mirrors around so that students can see how they look.

6. Give each student two cotton balls and have them place them gently inside their ears. Ask them questions in a very soft voice and see if they have trouble hearing you.

7. Have students put on sunglasses and turn out all of the lights in the room. Pull down the shades or blinds so that the room is as dark as possible. Ask students to find small objects that you have placed around the room.

8. Give some students a cane, a walker, or a pair of crutches and have them walk around the room. Or, have them sit in a wheelchair. Ask them to navigate around tables and chairs, open closed doors, climb stairs, move items from one place to another, etc.

9. Give students some time to experience all the challenges presented by the props. Then bring everyone back together and have them remove the props and costumes. Ask students to share how it felt to have their abilities impaired. Ask them to imagine what it would be like if they had to deal with these impairments all the time, for the rest of their lives.

10. Conclude this activity by discussing with the students the importance of being sensitive to people who are not as "able" as they are. Emphasize the Jewish perspective on how we treat the elderly, using material from the "Big Idea" (page 147), the "Inspiration" section for this topic (page 151), and the "Inspiration" sections from the music, creative writing, and visual arts activities in this unit (pages 148, 153, and 156). Ask students to share ideas of how they can treat their elders with dignity and respect.

Helpful Hints

- There is bound to be a certain amount of giggling during this activity, but keep urging students to stay on task. In the follow-up discussion, make sure to emphasize that not all older people lose all of their abilities, but many older people do face such challenges. Focus the discussion on the importance Judaism places on honoring and being sensitive to the needs of the elderly in our community.

- This activity will be most effective in the context of a unit on aging—for example, it would make an excellent introduction in advance of visiting a nursing home.

Resources

The Jewish Life Cycle—The Aging Process: Late Life Questions
http://www.jafi.org.il/education/lifecycle/jewishlc/06-0.html
This Jewish Agency for Israel Web site includes a wealth of background information, text sources, and activities about Judaism and the aging process.

Miller, Ronald S., and Zalman Schachter-Shalomi. *From Age-Ing to Sage-Ing: A Profound New Vision of Growing Older.* New York: Warner Books, 1995.
The authors suggest the concepts of "elderhood" and "the art of life completion" to create a positive, personal-growth oriented approach to growing older.

STANDING ON THE SHOULDERS OF THE ONES WHO CAME BEFORE
Grades K–1

Note: The four activities for this topic can easily be integrated into a multisession unit on aging. This creative writing activity will require some advance preparation and involves inviting older guests to the classroom.

Inspiration
"Regarding the person who learns from the old, to what can this person be compared? To one eating ripe grapes and drinking old wine" (Pirkei Avot 4:20).

From generation to generation, *mi'dor l'dor*, we listen to our elders and learn from their experiences and lives. Speaking with our elders is not only a way to transmit history, but a way to gain perspective on our own lives and acquire wisdom that would otherwise be lost forever.

Objectives
Students will interview senior citizens in order to get to know them, develop a relationship, and come to understand what it is like to grow older.

Materials
- Copies of the Interview Questions (page 155)
- Pens or pencils
- Clipboards or notebooks (hard surface on which to write)
- Name tags

Process
1. Several weeks in advance, invite a group of seniors to visit the classroom. The visitors could be the grandparents of the students, or they could be residents of a local senior center, nursing home, or retirement living center. Alternatively, arrange for the class to make a visit to a nearby senior housing location.

2. In preparation for this activity, make sure that students have a basic understanding of the Jewish attitude toward aging. Use as background the "Big Idea" (page 147), the "Inspiration" section above, and the "Inspiration" sections from the music, drama, and visual arts activities for this topic (pages 148, 151, and 156). You may also wish to do the drama activity for this topic (page 151) with students as an introduction to the topic and as a way of preparing them to meet their senior guests.

3. In a class session before the date of the guests' visit, have one or two interview "practice rounds" in the classroom. The teacher can play the part of the elderly guest, and the students can practice asking questions and getting comfortable with the idea of interviewing someone. Speak to the students about what to expect, and make it clear that they can ask for help during the interview process if they need it.

4. On the day of the activity, just before the guests arrive, "set the scene" by reading aloud the following:

 There are many things in life that become more precious as they get older—fine jewelry, an ancient book, a beautiful antique wooden cabinet. So it is with the people in our lives

too—grandparents, great-grandparents, aunts, uncles, rabbis, and teachers. When we visit and spend time with older people, we get a chance to hear stories from long ago, to learn songs that no one knows anymore, to try on clothing or jewelry from a past time.

Older people give us wisdom and can answer many questions for us. Sometimes it may be hard to understand an older person's words, or truly relate to the experiences they have had in their lives, but we have so much to learn from them. We honor and respect them—some people call it "standing on the shoulders of the ones who came before."

Today we will be joined by a group of grandparents and special friends who are visiting our school. We will be interviewing our guests and will have the opportunity to learn about their lives and history. What kinds of things do you think you can learn from an older person?

5. Distribute copies of the Interview Questions (page 155). If the interviews are conducted outside the classroom, make sure students have a notebook, clipboard, or other hard surface on which to write.

6. Match students up with their senior interviewees, making sure that introductions are made and that everyone has a name tag. Allow students to spend up to thirty minutes on the interview. If the interview is over in less than thirty minutes, have an art project or puzzle page ready for the elderly guest and student to work on together. Alternatively, integrate the visual arts activity for this topic (page 156) into the visit.

Helpful Hints

- The names of grandparents and elderly friends attending must be received ahead of time so teachers can preassign which child interviews which guest. If possible, try to get some background information about the seniors to help match them up appropriately with students—for example, if among the group of seniors is a gentleman who had a career as a sportswriter, match him up with a student or students who love baseball. Depending on the age and level of maturity of the students, it may be best to team up two students with each senior, or have parent volunteers accompany the students.

- Having the children perform a song for the senior guests upon their arrival can help "break the ice" and further the interaction between them.

- Display the completed Interview Question sheets either in a large binder or as a wall or bulletin board display. If possible, include Polaroid or digital photos of each team of seniors and students.

Resources

Barbara, Diane. *Grandmother and Me: A Special Book for You and Your Grandmother to Fill in Together and Share with Each Other.* New York: Harry N. Abrams, 2004.
 A unique combination of baby book, scrapbook, and family record in which grandmothers and their grandchildren can record their memories and collect mementos.

Blumenthal, Deborah. *Aunt Claire's Yellow Beehive Hair.* East Rutherford, NJ: Dial Books, 2001.
 Annie reaches into the past with the help of her great-aunt to learn more about her ancestors.

JewishGen: The Home of Jewish Genealogy
http://www.jewishgen.org
 JewishGen is the primary Internet source for researchers of Jewish genealogy worldwide. The site includes learning and research tools for researching one's Jewish ancestry.

INTERVIEW QUESTIONS

1. What is your English name and your Hebrew or Yiddish name?

2. Where were you born, and where did you grow up?

3. What was your work or job before you retired?

4. Please tell me about two things that were very different when you were eight years old than the way they are today.

5. What was your favorite Jewish holiday when you were growing up?

6. The Jewish holidays incorporate many family customs. Which special family custom comes to mind from your childhood?

7. Judaism prepares us for ways we should live. What is your best advice for how I should live a proud Jewish life?

Jewish Life Cycle > Growing Older > Visual Arts

BRINGING OUT THE BEAUTY IN OUR ELDERS' FACES
Grades 2–3

Note: The four activities for this topic can easily be integrated into a multisession unit on aging. This visual arts activity will require some advance preparation.

Inspiration

Author, poet, and tzedakah maven Danny Siegel translates the quote from Leviticus 19:2 found in the "Big Idea" (page 147) with a slightly different interpretation:

"You shall rise before an elder and allow the beauty, glory, and majesty of their faces to emerge."

Beauty and glory are two characteristics that should follow us throughout our lives. Siegel incorporates this idea into specific ways of involving ourselves with our elders: "Reverence for older people is most assuredly a mitzvah, and whatever it takes to make it happen, Jews are required to do no less than Jews are required to fast on Yom Kippur. A few ways to do this include providing them with animals and gardens; having them make tzedakah boxes and challah covers for us or with us; taking photographs with them . . ." (Danny Siegel, "The Mitzvah of Bringing Out the Beauty in Our Elder's Faces" in *A Heart of Wisdom: Making the Jewish Journey from Midlife Through the Elder Years,* edited by Susan Berrin).

No matter our age, there is joy to be found in creating and surrounding ourselves with beauty.

Objective

The student will make, or help an elderly person make, a creative covering for a plant container, book, or picture frame.

Materials

- Heavy aluminum foil, cut into sheets
- Colored tissue paper
- Scissors
- White glue
- Wide disposable brushes
- Cardboard cut into eight-by-ten-inch sheets (for photo frame project)
- Glitter and metallic threads (optional)

Process

1. Engage the students in a discussion about beauty in the world surrounding them. What is beautiful about their hometown or the community in which they live? Answers might include natural features like mountains or rivers, or man-made features like buildings, gardens, art, and sculpture. Ask:
 - How do these things make you feel?
 - Have you ever been to a place that was not so pretty (streets crowded with run-down buildings, trash-filled vacant lots, etc.)?
 - How do places like that make you feel?
 - Why do you think it is important to live in a place surrounded by beautiful things like nature, art, and pictures?

2. Ask the students if they know anyone who lives in a nursing home or senior retirement center. Ask them to describe what it feels like to be in that place. In many old-age homes, the rooms tend to have little beauty or individual character. Creating something that can add color or personality, or change the environment in some way, can mean a great deal to someone living there. Ask the students why they think it is important to help someone to beautify the place in which they live.

3. Before the activity begins, mix equal parts water and white glue in a mixing cup. Store this mixture in a jar with a lid.

4. Cut or tear pieces of colored tissue paper into strips or odd shapes.

5. Give each student a piece of aluminum foil, cut to the appropriate size for the project they wish to create. For a plant holder cover or book cover, measure to the specific object. For a photo frame, use a sheet of foil approximately ten inches by twelve inches. Have the students place the foil on the table with the shiny side up.

6. Using a wide brush, paint the aluminum foil with the glue mixture, coating it evenly.

7. Place pieces of colored tissue paper on the aluminum foil to create a design, and paint over them with the glue mixture. As the tissue paper becomes saturated, the colors will run to create new colors. If desired, add glitter or metallic threads while the glue is still wet. When finished, set aside and let the glue dry overnight.

8. When dry, wrap the foil around a plant pot or book to create a decorative cover. Tape in place. For a picture frame, wrap the foil around a sheet of cardboard and tape the edges to the back. Then tape or glue a photo in the middle to create a "frame" that surrounds the picture.

Helpful Hints

- When preparing the aluminum foil, make sure to allow for a generous piece so you are able to cover your project completely.

- This project can be completed in the classroom before a visit or it can be a project that is part of a program while visiting a nursing home. Either way, it will bring beauty and creativity to someone's living area.

Resources

Berrin, Susan, ed. *A Heart of Wisdom: Making the Jewish Journey from Midlife Through the Elder Years.* Woodstock, VT: Jewish Lights, 1997.
A collection of thoughtful and often provocative essays by rabbis, social workers, journalists, lecturers, and lay Jews on the many facets of aging.

Jewish Life Cycle > Bar/Bat Mitzvah

BECOMING a RESPONSIBLE ADULT

ACTIONS that CREATE a JEWISH WORLD

The BIG IDEA

BAR/BAT MITZVAH
Grades 4–6

"Becoming a bar mitzvah or a bat mitzvah means that one is subject to the requirement of carrying out religious deeds, that one bears responsibility for himself or herself. That simple transaction—coming for the first time as an adult to assume the rights and responsibilities of maturity—forms the single most powerful occasion in the life of the maturing young Jew and his or her family"
(Jacob Neusner, *The Enchantments of Judaism*, page 140).

When a young Jewish member of our community becomes of age, he or she enters into the most important rite of passage for Jewish children, the bar/bat mitzvah. This rite of passage requires that we become responsible for our actions and recognize our obligations to ourselves, to our community, and to God.

ANSWERING when CALLED UPON

finding MEANING and DEPTH through ACTION

INTEGRATING THE ARTS INTO JEWISH EDUCATION

Jewish Life Cycle > Bar/Bat Mitzvah > Music

AND YOU SHALL PUT SOME OF YOUR HONOR UPON HIM
Grades 4–6

Inspiration
"And Moses spoke unto Adonai, saying, 'Let Adonai, the God of the spirits of all flesh, set a man over the congregation, which may go out before them, and which may go in before them, and which may lead them out, and which may bring them in; that the congregation of Adonai be not as sheep which have no shepherd.' And Adonai said unto Moses, 'Take thee Joshua the son of Nun, a man in whom is the spirit, and lay your hand upon him. . . . And you shall put some of your honor upon him, that all the congregation of the children of Israel may be obedient" (Numbers 27:15–20).

Objective
Students will study and discuss the transition of leadership between Moses and Joshua in the Torah portion *Pinchas* and compare it to their own personal journey to becoming a Jewish adult.

Materials
- Recording of the song "Joshua, I Wanna Talk with You" by Peter and Ellen Allard
- CD player
- Copies of an English translation of Numbers 27:15–20 from the Torah portion *Pinchas*

Process
1. Listen to the recording of the song "Joshua, I Wanna Talk with You." Distribute copies of the lyrics (page 162) and read through them as a class. Explain that in a few moments the students will read the verses from Torah on which the song is based.

2. Distribute copies of the English translation of the Torah portion *Pinchas* (Numbers 25:10–30:1) and read through the *parashah*. Focus specifically on chapter 27, verses 15–20, and engage the students in a discussion of how these verses relate to becoming a bar or bat mitzvah. Emphasize the concepts of assuming leadership roles in the synagogue, during the worship service, and within the Jewish community. Draw the parallel between the assumption of these responsibilities by Joshua as leader of the Israelites and the assumption of similar responsibilities by a young person becoming bar or bat mitzvah.

3. Lead students in a comparison of the lyrics of the song with the text of the specified verses from Numbers. Use the following questions to guide the discussion:
 - Which character from the *parashah* is singing the song?
 - Which character in the *parashah* is being sung to?
 - Why do you think the name "Joshua" is repeated so many times?
 - Do you think it is effective to start every line in each verse with the name "Joshua"? Why or why not?
 - Why is Joshua an important character in this *parashah*?
 - Why might Joshua be afraid to do what Moses is asking him to do?
 - What might the relationship between Moses and Joshua have to do with you as you prepare for your bar or bat mitzvah?

OPEN IT UP!

- What makes you nervous or apprehensive about becoming a bar or bat mitzvah?
- What does it mean to you to take on a leadership role in your service?
- Do you feel that becoming a bar/bat mitzvah means taking a leadership role in the community?
- Can you think of a setting in which this song could be sung? Could this song be sung during your bar or bat mitzvah service?
- After your bar or bat mitzvah, how would the lyrics to this song help you live your life as an adult Jew?

4. Discuss with the students the idea of an apprenticeship. An apprentice studies with a skilled person in order to learn from him or her and be able to do the same work. Joshua was Moses's apprentice in that Moses taught him, by example, how to lead the Israelites. Use the following questions to guide the discussion:
 - Can you give an example of a profession in which a young person can learn from an older, more experienced person?
 - If you could have a younger person as your apprentice right now, what skills do you possess that you would want to teach?
 - If you could be the apprentice of an older, more experienced person right now, what would you want to learn?
 - Who guides you in learning how to be a Jew?

5. Play the song for students again, and have them listen carefully and pay close attention to the lyrics. Ask:
 - Does Moses feel happy or sad that Joshua must take on more responsibility in the community?
 - How do you think Joshua feels to be gaining all of the responsibility for the care of the community?
 - How do you think he would have felt if he were able to share more of the responsibility?

6. If time allows, conclude the activity with an open discussion of the students' fears and excitement at becoming bar or bat mitzvah. Emphasize that students are not alone in this "rite of passage," that their teachers, rabbis, cantors, principals, and parents are there to guide them on this exciting journey.

Helpful Hints
- If possible, ask the cantor or music teacher to come in and sing the song for your students.
- Ask high school students to come in and speak to your pre–bar and bat mitzvah students about their transition into Jewish adulthood. You may wish to ask them to respond to some of the questions above.

Resources

Allard, Peter and Ellen. "Joshua, I Wanna Talk with You." Audio recording. *Available on the compact disc* Sounds of Holiness/Sounds of Sinai/Sounds of Promise *from Sounds Write Productions, Inc., www.soundswrite.com.*

Metter, Bert. *Bar Mitzvah, Bat Mitzvah: How Jewish Boys and Girls Come of Age.* New York: Clarion Books, 1984.

Background information on the bar/bat mitzvah process for older elementary school students.

JOSHUA, I WANNA TALK WITH YOU
Words and music by Peter and Ellen Allard

Joshua, I wanna talk with you,
Joshua, I wanna walk with you,
Joshua, I wanna tell you what I am thinking.
Joshua, you know my time is done,
Joshua, you know you are the one,
Joshua, you are the next one in line.

Chorus: God asked me to lay my hand upon you.
By doing so, I will give you my blessing and consent.
Surely you can lead your people, Joshua,
It's time for you to meet Adonai inside the tent.

Joshua, you've seen me through it all,
Joshua, you've seen me do it all,
Joshua, you've been watching for many years and
Joshua, come on and try it now,
Joshua, come on apply it now,
Joshua, I will show you the way.

Chorus

Joshua, you stand above the rest,
Joshua, you stand up to the test,
Joshua, you stand to be the next Jewish leader.
Joshua, won't you take my hand?
Joshua, won't you take a stand?
Joshua, won't you carry it on?

FINDING THE "MITZVAH" IN BAR/BAT MITZVAH
Grades 4–6

Inspiration
"A Jew's actions create a Jewish world. Judaism has much to add about inner life, dignity, relationships, sanctity, public and private fidelity, gratitude, commitment, and the family. Many Jewish stories embody those virtues. But, in reality, we learn less from maiseh *(story) than from mitzvah. The* mitzvot *are the most effective teaching tools about the search for goodness because they are simple, immediate, and concrete. They do not require interpretation. They require doing"* (Rabbi Jeffrey K. Salkin, *Putting God on the Guest List,* page 66).

Adolescents learn the most effective lessons in action, in doing, and in motion. They find great meaning in being productive members of society. Give them a meaningful task, and they will feel valued and important. *Mitzvot* are the Jewish way of inviting adolescents into our community with significant purpose and direction.

Objective
Students will role-play their understanding of the *mitzvot* that they begin to observe when becoming a bar or bat mitzvah.

Materials
- Brown paper bag
- Scraps of paper with names of various *mitzvot* and *middot*. Suggestions include *anavah* (humility), *emet* (truthfulness), *lo levayesh* (not embarrassing), *miyut sichah* (minimizing small talk), *nedivut* (generosity), *ometz lev* (courage), *sh'mirat haguf* (taking care of your body), *shalom bayit* (peace in the house), *tzedakah* (justice), *tikkun olam* (repair of the world), *bal tashchit* (not wasting), and *tza'ar ba'alay chayim* (kindness to animals).

Process
1. Engage the students in a discussion about the process of becoming a bar or bat mitzvah. Focus not only on the ceremony but also on the process of becoming a mature person in the Jewish community. Explain that an important part of the transformation from child to adult means not just leading a service for the community but acting like a *mensch* (someone who does the right thing in a humble manner) in the community to the best of one's ability at all times.

2. Divide the class into small groups of three or four students. Instruct each group to draw a *middah* or mitzvah from the paper bag. Have the groups spread out around the room and give each group five to ten minutes to create a short scene in which one of the group members is challenged to express that value. For example, if the group draws "humility," they might create a scene about someone who gets a really cool, expensive bar mitzvah present and wants to brag about it to his friends. How could he show he's excited about the gift in a humble way?

3. Circulate among the groups, offering help in thinking up a circumstance where they could express their value or mitzvah. Help the students to brainstorm to come up with ideas.

4. Bring the groups back together and have them share their scenes one at a time. Encourage each group to listen respectfully to the others. Instruct students to watch for the value or mitzvah and guess what it is at the end of the presentation.

5. After the groups have all presented, lead the students in a discussion about which *middah* or mitzvah felt most challenging to take on. Which *middot* or *mitzvot* do they feel are the most important to embody as an adult?

Helpful Hints

- To extend the activity, ask groups to present two scenarios: one in which an inappropriate response is played out (i.e., not exemplifying the *middah* or mitzvah), and then the appropriate *mensch*-like response to the scenario.

- To further extend the activity, have students write about one of the values as a short follow-up to the role-play.

Resources

Leneman, Helen, ed. *Bar/Bat Mitzvah Education: A Sourcebook.* Denver, CO: A.R.E., 1993.
Includes a chapter on successful mitzvah programs.

Salkin, Rabbi Jeffrey K. *Putting God on the Guest List: How to Reclaim the Spiritual Meaning of Your Child's Bar or Bat Mitzvah.* Woodstock, VT: Jewish Lights, 2001.
This book of explanation, instruction, and inspiration helps people find core spiritual values in the bar and bat mitzvah ceremony.

Ziv Tzedakah Fund: Bar Mitzvah/Bat Mitzvah
http://www.ziv.org/bar_bat_mitzvah.html
This Web site features an article that offers ideas and suggestions for creating a unique mitzvah project that will add a special ingredient of tikkun olam *to a bar or bat mitzvah celebration.*

Jewish Life Cycle > Bar/Bat Mitzvah > Creative Writing

BECOMING A CHILD OF THE COMMANDMENTS
Grades 4–6

Inspiration
"My God and God of my ancestors, in truth and sincerity, I lift up my eyes to You on this great and sacred day and say: My childhood days have passed and I take upon myself the responsibilities of a Jew. It is my duty to keep the Commandments and I must answer when called upon for my own actions, for which You hold me responsible. Until now I have been a Jew by birth alone, but today I freely enter Your congregation and before all the world I will revere Your name" (prayer recited by bar/bat mitzvah).

Accepting the commandments bears great responsibility. As young Jews look forward to becoming children of the commandments, they must also begin to envision who they desire to become in the future when much more will be expected of their actions and decisions.

Objective
Students will write letters to themselves for sealing away and reading at a later time; these letters will set goals for accomplishment in the future when they have reached bar/bat mitzvah age.

Materials
- Writing paper
- Pens or pencils
- Sealing wax or simple dripped candle wax
- Optional: a seal to press into the wax

Process
1. Distribute paper and writing instruments.
2. "Set the scene" by reading aloud the following:

 A bar or bat mitzvah ceremony is a very serious occasion. Some of you might know this if you've attended a ceremony before. It is one/two/three years until you become bar or bat mitzvah yourself and you're beginning to think about it a lot. This is no small responsibility—it is a huge and important one! According to Jewish law, you will be considered a Jewish adult, expected to make decisions, expected to be a leader in the community, expected to be a junior leader in the congregation. You'll be leaving childhood behind, but won't exactly feel like an adult because in the non-Jewish world you have to be eighteen or even twenty-one to be considered an adult.

 But you are learning to read Torah and taking on the responsibility for more adult commandments. The younger children in the synagogue think you are totally cool—they want to do everything you do. This makes you see how important it is to be a role model for younger children. Isn't that what becoming an adult is all about?

 Today you will be writing a letter to yourself to be read when you reach bar or bat mitzvah age. You can make your writing very personal—once it is sealed no one will see the letter but you. When you're finished, we will seal the envelopes with sealing wax, only to be

opened when you become bar or bat mitzvah.

Think very seriously about the person you want to become when you take on the responsibility of becoming a bar or bat mitzvah. Write about your goals for yourself at bar/bat mitzvah age. Write about two things that you'd like to accomplish in seventh grade. Write at least one Jewish commandment you'll be taking responsibility for fulfilling in the bar/bat mitzvah year (for example, leading prayer, helping others in your family, or helping the environment). Use your imagination to the fullest. What should your more grown-up self be doing at age twelve or thirteen? Write for fifteen minutes. Just let the words flow. Start now.

3. Allow students to write freely for fifteen minutes.

4. Instruct the students to seal their completed letters in an envelope. If desired, help the students seal their letters with hot wax and stamp with a seal such as an Israeli coin.

5. Send the letters home to parents along with a brief letter explaining the activity and asking them to keep the letter in a safe place and give it to their child on the occasion of his or her bar or bat mitzvah.

Helpful Hints

- The completed letters, in envelopes with colorful wax seals, can make an attractive display. Create a placard explaining the project and its goal for the pre–bar/bat mitzvah students. Put the letters in a large glass fishbowl and display in a prominent place in the synagogue.

- If desired, the principal or rabbi can keep the letters and distribute them to the students at the appropriate time.

Resources

Goldin, Barbara Diamond. *Bat Mitzvah: A Jewish Girl's Coming of Age.* New York: Viking, 1995.
An excellent guide to understanding the meaning and significance of this ritual passage.

Neusner, Jacob. *The Enchantments of Judaism: Rites of Transformation from Birth to Death.* New York: Basic Books, 1987.
An excellent explanation of the whys and wherefores of the basic rites and practices of Judaism, including bar and bat mitzvah.

TAKING ON RESPONSIBILITY, TAKING ACTION
Grades 4–6

Inspiration
"At five, one should study Scripture; at ten, one should study Mishnah; at thirteen, one is ready to do mitzvot; *at fifteen one is ready to study Talmud; at eighteen, one is ready to get married; at twenty, one is responsible for providing for a family"* (Pirkei Avot 5:24).

At this critical juncture in a young Jewish life, it is important that the bar or bat mitzvah take responsibility not only for his or her actions, but begin to take responsibility for the welfare of the community. Taking action through *mitzvot* brings meaning and depth to the bar or bat mitzvah experience.

Objective
The student will create a personalized *tzedakah* box using family photos and meaningful images.

Materials
- Containers of all kinds with tops or plastic lids
- Scissors
- X-acto knife
- White glue
- Disposable sponge brushes
- Magazines
- Personal photos

Process
1. In preparation for class, send a letter home to parents asking each student to bring to class two items:
 a. a container with a lid or plastic top (for example, a metal can of nuts or a paperboard snack container like a Pringles can), to be used for making a personal *tzedakah* box. It's a good idea to have extras available on the day of the activity for those students who might forget.
 b. Old family photographs or childhood pictures of the student, to be used in decorating and personalizing the *tzedakah* box. Parents can make color or black-and-white copies of the old photos if they wish to save the originals. Explain in the letter how old photos connect the students to their family history, an important part of becoming a bar or bat mitzvah.
2. On the day of the activity, engage the students in a discussion about becoming a bar or bat mitzvah. Focus on the concept of becoming a mature person in the Jewish community. Explain that an important part of the transformation from child to adult means assuming responsibility for performing *mitzvot*. One of the most important *mitzvot* is *tzedakah*, meaning "justice" and "righteousness." The rabbis taught that *tzedakah* was as important as all the other *mitzvot* combined (*Baba Batra* 9a). Ask:

- What does it mean to be a righteous person?
- How is giving to those in need a righteous act?
- Why do you think *tzedakah* is so important in Jewish life?

Explain that *tzedakah* can also be translated as "sacred giving" and that it is a custom to give *tzedakah* each week before lighting the Shabbat candles. Why do you think this tradition of sacred giving is tied to Shabbat? Tell the students that as part of their process of becoming bar or bat mitzvah, they will be making *tzedakah* boxes to help them fulfill this important mitzvah.

3. Ask a few students to share an explanation of the photos they have brought in to use for their *tzedakah* boxes. Ask: Why is it appropriate and meaningful to have pictures of family members on a *tzedakah* box? Emphasize the concepts of good values being passed down from one generation to the next, and that each of us owes much to the kindness and righteousness of those who came before us.

4. Instruct the students to trim their photographs to fit on their containers. Provide them with magazines from which they can choose images to decorate their *tzedakah* box in addition to the photographs. These images should represent various categories of *mitzvot* and *middot* (values), such as *tzedakah* (justice or righteousness), *g'milut chasadim* (acts of kindness), *hiddur p'nei zakayn* (respect for elderly), *talmud Torah* (the study of Torah), *tza'ar ba'alay chayim* (kindness to animals), or any other relevant mitzvah or *middah* the students would like to include.

5. Cover the workspace, and pass out glue for students to adhere images to their containers. Allow the collages to dry.

6. Pass out a sponge brush to each student, along with a mixture of equal parts white glue and water. Instruct the students to coat the entire collage with the glue-and-water mixture to seal the images and protect them from peeling off.

7. With an X-acto knife, cut a slot in the top of the container to drop money in.

8. Ask students to present their *tzedakah* boxes to the class. Have each student explain why they chose certain images and pictures. Ask students to describe actions they can take to fulfill the *mitzvot* pictured on their *tzedakah* boxes. These images can help them to decide where to send the money they collect. Give students a list of possible charities and match the charities to the particular *mitzvot* they chose to represent on their *tzedakah* boxes. Encourage each student to choose a charity and take action!

Helpful Hints
- Many synagogues require each bar/bat mitzvah student to engage in a community mitzvah project as part of their preparation. This activity can be an excellent introduction and kickoff to that process.
- If students bring in original photographs, make copies of them. The copies will be easier to work with when gluing them to the container.

Resources

Loeb, Sorel Goldberg, and Barbara Binder Kadden. *Teaching Torah: A Treasury of Insights and Activities*. Rev. ed. Denver, CO: A.R.E., 1997.
Includes a suggested bar/bat mitzvah project for each Torah portion.

Salkin, Rabbi Jeffrey K. *For Kids: Putting God on Your Guest List: How to Claim the Spiritual Meaning of Your Bar/Bat Mitzvah*. Woodstock, VT: Jewish Lights, 1998.
This book helps young people understand that becoming bar or bat mitzvah is more about the quality of their lives than about the quality of their performance in leading the service. Included are excellent suggestions and resources for acts of tzedakah *as well as "little mitzvahs."*

Jewish Life Cycle > Death

a favorite **SONG** or **MELODY**

COMFORTING the **MOURNER**

The BIG IDEA

DEATH
Family Education

*"In the rising of the sun and in its going down, we remember them.
In the blowing of the wind and in the chill of winter, we remember them.
In the opening of the buds and in the rebirth of spring,
we remember them.
In the blueness of the sky and in the warmth of summer,
we remember them.
In the rustling of leaves and in the beauty of autumn, we remember them.
In the beginning of the year and when it ends, we remember them.
When we are weary and in need of strength, we remember them.
When we are lost and sick at heart, we remember them.
When we have joys we yearn to share, we remember them.
So long as we live, they too shall live, for they are now
a part of us, as we remember them"*
("Memorywork" by Jack Riemer and Sylvan D. Kamens).

Memory is our hope, our tie, our
connection to our loved ones
after they have gone
from this earth.

creating **MEMORIES** and **CONNECTIONS**

the **LIGHT** of a loved one's **MEMORY**

INTEGRATING THE ARTS INTO JEWISH EDUCATION

Jewish Life Cycle > Death > Music

SONGS THAT SPARK MEMORY
Family Education

Inspiration

"He who stands on a normal rung weeps; he who stands higher is silent; but he who stands on the topmost rung converts his sorrow into song" (Abraham Joshua Heschel, *A Passion for Truth*, page 283; quoting a Chasidic teaching about mourning and loss).

Music communicates much of who we are. When we remember someone through music, whether through a song he or she loved or a song that reminds us of a shared experience, we are connected to that person on a higher emotional level.

Objective

Students and families will describe a favorite song or melody of a loved one whom they remember.

Materials

- CD player
- Copy of the CD *Bring the Sabbath Home* by Peter and Ellen Allard (includes the song "We Remember")
- Copies of the Family Questionnaire (see page 174)
- Copies of the lyrics to "We Remember" (see page 175)

Process

1. In advance of the activity, send home a letter asking each family to think about a family member, a friend of the family, or someone in their community who has passed away. Ask them to bring to the activity the title of one or more songs that remind them of that person.

2. At the start of the lesson, play the song "We Remember" from the CD *Bring the Sabbath Home* by Peter and Ellen Allard. Distribute a copy of the lyrics (page 175) to each family so they can read along as the song is played. Play the song a second time and ask the participants to sing along.

3. Pass out copies of the Family Questionnaire (page 174). Ask each family to discuss and answer the questions in their small group.

4. Ask the families to assemble again as one large group. Invite a representative from each family to speak for a few minutes about the person their family focused on, incorporating the answers to the questions from step 3 in their comments. Make sure that all family representatives name the song or songs that remind them of the person they remembered. On the chalkboard, a flip chart, or a large sheet of butcher paper, create a master list of the families, the people they remember, and the song or songs that remind them of those people.

5. When every family has had a chance to speak, take a look at the list of songs. Are there any songs in common between families? Are there any common themes among the songs? Emphasize that it is the positive memories of our loved ones evoked by the songs that makes them live on in our hearts.

6. End the activity by once again singing "We Remember," with or without the CD.

Helpful Hints

- If possible, ask the cantor or music specialist to sing and teach "We Remember" at the beginning of the activity.
- Give specific instructions as to the length of time each family may speak. This can be an emotional exercise, and all participants should have the same opportunity to talk about their loved ones.

Resources

Allard, Peter, and Ellen Allard. *Bring the Sabbath Home.* 80-Z Music. Compact disc.
Includes the song "We Remember." Available from www.peterandellen.com.

Astor, Cynthia. *A Song for Cecilia Fantini.* Tiburon, CA: H. J. Kramer, 1997.
This book tells the story of a young girl whose much-loved piano teacher dies, and the girl learns to cope with her loss with the help of family and friends.

Diamant, Anita, and Karen Kushner. *How to Be a Jewish Parent: A Practical Handbook for Family Life.* New York: Schocken, 2000.
This easy-to-read guide is really "a book of choice" for parents who wish to raise happy, healthy Jewish children. Includes a section on observing life-cycle rituals from birth to death.

Virtual Cantor.com
http://www.virtualcantor.com/yizkor.htm.
Click on the last link, Track 182, to hear a version of El Malay Rachamim, *the memorial prayer traditionally chanted at a funeral and during* Yizkor.

FAMILY QUESTIONNAIRE

1. What is the name of the person you are remembering today?

2. What do you remember about this person?

3. When you think of this person, do you picture him or her in a certain place?

4. Are there certain smells that make you think of this person?

5. Are there certain sounds that make you think of this person?

6. Are there certain songs that make you think of this person? When you hear these songs, how do they make you feel?

7. Are there certain times when you remember this person?

8. What will you continue to do to help yourself remember this person?

WE REMEMBER

Words and music by Peter and Ellen Allard
© 2002 80-Z Music, Inc.

Chorus: We remember, we remember
 We remember, yes we do
 We remember all of you.
 We remember, we remember
 We remember, yes we do, we remember.

All of you who came before
On whose shoulders we stand
All of you who came before
Every woman, every child and man.

Chorus

As we travel on this path
And we move further on
As we travel on this path
You are never really gone.

Chorus

We give praise and thanks to God
In everything we do
We give praise and thanks to God
This strong love will see us through.

Chorus

MAKING A *SHIVA* CALL
Family Education

Inspiration

"Now when Job's three friends heard of all the terrible things that had happened to him, they each came from his own home . . . and they agreed to go together to sympathize with Job and to comfort him. And when they saw him from a distance, and did not recognize him, they cried out loud and wept; and each of them tore his clothing, and threw dust upon their heads toward heaven. Then they sat down on the ground with him for seven days and seven nights. No one said a word to him, for they saw that his grief was very great" (Job 2:11–13).

One of the most important obligations a person can fulfill during a time of mourning is *nichum avelim,* comforting the mourners. Visiting a friend or loved one during *shiva* is a mitzvah. Taking time to remember this special person during a difficult time for the mourner can be comforting and healing.

Objective

Parents and students will work together to create a set of words and phrases to use when making a *shiva* call.

Materials

- Laver for hand-washing
- Mourning benches
- Food (real or fake)
- *Siddurim*
- Covered mirrors

Process

1. Engage the families in a discussion about the traditions connected to Jewish mourning, in particular the process of sitting *shiva*. Make sure all participants understand that *shiva* is an important part of the mourning process, and that it is a mitzvah to go to the *shiva* house and comfort the mourner. For many people, this experience is an uncomfortable one, simply because they are unsure of how to act or what to say at a house of mourning. Explain that this exercise will dramatize the customs that take place during *shiva* and will allow families to work together to figure out what to say to the bereaved.

2. Set up an area in the room to look like a *shiva* house, using as many props as possible—a laver for hand-washing outside the door, covered mirrors inside, etc. Make sure to explain to the participants any and all Jewish ritual objects used so everyone is familiar with Jewish mourning traditions.

3. Brainstorm with participants to create a list of phrases and words people often say when visiting a *shiva* house or any other house of mourning they have visited. Encourage families to share things they like to hear—or not hear—when they are facing a difficult time. Write the words and phrases on a blackboard, a flip chart, or a large piece of butcher paper so all can see.

4. Break up into family groups. Instruct each group to discuss some of the words and phrases shared by the group. Have each family choose two or three that resonate with them.

5. Explain to the families that they will have a chance to practice what to say in a situation where they will need to comfort a friend of the family who is in mourning. You can create as specific a scenario as you like. As the teacher, you will be playing the bereaved person. For example, you could say to the group, "Imagine that my name is Mrs. Cohen and I have been your neighbor for twenty years. My husband has just died in a car accident and I have two teenage children. You are coming to visit me two days after my husband's funeral."

6. Give each family a few minutes to sit together and talk about what they can say and do when they go to the *shiva* house.

7. Encourage families to "visit" one at a time, so that the group as a whole can experience each other's visits. Encourage them to use the props that are set. For example, they may walk in carrying a basket that is supposed to be food for the bereaved. Give each family group a few minutes to be in the house and then leave.

8. Wrap up the activity with an opportunity for people to reflect on and discuss their experiences. Begin with the children and ask them what aspects of the experience they found really difficult. What helped them to feel comfortable? Then open up the discussion to include the adults as well. Invite them to share experiences from their own lives about making *shiva* calls.

Helpful Hints

- For families who have experienced a recent loss, this experience may be a bit too close to home. Talk to your education director or congregational rabbi in advance of class to find out if anyone has experienced a recent loss. If so, call the family ahead of time and let them know what you are planning to do in the family education program.

- You may wish to take notes during the discussion and type up a letter to the families that includes some of the helpful things that they thought of to say at a *shiva* house.

Resources

Generation to Generation: Jewish Families Talk About Death. VHS. Produced by Sue Marx. 35 min. Sue Marx Films, Inc., in cooperation with the Jewish Federation of Metropolitan Detroit. Available from Behrman House, http://www.behrmanhouse.com.
 This video offers help for families in talking about a difficult and painful subject: the death of a loved one.

Kadden, Barbara Binder, and Bruce Kadden. *Teaching Jewish Life Cycle: Traditions and Activities.* Denver, CO: A.R.E., 1997.
 Includes a comprehensive chapter called "The End of Life: Death, Burial, and Mourning."

Techner, David, and Judith Hirt-Manheimer. *A Candle for Grandpa: A Guide to the Jewish Funeral for Children and Parents.* New York: UAHC Press, 1993.
 This illustrated story sensitively explains the Jewish view of death and funeral practices and rituals to young children.

Jewish Life Cycle > Death > Creative Writing

ZICH'RONAM LIV'RACHA: MAY THEIR MEMORY BE A BLESSING
Family Education

Inspiration

"There are stars whose light reaches the earth only after they themselves have disintegrated. And there are individuals whose memory lights the world after they have passed from it. These lights shine in the darkest night and illumine for us the path" (Hannah Senesh).

Life is about creating memories and connections. When we have a close relationship with a loved one, we create shared memories. Once that loved one is gone, those memories live on and carry us through, enriching our lives and making us better people for having shared special times together.

Objective

Families will write memories of a beloved relative or family friend who has died.

Materials

- Writing paper
- Pens or pencils

Process

1. Distribute paper and writing instruments.

2. "Set the scene" by reading aloud the following:

 In Jewish tradition we say the Kaddish prayer when someone we love has died. Kaddish is not a mournful prayer, but instead it is a way to praise God even though we may be feeling great pain. When someone dies, the words we also say are *"Baruch dayan emet"* ("Blessed is the true judge") because we must always remember that God is the true judge even though we may not be able to understand why a person had to die.

 There is a Jewish tradition at the holiday of Sukkot called *ushpizin* where we imagine that we are inviting into our sukkah famous figures from the Bible stories. Today we will pretend that we are in a giant white tent rather than a sukkah. In our tent, we will do an *ushpizin* activity where we will each invite into the tent a person who has died and who has left us with good memories. We will fill the tent with our *ushpizin* memories.

 Think for a few minutes about a person who has died but about whom you still have strong memories. Do you remember something you did with this person when he or she was alive? Do you remember a story that the person told you? Do you remember something unusual about this person—the way he or she laughed? The perfume or after-shave lotion that became his or scent? The way he or she sang? His or her favorite music? The clothing that he or she wore? Did this person ever tell you anything that was very important to you and that you still remember to this day?

3. Instruct each participant to write freely for about fifteen minutes. Have them begin with the words "Here comes Uncle Max into the tent," inserting the name of their loved one in place of

OPEN IT UP!

"Uncle Max." Have them continue with the narration, for example: "Uncle Max is wearing his famous red socks and he is telling one of his legendary stories." Encourage participants to just let the words flow.

Helpful Hints

- Those too young to write can dictate to an adult, or into a tape recorder for later transcription.
- To extend this activity, have each family member create a "memory page" with their writing about their loved one. The page can include drawings, poems, photographs, etc. (notify families in advance if you wish to have them bring photographs). All the pages of each family can be bound together in a "memory book" that they can take home with them.

Resources

Halevi, Moshe. *Saying Goodbye to Grandpa*. Jerusalem: Pitspopany, 1997.
A young boy learns the tradition of saying Kaddish for his grandfather.

Hesse, Karen. *Poppy's Chair*. New York: Macmillan, 1993.
Following the death of her grandfather, Leah and her grandmother talk together about death and dealing with loss.

Liss-Levinson, Nechama. *When a Grandparent Dies: A Kid's Own Remembering Workbook for Dealing with Shiva and the Years Beyond*. Woodstock, VT: Jewish Lights, 1995.
A tool for helping children to participate in the process of mourning, and to overcome the awkwardness that can often accompany the traditional grieving rituals and events.

Jewish Life Cycle > Death > Visual Arts

RITUAL AND MEMORY
Family Education

Inspiration

"When I die, if you need to weep, cry for someone walking on the street beside you.
And when you need me, put your arms around others and give them what you need to give me.
You can love me most by letting hands touch hands and souls touch souls.
You can love me most by sharing your simchas and multiplying your mitzvot.
You can love me most by letting me live in your eyes and not in your mind.
And when you say Kaddish for me, remember what our Torah teaches:
Love doesn't die, people do.
So when all that's left of me is love, give me away"
(Author unknown, adapted from "Epitaph" by Merrit Malloy).

Jewish tradition tells us that on the anniversary of a loved one's death, we light a *yahrzeit* candle to remember and show our love for that person. The candle burns for twenty-four hours to fill the day with the light of that person's memory.

Objective

The students will use wire to weave a container for a *yahrzeit* candle.

Materials

- One *yahrzeit* candle for each family
- Flexible wire, 20 to 25 gauge
- Wire cutters
- Masking tape

Process

1. Engage the participants in a discussion about the importance of memory within Jewish traditions of death and mourning. Use the "Big Idea" (page 171) and the "Inspiration" section above as background. Emphasize the concepts that the good deeds a person does in life remain after they are gone, and that by remembering our loved ones we keep them alive in our hearts. Ask: What are some of the rituals that Judaism provides for remembering our loved ones? There are many appropriate answers, including saying Kaddish, visiting the cemetery, and unveiling a headstone, but steer the conversation toward the ritual of lighting a *yahrzeit* candle. Make sure all participants understand this ritual and its purpose (see the "Resources" section, page 181, for suggested background material).

2. Explain to the group that the activity they are about to do uses wire to create a holder for a *yahrzeit* candle. Wire is a particular medium that has "memory," retaining all the bends and twists that we intentionally create. Therefore, wire can be used as a metaphor for memory in the performance of the *yahrzeit* ritual. Tell participants that today they will create a special container for the *yahrzeit* candle with the memory of a specific person in mind.

3. Cut six or seven lengths of wire about twelve inches long for each family. Instruct the families to lay four of the pieces on the table, crossing them at the center. These will serve as the "spokes" of the container (see diagram #1, page 182). Affix the ends to the table with masking tape to hold them in place.

4. Take one of the remaining pieces of wire (the "weaver") and wrap one end of it around the center intersection so that it is secure. Then choose one of the spokes and wrap the weaver in a circle around it. Move clockwise to the next spoke and wrap it in the same way (see diagram #2, page 182).

5. Continue this process until the weaver piece runs out of length (i.e., you are unable to circle around another spoke). Attach another piece of wire to the weaver by twisting the two wires together, and continue the wrapping process. Continue until you have created as many circular rotations around the base as you like. Wrap the loose end of the weaver around one of the spokes to secure it, making sure there are no sharp edges sticking out.

6. Place the *yahrzeit* candle in the middle of the piece. Bend the wires up and around the candle to create a holder. Bend back the portion of the spokes that stick above the candle, and make downward-curving coils (see diagram #3, page 182).

7. With one more piece of wire, continue weaving over the curving coils for two or three more rotations. Again, secure the weaver around one of the spokes, making sure that there are no sharp edges sticking out.

Helpful Hints

- Wire comes in all gauges. The higher the number, the thinner and more flexible the wire. Make sure the wire you choose bends easily, is strong enough to hold the form, and doesn't break when you bend it back and forth a few times.

- You can use uncoated copper wire for a beautiful copper-colored container, or use plastic-coated wire in a variety of colors. Each participant can choose their own colors to create a personalized candleholder.

- To extend this activity, suggest to the families that each time they finish another circle of weaving they share one special memory of the person or people they are thinking of during the project.

Resources

Behrman House. *The Jewish Mourner's Handbook*. Springfield, NJ: Behrman House, 1992.
A brief but comprehensive guide to all aspects of the Jewish rituals and traditions related to death, burial, and mourning.

Gootman, Marilyn E. *When a Friend Dies: A Book for Teens About Grieving and Healing* (rev. ed.). Minneapolis, MN: Free Spirit, 2005.
This simple, sensitive book answers many of the questions teens have at a time of loss, helping them wrestle with the questions they may be too scared to ask.

About Judaism
http://judaism.about.com
Type "yahrzeit" in the "Search" box for links to several articles about how and why Jews light the yahrzeit *candle.*

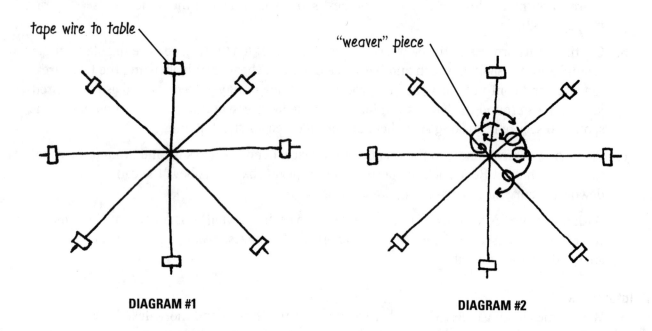

DIAGRAM #1

DIAGRAM #2

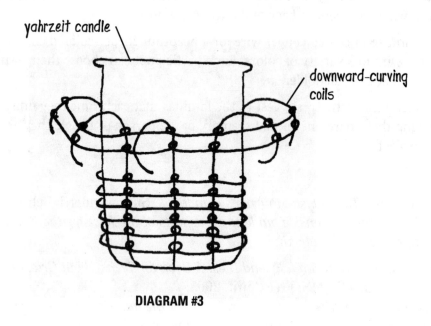

DIAGRAM #3